AWARD—WINNING ADVERTISING OF THE 20TH CENTURY
THE ART DIRECTORS CLUB INC.

THE ART DIRECTORS CLUB INC.
EDITED BY JACKIE MERRI MEYER

• • • • • First published in the United States of America in 2000
by UNIVERSE PUBLISHING
A Division of Rizzoli International Publications, Inc.
300 Park Avenue South
New York, NY 10010

00 01 02 03 / 10 9 8 7 6 5 4 3 2 1

ISBN: 0-7893-0369-8

Library of Congress Cataloging-in-Publication Data

Mad Ave: a century of award-winning advertising / The Art
Directors Club; foreword, Jerry Della Femina.
p. cm. ISBN 0-7893-0369-8
1. Advertising—United States. 2. Commercial art—United
States
I. Della Femina, Jerry. II. Art Directors Club (New York, N.Y.)
HF5813.U6 M23 2000
659.1'0973—dc21
99-042238

Printed in Singapore

Design by Pentagram

JERRY DELLA FEMINA
CHAIRMAN/CEO
DELLA FEMINA/JEARY AND PARTNERS

It turned out that the carrot was claustrophobic—that was a bit of bad luck. As he was being carried into the giant oven by two over-sized gaffers he screamed, "Sid, get me out of here. Sid, I beg you, please get me out of here! I can't breathe." To make things worse, the legs of the two peas, which were folded under them, began to cramp up, and the peas started to complain. This didn't sit well with the asparagus, who, furious at the lack of professionalism of the rest of the vegetables, refused to read his line until Sid, the usually amiable director, lost his temper and threatened the asparagus that he would never work again as an asparagus or any other animal, vegetable, or mineral. The vegetables—with the exception of the carrot, who, resigned to his fate, was now softly whimpering—quieted down. Then we rolled the twenty-foot sheet of plastic wrap over them, and they started to sing about the virtues of being cooked in a microwave oven while protected by Saran Wrap.

When the shoot was over the actors playing the vegetables took off their costumes and told us how much they enjoyed the shoot and inquired about the possibility of this becoming a long-standing campaign. Then the carrot assured us that the next time he would "be just fine" in the role, and the asparagus mumbled that he would not lose his temper the next time. The peas, who were played by two incredibly chubby sisters, said nothing. They just limped away in search of liniment for their aching legs.

The commercial I just described was shot in 1979. It ran a few times, then the client pulled it off the air because, based on one showing for a research measurement that is no longer in existence today, it scored two points under the norm for the category. If you work in advertising as a creative person or a copywriter or an art director or a producer or a director you know when you wake up in the morning that at least once, sometime during the day, someone will break your heart. But you also know that many times during the day you'll laugh as no one in any other profession will laugh.

What fun this wonderful business called advertising was.

What fun this wonderful business called advertising is.

When I started in the advertising business in the 1960s, I was told by creative veterans the "golden age" had past; the real fun was in the 1950s. The veterans were wrong. By the end of the sixties I felt there could never be a better time than the sixties. I was wrong. The seventies were better than the sixties and the eighties were better . . . and so on and so forth. The fact is, advertising gets better and better, because it is so ridiculous.

We make thirty-second minimovies. We go to exotic places to shoot wonderful spots. We take weeks to conceive them, months to complete them, and then the person whom we intend to see the spot waits until our pride and joy comes up on the TV screen and then gets up and goes to the bathroom. Is it any wonder that we ad people are all a little bit mad?

The other day, some twenty-five years after the vegetable shoot, I found myself on a shoot in the middle of Los Angeles for the World Gold Council. The scene was of conquistadors traveling the desert in search of gold. For the sake of authenticity, a Gila monster —it looked like a big fat lizard to me—was supposed to be resting on a log as the explorers rode past. Naturally, a Gila monster "wrangler" was employed. He made a frightening announcement: "If the Gila monster breaks loose and comes near you, do not move. I warn you, do not move, as his bite is highly poisonous. If you are bitten you will die in a few minutes." He then mumbled something about having plenty of antidote for the bite, but to tell the truth, I wasn't listening. I was counting the number of cast and crew members—it was thirty-six. I figured that the Gila monster would have his choice of seventy-two legs before he got to me, because I was planning on moving mine like the wind.

The Gila monster was carefully placed on the log. Seventy-two eyes were trained on him. The desert was so quiet you could hardly hear the horses' hooves softly touching the desert sand. The near silence was shattered by the sound of the "William Tell Overture." Yes, it was the ring of my cell phone. The Gila monster, not familiar with the "William Tell Overture," stared at me through heavily hooded eyes.

"Hello," I whispered.

"Hello." came the loud voice of my partner.

"I can't talk now, there's a Gila monster staring at me."

"Are you OK?" he asked. "Yes. How come you can't get through to me when we're both in New York City, but you sound like you're next door when I'm in a desert a million miles away under the watchful eye of a Gila monster?"

Now the Gila monster was starting to stir. I hung up and started to get ready to run for my life.

Talking vegetables and Gila monsters in the desert. After all these years, advertising is still the most fun you can have with your clothes on. And now, at my age, it's even more fun than I can have with my clothes off.

EDITOR'S NOTE

It has been a privilege to compile this treasure trove of award-winning advertising. I enjoyed working with so many talented, creative people and was pleased with how passionate, gracious, and generous they were with their contributions. Thanks, too, to their fabulous assistants.

This book culls the history and insights of several generations of advertising luminaries. For each recorded decade of the twentieth century, we invited a guest editor renowned for his or her contribution to the advertising profession (with the exception of Steven Heller, an art historian of wide ranging expertise) to write a piece on the world of advertising at that time and to select the advertisements that best represent the era. Their criteria was not based on the nature of art or copy alone, but on the overall best, well-executed concepts. It is important to note that these ads were chosen in hindsight—our editors had the freedom to choose "the best of the best" without any agendas, political or otherwise, that might have hindered such a selection at the time these ads were initially created. The resulting collection represents a scope of work never before presented in a single volume. Curated from the standpoint of today's modern media sensibilities, these pieces recreate before our eyes the story of American advertising from its infancy in the 1920s to its full maturity as the century comes to a close.

I have worked in the publishing world for twenty years and have always subscribed to and pored over the advertising trade journals. Advertising is a much maligned business, yet its force in shaping our lives is tremendous. I have been fascinated by the changes that the advertising industry has gone through over the decades. Many say that advertising today is not as good as the old days, but having looked through eighty volumes of work, I can say that there was always the good, the bad, and the ugly. Truly great advertising is rare, and it is perhaps more difficult to achieve than it was decades ago. However, in spite of today's obstacles, good work always seems to make it through—just take a look at today's profusion of multimedia, from the Internet to over one hundred TV channels.

Jackie Merri Meyer

All royalties from MAD AVE go directly to The Art Directors Club of New York, a not-for-profit organization, founded by creative professionals, that is dedicated to encouraging and recognizing excellence in visual communication and presenting "visual fuel."

➤➤ ACKNOWLEDGMENTS

Thank you to Abigail Wilentz and Charles Miers of Universe for inviting us to create this book and for making this compendium a reality.

Many thanks as well to Bonnie Eldon, Belinda Hellinger, and Michael Vagnetti at Universe for your expertise and attention to detail throughout the publishing process, and thanks especially to Dave McAninch and Stephanie Iverson for poring over the text with an eye for detail.

I would also like to thank the ADC Publications, Inc. board members: Nicholas Callaway, Stefan Stagmaster, Joseph Montebello, and especially Myrna Davis, Director of ADC—nothing gets done without her blessing and wise counsel.

My gratitude to Paula Scher and Pentagram as well as Keith Daigle and Tina Chang for an elegant and thoughtful book design and for making the process so much fun.

Thanks to the outstanding contributors, who each adopted a decade and took the time to choose the ads and provide engaging essays.

Lastly, thanks to the generous folks who volunteered and assisted with the many details of coordinating and promoting this project: Ana Crespo, Rachel McClain, Claire Brown, Chris Standish, Olga Grisaitis, Melissa Hirsch, Jeff Newelt, Jenny Synan, Ann Schirripa, Laetitia Wolff, Glen Kubota, Gwendolyn Leung, Judy Lee, Pierre-Michel Hyppolite, Meg Monagan, Steve Chow, Tony Zisa, Michael Trent, Jennifer La Barge, Bill Gray, Mary Jordan, Victoria Venantini, Marianne Flatley, Nora Slattery, and Kate Wilentz.

Jackie Merri Meyer
Editor, MAD AVE
President, The Art Directors Club Publications Inc. 2000

· · · · ·

1920

"It was no longer possible to make an advertisement striking, conspicuous, and attractive by still pictures and realistic groups."

➤➤ Commercial Modern: Commodity Fetishism and American Design Style in the 1920s and 1930s

STEVEN HELLER ▼ ▼

CHAIRMAN, MFA/DESIGN PROGRAM, SCHOOL OF VISUAL ARTS
ART DIRECTOR, NEW YORK TIMES BOOK REVIEW
EDITOR, AIGA JOURNAL OF GRAPHIC DESIGN

• • • • •

Modernism is one of the most slippery terms in our cultural lexicon. Its root, "modern," means "new," "fresh," or "of the moment." When the "M" is capitalized, however, it signifies the revolutionary developments in art and design in Europe during the early twentieth century. Modern art refers to the first blush of non-traditional art in the early 1900s, such as Fauvism, Cubism, and Expressionism. It is also the rubric for kindred movements of the late teens and early 1920s, Futurism, de Stijl, Orphism, Constructivism, Purism, DaDa, Surrealism, and of course, The Bauhaus, which all challenged antiquated traditions with politically and aesthetically radical ideas. As graphic design, Modernism was codified in 1925 and called The New Typography, referring to the asymmetric composition, sans serif letterforms, and photographic images that replaced archaic type design, central-axis page layout, and realistic illustration. After World War II, this evolved into a strict design canon known as the International Style, which in the 1950s evolved further into the Corporate Style—a clean, economical, and rational design system applied to business. Today, this is accepted as American Modernism. But back in the 1920s modernism with a small "m" was emerging as an alternative to both traditional and radical approaches. This mannerism spread via France throughout Europe and Asia, and, in 1925, made its way to the United States, where it was harnessed as a tool of advertising and was instrumental in the American consumer boom. Because this "commercial modernism" was a marriage (though some critics considered it a sordid affair) of radical art and strategic merchandising, it is historically overshadowed by revolutionary Modernism. This article, therefore, will shed light on an often overlooked pivotal stage of the alternative American modernism.

The story begins in 1925 at a playground of modernity in Paris along the banks of the Seine. The Exposition Internationale des Arts Décoratifs et Industriels Modernes was laid out in boulevards lined with funhouses of consumerism decorated with geometric, planar ornament and neo-classical friezes incorporating functional and decorative designs. The world's leading clothing, furniture, and houseware manufacturers, and many grand retail emporia were encouraged to exhibit their latest products and designs. But one

player was noticeably absent. The United States, the world's largest industrial nation with the most expansive consumer culture, declined an invitation to participate at the urging of its industrial leaders. In 1923, U.S. Secretary of Commerce Herbert Hoover apologetically announced to the Fourth Annual Exposition of Women's Arts and Industries that although "we produce a vast volume of goods of much artistic value . . . [America could not] contribute sufficiently varied design of unique character or of special expression in American artistry to warrant such participation."

The leaders of American industry believed "that they could not match the French designers either in making a stripped Arts and Crafts 'modernism' (with its threat of becoming a new 'universal' style) or by boldly countering with a national style," explains Terry Smith in *Making the Modern: Industry, Art, and Design in America* (University of Chicago Press, 1993). Although by 1923, America had become the world's foremost manufacturer, distributor, and marketer of machinery and consumables, quantity did not equal quality—nor did efficiency. American industrial products were made to last forever, but they looked cold, commonplace, and curiously old fashioned, as if they had actually been around forever. By the early twenties, American industry had not developed a national design aesthetic, as had France or England, but rather accepted appearances determined by the limitations imposed by engineering and materials. If design entered into the operation at all it was imported. Terry Smith adds that "buying 'designs' was cheaper than investing in the design process, cheaper than importing already trained designers."

American products were either nondescript or laden with Beaux Arts ornament to camouflage a mass-produced look. Although mass production was the foundation on which the modern American economy was built, many cultural critics felt that items coming off the assembly line lacked good taste. While the Bauhaus, Constructivism, and other European Modern avant gardes had already embraced the machine and proffered the integration of Modern art and industry, American industrialists, who could easily afford to aesthetically improve their products, were usually apathetic, if not resistant, to the idea. What they did not resist, however, were marketing strategies that would insure greater profits. So following a brief economic downturn and a subsequent boom in the

early twenties, industry frantically tried to find a new means of stimulating even further sales. It was the profit motive, not any transcendent utopian ethic or aesthetic ideal, that paved the way for commercial modernism in the United States, which was introduced to American advertising in 1925 by Earnest Elmo Calkins (1868–1964), an advertising pioneer, design reformer, and founder of Calkins and Holden Advertising Co. Like other American advertising and marketing executives he visited the Exposition Internationale des Arts Décoratifs et Industriels Modernes and came away inspired.

Describing the array of cubistic and futuristic graphics, packages, and point-of-purchase displays that he discovered in the pavilions for department stores like Bon Marché and Galleries Layfayette, Calkins wrote to his staff in New York: "It is extremely 'new art' and some of it too bizarre, but it achieves a certain exciting harmony, and in detail is entertaining to a degree. [Everything is] arranged with an eye to display, a vast piece of consummate window dressing. . . . It is not always beautiful, but it is diabolically clever." What was so different from most American advertising art was the noticeable rejection of realism in favor of abstraction. Illustration was not representational but, through symbols, metaphors, and allegories, exuded a "magical" atmosphere. Boxes and bottles were no longer mere utilitarian vessels for their contents, but rather represented the essence of what the product symbolized to the consumer. Later in an article, "The Dividends of Beauty" (*Advertising Arts*, 1933), Calkins summarized the development this way: "Modernism offered the opportunity of expressing the inexpressible, of suggesting not so much a motor car as speed, not so much a gown as style, not so much a compact as beauty." If this had a similar ring to one of F. T. Marinetti's Futurist manifestos, it was because Calkins studied and borrowed heavily from the European avant garde. He was a tireless advocate of a formalist version of modernity in commercial art and industrial design. "[W]hat seemed to be a new method for transfiguring commonplace objects became for Calkins a means of disconnecting form and content, thoughts and things," states Jackson Lears in *Fables of Abundance* (Basic Books, 1994).

Modern art, or what the leading advertising trade journal *Printers' Ink* magazine in 1928 called "foreign art ideas," elevated advertising art to a higher aesthetic level. For most advertising art direc-

tors, modernism was a "bag of tricks the artist could use to set an ordinary product apart," continues Lears. And advertising artists were indeed quick to appreciate the possibilities of modernism since realistic art had reached, what Calkins termed a "dead level of excellence." It was no longer possible to make an advertisement striking, conspicuous, and attractive by still pictures and realistic groups. Spearheaded by Calkins and Holden, and later adopted by such progressive agencies as N. W. Ayer (who opened its own galleries to display and promote their own modern advertising art) and Kenyon and Eckart, commonplace objects—toasters, refrigerators, coffee tins—were presented against new patterns and at skewed angles; contemporary industrial wares were shown in surrealistic and futuristic settings accented by contemporary typefaces with contempo names like Cubist Bold, Vulcan, Broadway, Novel Gothic, and more. Mise en page, or layout, inspired by the European New Typography, also became more dynamic in its asymmetry. Modernism offered what Jackson Lears calls the "aura of cosmopolitan culture and avant-garde style" and signaled the spread of an aesthetic coming of age of American advertising. In an essay titled "Cavalcade," (*Advertising Arts*, 1935) leading advertising artist René Clark enthusiastically recalled the years between 1925 and 1931 as the "golden age of advertising . . . merchandise sold easily . . . clients spent freely and gave us wide latitude of invention and experiment."

Calkins, who in 1903 joined forces with Ralph Holden, with whom he co-authored *Modern Advertising* (D. Appleton and Company) in 1905, early on proposed that fine typography must be a component of successful advertising rather than an afterthought thrown in by job printers. The first man to specialize in advertising typography was Benjamin Sherbow, whom Calkins had hired as a copywriter in 1919 but who soon began to experiment with display and text type (he later published a manual titled Sherbow's Charts, which Calkins touted as a "must" item in agency production departments). Around 1920 Calkins introduced the job of "type man," later called "type director," who specialized in providing fresh points of view to counter the clichés of the average printer. Integrating good typography and art was "a more subtle way of suggesting beauty in the products than baldly stating the fact in the text," wrote Calkins in his autobiography, *And Hearing Not* (Charles A. Scribn-

er's Sons, 1946). Suggesting a special relationship between the advertisement and goods by the style of the graphic design was something Calkins called "atmosphere," a fetishistic trait that ultimately rubbed off on the product itself. "Improving the physiognomy of advertising had a twofold result," he explained. "It directly influenced the taste of the public and indirectly conditioned the production of goods." Calkins recalled that he and artists were irked when they had to produce a good-looking advertisement for something that did not lend itself to attractive pictorial treatment.

This dichotomy between artistic advertising and humdrum product design sparked the engines of commercial modernism; by 1926 packages were redesigned and form and color given to old, established, commonplace articles. In Calkins's view, advertising was the Hy-test running the engines of industry. He was not wrong. "The styling of manufactured goods," he wrote in "Advertising Art in the United States..." (*Modern Publicity*, 1931), "is a byproduct of improved advertising design . . . The technical term for this idea is 'obsoletism.' We no longer wait for things to wear out. We displace them with others that are not more efficient but more attractive." Although clothing manufacturers had for decades been changing styles annually to increase consumer interest, industry had not adopted this strategy until Calkins made it his mission. "It seemed reasonable that if design and color made advertising more acceptable to the buying public," he wrote, "design and color would add salability of goods." He also noted that the majority of consumers were women, who indeed were accustomed to changes in fashions and were happily seduced by the sleek new designs. Although Calkins's and Holden's clients included car, cereal, and men's hat manufacturers, the majority of their accounts were for products targeted at women, such as appliances, housewares, and detergents.

In addition to print advertising, commercial modernism was introduced to the American public under glass. Influenced in 1925 by the Parisian style of cubistic patterns and ornament (pioneered by Paul Poiret), managers for the largest American department stores experimented with window designs. In Chicago, the Marshall Fields store placed stylized mannequins in front of surreal backgrounds as if they were three-dimensional paintings. In New York City, Macy's created windows with layers of modern ornament

framing the latest fashions. In 1928 the Macy's design department also devoted floor space to the International Exposition of Art in Industry, which introduced European-inspired modern wares to the American buying public. Outside on the street many store fronts were also designed with modern veneers. The department store had become such a showcase for modernism and modernity that contemporaries called this early phase "Department Store Modernism." In 1927, Alfred Barr, the first director of New York's Museum of Modern Art, and the first curator to promote revolutionary Modernism in America with an exhibition of The Bauhaus, wrote in a somewhat disapproving but nevertheless accurate account that Saks Fifth Avenue in New York, "through its advertisements and show windows . . . has done more to popularize the Modern Mannerism in pictorial and decorative arts than any two proselytizing critics."

Window design, like advertising, had historically relied on the "untutored intelligence of the outsider—the lithographer—who ordinarily knew little about advertising, less about the unique functions of the window display," wrote Herschel Deutsch in "Today's Trend in Window Displays" (*Advertising Arts*, 1931). But one of the key offshoots of Department Store Modernism was an increased need for trained designers to do the work that had been haphazardly done by non-designers. Deutsch further asserted that the designer tutored in Modern methods made window display a complex and individual form of advertising that called for careful study of the manufacturers' and retailers' needs: "The truly modern design," he wrote, "will be backed by a thorough understanding of every phase of its use and the manner in which its beauty can be built around that use rather than in denial of it . . . ". He went on to say in a somewhat obtuse reference to the Modern ethos, "If this be 'functionalism,' the new trend in window display design is making the most of it." In fact, what the orthodox Modernist regarded as functionalism was a stripped-down fundamental form, while the commercial modernist did not subscribe to such aesthetic asceticism.

Color, which was comparatively rare in magazine advertisements in the mid-1920s, was another aspect of Department Store Modernism introduced as a raucously decorative component in windows, which until then had been prosaic displays of products. The new windows borrowed primaries from de Stijl and The

Bauhaus and combined them with bright purples, greens, and oranges. In addition, "Modernism to the general public came to mean silver and black," explains Frederic Ehrlich in his book *The New Typography and Modern Layout* (Frederic A. Stokes, 1934), one of the most astutely written critiques (posing as an instructional manual) of Modern practice published in America at that time. Ehrlich was referring to the metallic silver papers and black silhouettes that were ubiquitously used in window displays and later in magazine advertisements, menus, etc. The new silver alloy, aluminum, symbolized the Machine Age as vividly as pictures of factories, crucibles, and gears. It suggested the commercial modern spirit in the same way F. T. Marinetti's Futurist book of poems, *Parole in Liberta Futuriste* (1932), with its shiny metallic covers, symbolized the revolutionary Modern spirit.

Department Store Modernism was practiced both by those who believed they honestly understood European Modernism and by others who simply practiced excess. Raymond Loewy—the designer of Bonwit Teller's stylish advertisements—represented the former, and wrote in the company's promotional magazine: "[M]odernism, its every phase, is in a state of evolution . . . which accounts for the fact that many atrocities as well as singular beauties are committed in its name. True modernism is good taste!" And here is the key distinction between the radical forms of European Modernism that are heroicized and romanticized today, and the commercial application introduced in the 1920s: The former was intended to violently disrupt the status quo and improve the visual environment, while the latter had no loftier purpose than to revolutionize the buying habits of the American public and so stimulate the economy.

In this sense this early phase of American modernism was not always favorably received by design critics. Frederic Ehrlich termed commercial modernism "a dark cloud," referring specifically to the decorative excesses in type, layout, ornament, and package designs created in the reflexive zeal to be modern. "'Modernism' . . . got off on the wrong foot in America," asserted advertising and industrial designer Walter Dorwin Teague in *Advertising Arts* (1931). "It had been developing as a school of design for many years in Europe, outgrowing its absurdities and cutting its wisdom teeth. But it burst on America as a full-fledged surprise, and we've never quite recovered

from the shock." He further argued that designers untutored in honest Modernist principles merely exploited the trend for its novelty: "They figured that the queerer they made their stuff, the better . . . Such was the penalty we paid for barging into a full-grown movement, instead of growing up with it. We had measles late in life."

The hostility to archaic tradition and, that promulgation of utopian universality which underscored the European Modern schools were not present in the modernity that American business embraced. Although certain visual traits of "revolutionary" Modernism were fundamentally influential, commercial modernism smoothed out the edges, reintroduced eschewed ornament, and accentuated a decorative, rather than a purely functional, sensibility. Orthodox Modernists disparagingly called this modernism, a vulgarization of experimental form—a false or perverted modernism. Indeed from the point of view of the purist, this was a valid description. Commercial modernism came in two distinct waves: The first was inspired by European Modernism but adopted geometric cubistic and futuristic decorative veneers that echoed the set-back silhouettes of skyscrapers; Frederic Ehrlich sarcastically wrote that this wave was welcomed by business as "a new force and hailed with the same enthusiasm as the discovery of a new scientific formula." The second wave, which hit around 1931, introduced streamlining to industrial, product, and graphic design, and was based on the principles of science and engineering as a determinant of modern form. According to Walter Dorwin Teague, one of its pioneers, it represented "the finest school of design, in contemporary manner, the world has yet seen." But although streamlining extolled the virtues of engineering, like the first wave, it also evolved into a commercial surface style exuding, what Jackson Lears calls "the cachet of modernism."

Today's Corporate Modernism bears little resemblance to American commercial modernism of the 1920s and 1930s (before the Europeans emigrated to the United States). Back then even the most utilitarian product was subject to intense styling. The goal of commercial modernism was to first increase consumer interest, and then make the world beautiful (or more accurately, stylish) through design. While the United States did not participate in the Exposition Internationale des Arts Décoratifs et Industriels Modernes, the

event nevertheless made an indelible impression on American marketers, promoters, and commercial artists who understood the practical benefits that could be reaped by promoting merchandise and styling products that were what the French expatriot advertising (and later pioneer industrial) designer Raymond Loewy called, "Most Advanced Yet Acceptable," or modern within proscribed limits. Loewy's so-called MAYA principle proposed rejecting the austere, non-ornamental aspects of avant-garde design and preserving the primary colors and rectilinear forms that signaled modernity yet would not repel a mass audience.

Calkins was a missionary of acceptable modernity who in his fervor to establish advertising as the agent of progress turned his attention to pseudo-science, and was instrumental in such modern marketing concepts as "consumption engineering," "forced obsolescence," and "styling the goods." These were the core concepts of an advertising strategy that introduced Modern art to an otherwise devoutly conservative profession whose primary responsibility was purchasing ad space from magazines and newspapers. By combining aspects of perceptual psychology with the pseudo-science of market research, Calkins proposed ways to control consumers' behavior through Pavlovian methods—by incrementally feeding them new mouthwatering styles. Consumption engineering was essentially a trick that encouraged redundancy, and artificially stimulated growth. "To make people buy more goods," he wrote in an essay titled "Advertising, Builder of Taste" (*The American Magazine of Art*, Sept. 1930), "it is necessary to displace what they already have, still useful, but outdated, old-fashioned, obsolete."

Calkins further believed that Modern art was, to put it in today's argot, as its own value additive. "When the uglier utilities of business cannot be beautified, art is used to make them disappear," wrote Calkins in "Advertising, Builder of Taste." "Gasometers are being painted according to the principles of camouflage . . . The bottles, jars, tubes, boxes, and cartons of hundreds of foods, drugs, toilet articles, perfumes, powders, pastes, and creams are in the hands of artists working solely to produce a container pleasing to the eye to add color and form to the shop window, or toilet table and kitchen shelf." This was one of innumerable pronouncements that Calkins made through trade journals, articles in newspapers

and magazines, and lectures before business and civic groups. He was a missionary who fervently believed that Modernism equaled beauty, and that beauty was the key to economic health and well-being. His pseudo-scientific notions provided a virtual catechism for the rightness of Modern design. Like the revolutionary European Modernists he pontificated that "we must acquire the new point of view, aided by the undeniable affinity that exists between some aspects of modern industrialism and some aspects of modern art."

Industrial art—commercial modernism—was as natural and logical an expression of Calkins's age as was religious art of the fifteenth century. "Business can and may be as stimulating a patron of the arts as the cardinals, prelates, and popes who represented the church . . . ," he wrote in his autobiography. But even Calkins cautioned against the excesses of the Modern spirit and the "distressing results in suddenly attempting to make over a thousand products in new shapes and shades . . . that did not harmonize with our ideas of luxury." Indeed Calkins, who spent his life attempting to raise the level of advertising from hucksterism to social science, argued as early as the 1930s, that advertising and product design should not exaggerate or falsify the product. And yet that is exactly what happened when commercial modernism reached its zenith as a widespread trend in 1929. "[I]nstances existed—and still exist—of advertising in which the product was lost sight of in preoccupation with creative technique. Even today we . . . see advertisements so 'fancy,' so 'arty' and artificial, that they neglect to sell the goods," wrote Harry A. Batten, Vice President of N. W. Ayer & Son, Inc., in an essay in *Modern Publicity*, 1931. And Frederic Ehrlich was even more vociferous in his condemnation of design eccentricity, characterizing much contemporary practice as "dynamic indigestion . . unreasoned and riotous composition . . . advertising monstrosities . . . the revolts of rebellions through which modernism had passed or was a part of."

The trade magazines touted the fact that modern advertising increased sales, which triggered greater production, which stimulated the economy. Advertising executives perpetuated this idea through self-promotional ads in trade and business magazines. And many advertising artists extolled the virtues of their own practice as contributing to social progress, such as this spirited comment by René Clark in "Cavalcade": "For fifteen years I've seen this styling

idea coming closer and closer to the thing that really counts . . . a low priced package . . . a container that millions of hands stretch out to buy because it says something to them that they can't resist!" But by 1929, merely four years after the introduction of commercial modernism, business and industry were producing too many goods to sustain such high levels of continued sales. Calkins's style engineering and obsoletism was being flagrantly employed with the most trivial items, such as razor blade wrappers, soap packages, and hat boxes, which received frequent makeovers. This kept designers occupied, factories busy, and retailers ordering more stock until the Crash of 1929. Overzealous advertising and product manufacturing in the bull market did not cause the catastrophic economic downslide that triggered America's Great Depression, but it was symptomatic of the what N. W. Ayer's Harry Batten described as economic overconfidence, "a sort of gambling fever [which] spread into every level of society."

Although advertising continued to be produced after 1929 in reduced quantities, Batten reported that business leaders complained that "advertising . . .had become effete; it was no longer practical. 'Let's have something with punch in it,' they chorused. 'Let's get in there and sell.'" Good appearance was not considered an asset, and businesses began to clamor for a return to hardsell methods. Modernist conceits could impart a magical aura to a product but that was insufficient when consumers were pennyconscious. In *Advertising The American Dream: Making the Way for Modernity* 1920–1940 (University of California Press, 1985), Roland Marchand writes that, "Depression advertising was distinctively 'loud,' cluttered, undignified, and direct." He asserts that advertising's leaders interpreted the Depression as a "deserved chastisement for follies and excesses of the boom years" and condemned styles of prosperity for being too abstract, too self-indulgently beautiful, too sleek and opulent. Some advertising men proclaimed what the trade journal *Printer's Ink* called a new "shirt-sleeve advertising," which intentionally imitated tabloid newspaper and pulp magazine layouts, and introduced comic strips as a frequent attention-grabbing device.

Despite overwhelming pressure to lower aesthetic standards, the modern agencies, particularly Calkins and Holden, N. W. Ayer, and

Kenyon and Eckart, struggled to maintain high levels taste. Batten insisted that "the advertising that did the best job during 1930s . . . was of the type representative of the best and highest development in layout, art-work and copy." Yet the Depression created strictures for the creation of ads, many of which were produced on short notice allowing little time for elaborate illustration. "Owing to lack of time . . .photography came into increasing favor," Batten added. "The art director found that . . .he could get a good modern page by using photographs." In the manner of European Modernism the photomontage soon replaced illustration, and as a further concession to business's criticism against "effete" advertising, a new New Typography, adhering to the original European ethic, more functional and less decorative, was introduced. "Type is becoming simpler every day, "wrote Batten comparing it with what he called the "modernistic" movement of 1929, which often failed to take into account that "advertising is primarily to be read." Similarly, layouts were inclined to be economical. "There was a noticeable lack of fussy ornament, an increasing cleanness and crispness of line . . . Fewer rules and type ornaments were used than in the first flush of 'Modernism.'" This new phase of American Modern graphic design is what Frederic Ehrlich referred to as "a return to typographic sanity," and "a glorious sunrise [that] dispelled the cold gray sky that overshadowed the real modernism in typography" He prophetically added; "If, or when Post Modernism appears to take the place of the Modern Typography, it cannot fail to incorporate the salient features of what we now know as modern."

By 1931, commercial modernism was on the wane. Advertising was practiced in either the hardsell "shirt sleeve" manner or a slightly more austere commercial modernism. By 1933, streamlining, the new industrial modernism aimed at reinvigorating the depressed American economy, began its influential rise, which would peak in architecture and displays at the 1939 New York World's Fair, "The World of Tomorrow." As a critical response to hardsell aesthetics on the one hand, and to the vacuum left by the demise of commercial modernism on the other, by 1938 the confluence of European émigré Moderns who escaped the Nazis and young homegrown acolytes began to forge the new American Modernism that would become the standard for postwar corporate communications. "Late

Modernism," as it might be called, characterized by strict grids, generous white space, and limited typographic variation, was the design canon until the early 1980s and the evolutionary high-water mark of Modernism itself. But today when Modernism is being critically scrutinized and harshly reevaluated it is useful to understand the complexities of this evolutionary process and the role of men like Calkins. Commercial modernism was a misinterpretation, indeed a perversion, of the European Modernist ideal, but not a crime against it. Orthodox European Modernism could never have taken hold in America in the 1920s in the same way as it did in the politically and socially troubled Germany and Russia. Despite its excesses, commercial modernism was necessary not only for stimulating the consumer culture through advertising, which ultimately filtered into other forms of graphic design, but also for encouraging American industry for the first time to adopt a design ethic.

Note:
In the belief that the quality of paintings being created for advertising during the first decade of the twentieth century was high enough to be judged by the same stringent standards as for fine art, Earnest Elmo Calkins initiated an exhibition of advertising illustration at the National Arts Club in 1908. A few more such exhibitions took place around New York City in the ensuing years, and by 1920 their success inspired the official founding of the Art Directors Club and its annual competition. Members of the newly formed ADC sent out its first Call for Entries that year, and a gold medal was commissioned from the popular young sculptor, Paul Manship. The first Art Directors Annual Exhibition and book were presented in the spring of 1921. (It should be noted that that Annuals were devoted exclusively to advertising illustration until 1948, when the competition expanded to include editorial art, and eventually, design, television commercials, and interactive media.)

Myrna Davis
Executive Director
The Art Directors Club

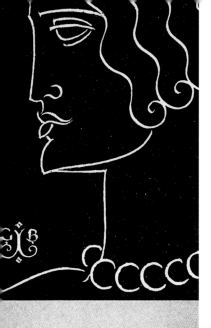

Cutting, waving and placing the hair to conform the best contour of the individual head. Skilled artists only are employed in the Charles of the Ritz salons

HAIRDRESSER TO HER MAJESTY, THE SMART AMERICAN WOMAN

Z-CARLTON, NEW YORK · RITZ-CARLTON, ATLANTIC CITY
Z-CARLTON, BOCA RATON, FLA. · THE PLAZA, NEW YORK
DISON HOTEL, NEW YORK · GLADSTONE, NEW YORK
YFAIR HOUSE, NEW YORK · PARK CHAMBERS, NEW YORK

➤ **Charles of the Ritz**
Artist: Gustav B. Jensen
Client: Charles of the Ritz

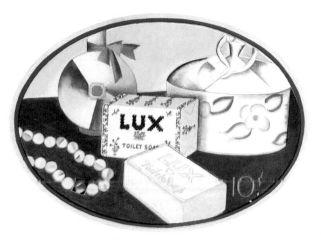

HELEN DRYDEN—Lux Toilet Soap
Loaned by Lever Brothers Company

➤ **Lux**
Artist: Helen Dryden
Client: Lever Brothers Co.

➤ **The Gibson**
Artist: Charles Coiner
Client: The Gibson Refrigerator Co.

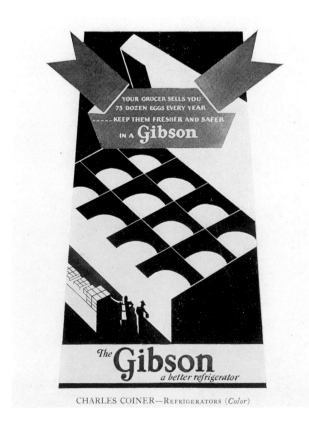

CHARLES COINER—Refrigerators *(Color)*

➤ **Bread is Your Best Food**
Artist: Jesse Willcox Smith
Client: Fleishman's Yeast

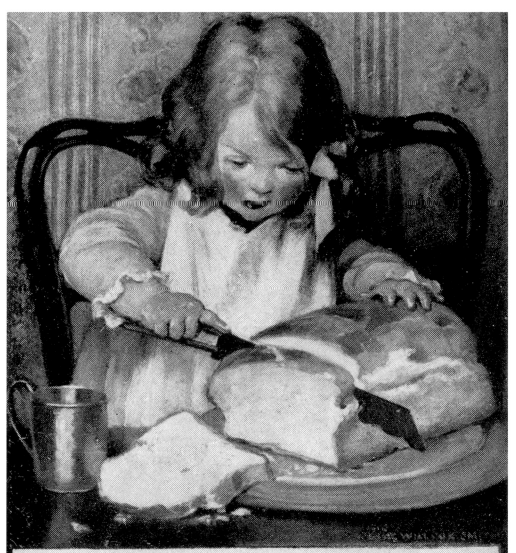

BREAD IS YOUR BEST FOOD!

Supreme in nutrition, it is lower in cost than the same amount of nourishment in any other form. It is your only economical food to-day.

Resolve to eat more Bread — and to give more of this health-building, muscle-making food to your children.

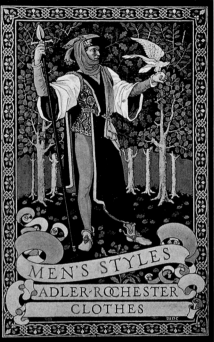

➤ **Men's Styles**
Artist: Walter Dorwin Teague
Client: Adler-Rochester Clothes

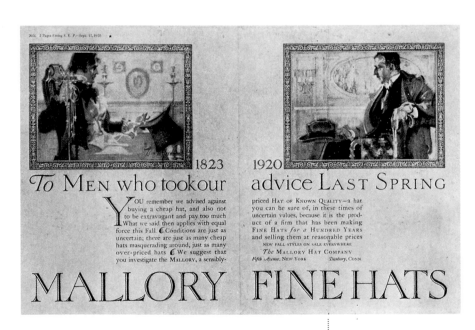

➤ **Mallory Fine Hats**
Artist: Leon N. Gordon
Client: E.A. Mallory & Sons

We used to tell a story at J Walter Thompson that illustrates the power of stories. It goes like this:
The Amish have an excellent reputation for making top quality products. It so happened that a family in a town close to an Amish community had to find homes for a litter of kittens.
They put out a sign that said "FREE KITTENS." For an entire week, no one stopped.
Then they changed the sign to "FREE AMISH KITTENS." The litter was gone in a day.

● ● ● ● ● **JAMES PATTERSON** / NOVELIST/ FORMER CHAIRMAN, J WALTER THOMPSON, NORTH AMERICA

➤ **Lion Collars**
Artist: C.C. Beall
Client: United Shirt & Collar Co.

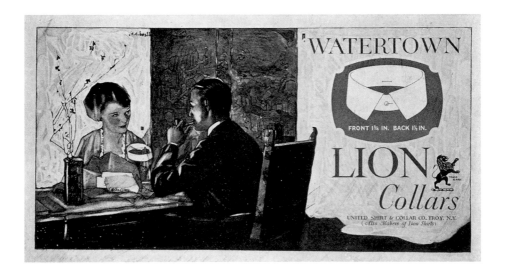

➤ **Post Toasties**
Artist: Maud Tousey Fangel
Client: Postum Cereal Company

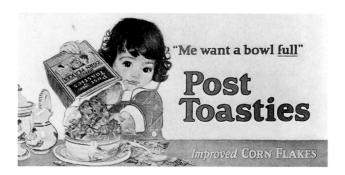

▲ **Beech-Nut Peanut Butter** Artist: Cushman Parker Client: Beech-Nut Packing Company

BEECH-NUT Peanut Butter
—one hundred per cent-
good! That's the children's ver-
dict. And grown-ups, too, con-
fess a fondness for its delectable
flavor. Why, just to spread it
out on bread in a smooth, golden-
brown layer, while the aroma of
fresh-roasted Virginia and Span-
ish peanuts drifts upward, is
enough to start anyone's appe-
tite! And how it does satisfy
that hunger-craving!

In jars, vacuum-sealed to pre-
serve its freshness to you.

BEECH-NUT PACKING CO.
Canajoharie New York

Beech-Nut
Peanut Butter

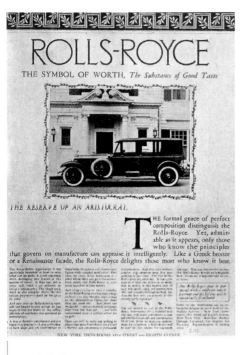

➤ **Rolls Royce**
Artist: Unknown
Client: Rolls Royce

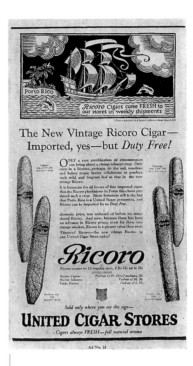

➤ **United Cigar Stores**
Art Director: F.G. Cooper
Client: United Cigar Stores

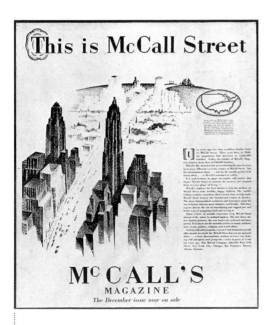

➤ **McCall's Magazine**
Artist: Unknown
Client: McCall's Magazine

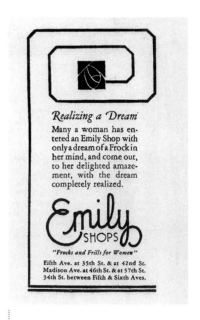

➤ **Emily Shops**
Artist: Clarence B. Hill
Client: Emily Shops

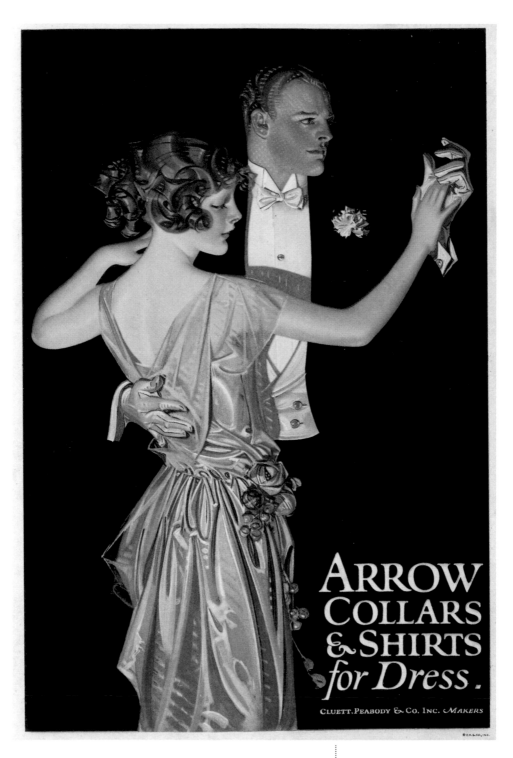

➤ **Arrow Collars & Shirts for Dress**
Artist: J.C. Leyendecker
Client: Cluett, Peabody & Co.

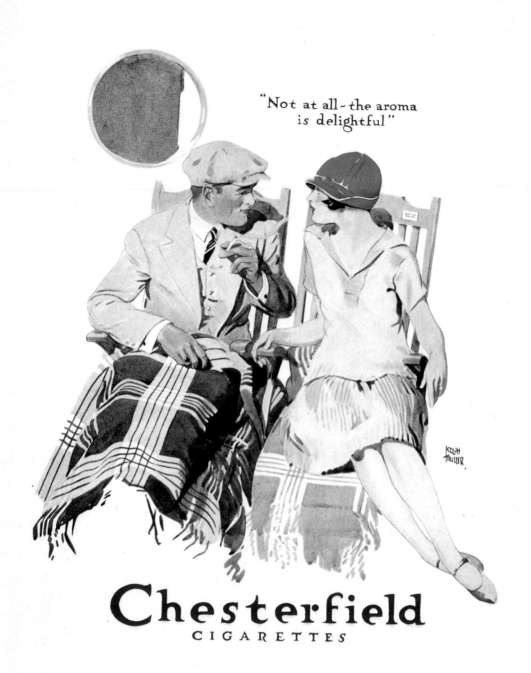

"Not at all ~ the aroma
is delightful"

Chesterfield
CIGARETTES

➤ **Chesterfield Cigarettes**
Artist: Sidney E. Fletcher
Client: Liggett & Meyers Tobacco Co.

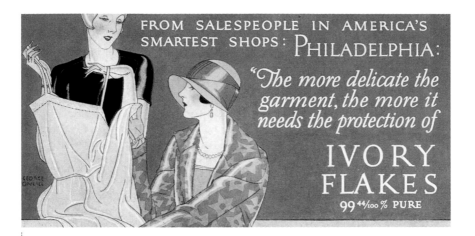

➤ **Ivory Flakes**
Artist: George O'Neill
Client: Proctor & Gamble Company

Absorb everything around you, through all your senses, and then decide what you believe in. You cannot straddle every fence. You cannot go through life bereft of convictions. You must believe in something. Those are the things that make good creative men and women. Those are the things that make people successful in our business. Those are the things that produce great advertising. And if you keep it up, regardless of your age, where you work, or what function you perform, your future is unlimited.

● ● ● ● ● **STEVE FRANKFURT** / SENIOR VICE PRESIDENT, SPECIAL PROJECTS, NUFORIA INC. / VICE CHAIRMAN, THE WOLF GROUP

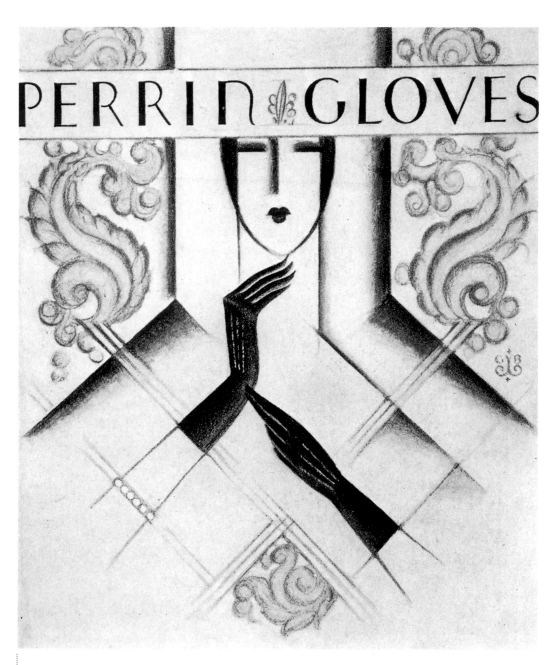

➤ **Perrin Gloves**
Artist: Gustav B. Jenson
Client: Perrin Glove Co.

Keeps dainty printed fabrics · b

➤ **Lux**
Artist: Helen Dryden
Client: Lever Brothers Company

> **Lux**
> Artist: Helen Dryden
> Client: Lever Brothers Company

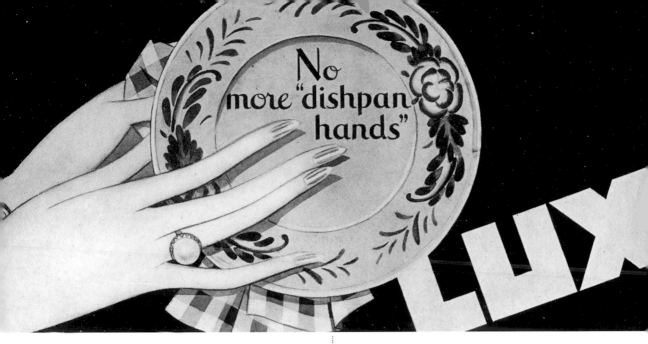

➤ **Lux**
Artist: Charles B. Gilbert
Client: Lever Brothers Company

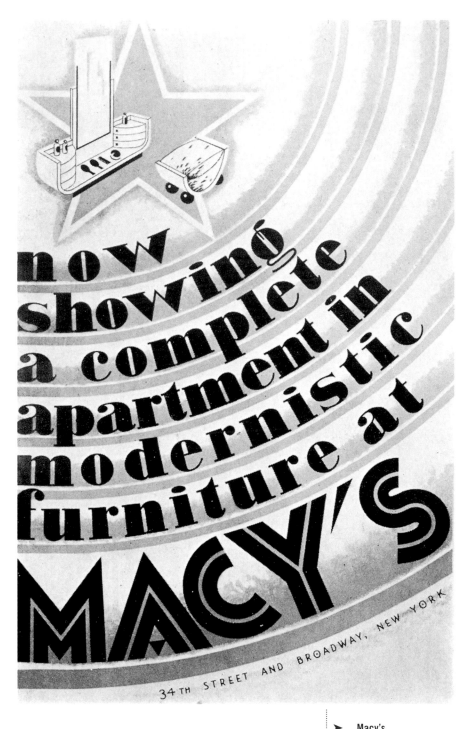

now showing a complete apartment in modernistic furniture at MACY'S

34TH STREET AND BROADWAY, NEW YORK

➤ **Macy's**
Artist: Gabriel Englinger
Client: R.H. Macy & Co.

MINUTES MEAN MONEY !

to the men who board "The Broadway"

"WHAT time have you?" we asked them. It seemed a silly question. There was the big smiling clock in the station to which they could refer. And yet as the parade of prosperous, well-groomed, successful men passed through the gate, one after the other obligingly pulled out his watch.

54 out of 59 had either the exact time or were within a scant thirty seconds of exact time.

Obviously they were successful men—business chiefs. Men whose time is valuable—whose minutes mean money. Whose watches must be accurate.

We don't mean to imply that carrying an accurate watch will bring a man success. But it is significant that successful men are accuracy-minded . . . and that a surprising number carry Hamiltons.

For years Hamilton has meant Accuracy—Railroad Accuracy. The Broadway, the Century and many other famous limiteds are timed—and have been timed for years—by Hamiltons.

The watches shown here are but a few of many your jeweler displays. Let us send a copy of "The Timekeeper," the interesting booklet showing a line of beautiful Hamilton models, and telling something of the meticulous care with which they are made. Hamilton Watch Co., American manufacturers of high-grade watches, 832 Columbia Ave., Lancaster, Penna., U. S. A.

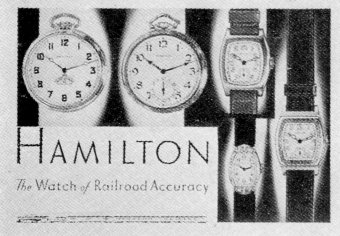

HAMILTON
The Watch of Railroad Accuracy

Left to right: The "Endicott" . . . With a medium size movement fitted in 14k filled white or yellow gold, $55. The "Piping Rock", in 14k green or white gold engraved included above, $50 to $300. The "Laureate", a distinguished strap-watch model, in 14k solid yellow or white gold, $60 to $300. "The Piccadilly", in 14k filled gold, yellow, green or white, plain, $55, engraved (as shown) $55. Lower left: The "Flintridge", in 14k white gold with platinum top, set with eight diamonds, $225.

Other Hamiltons for men and women from $40 to $685.

•••••

"It is difficult to evaluate the advertising art of the thirties. It was a time when the art director worked independently of the writer, and the illustrator, too, often demonstrated his independence."

Depression Era Advertising: In the Face of Economic Devastation

JAY CHIAT
FOUNDER
CHIAT/DAY

My earliest memories of the 1930s go back to when I was living with my grandparents in the Bronx, where I occasionally shared a bed with my cousin Jerry, whose family stayed with us from time to time. My father drove a truck for the Stag Laundry, and although my mother told me he was a shareholder, I could never resolve the conundrum: If he was a shareholder why was he driving a truck? Shouldn't he have an office?

My mother worked as a secretary, so after school I would go to my grandfather's tailor shop and brush trouser cuffs. He would pay me with a bag of empty soda bottles I could cash in at the market. Yet this isn't a sad story. We never went without a great meal. My grandmother, like all grandmothers, was a great cook. And my clothes were decent since many of them were hand-tailored by my grandfather. In fact, in family pictures I look like quite a fashion plate in my short pants, jacket and beret.

Still, the 1930s were a tough time for our family, and they were even tougher for most of the families in America. The decade-long depression that followed the 1929 stock-market crash had an enormous effect on the national psyche well into the Second World War. In 1933, unemployment in this country hit twenty-five percent and still hovered at twenty percent as late as 1938. These numbers did not even take into account the loss of livelihood suffered by the countless women who were simply labeled "home-makers" even though they had lost paying jobs. The Great Depression shook the nation to its core. The jobless wandered from city to city looking for work. Grown sons and daughters returned home to their families to save money, and farmers burned out by years of drought headed west to work as migrant laborers.

Yet even a quick look at the award-winning work included in the advertising annuals of the 1930s seems to indicate that advertisers and art directors were wholly unaware of the economic devastation wrought by the Depression. It was as if the Depression had been vacuumed from their collective psyche.

In the concluding words of his essay for the Eleventh Annual, Thomas Erwin makes not even a vague reference to the effects of the Depression: "It's a droll thought, but isn't it barely possible that the

• • • • •

historians of the 22nd Century might find one of these annuals as helpful, at least, as a gallery of Carnegie canvases in determining the state of human affairs in North America in 1932?" Only three years after the crash, Erwin seems content to characterize the advertising of the era as a cheerful and accurate portrait of the times.

The effects of the Depression aside, however, Erwin also evokes in the same essay some interesting defining traits of the advertising industry during this era. Most notable is the fact that "art directors and artists have relatively little hand in the conception of copy themes . . ." He goes on to specify that "this year's jury has followed the modest precedent of previous juries in judging not advertising but art work."

Indeed, the advertising of the 1930s brought to light the work of some immensely talented artists: Edward Steichen, Ludwig Bemmelmans, Peter Arno, A. M. Cassandre, Lester Beall, Horst, and George Hoyningen-Huene, to name a few. Additionally, the *Vogue*, *Vanity Fair*, and *Harper's Bazaar* covers from this era are brilliant, if elitist. In his foreword to the Fourteenth Annual, M. F. Agha, president of the Art Director's Club in 1934, reminded his members that the constitution of the Club describes the Art Director as a man whose duty it is to see that "when art is used in commerce, the commerce must be served and art not degraded. Therefore, the show presents advertising illustration in a way which would be possible as a continuous performance, only in an ideal and happier world—a world without deadlines, stubborn clients, prolific copywriters, and depressions." Flipping through the pages of the 1934 Annual, however, one encounters for the most part, with the exception of a few magazine covers, advertising that portrays a rather elegant lifestyle—themes, in fact, that prefigure today's advertising, which depicts over-the-top consumption.

It is difficult to evaluate the advertising art of the 1930s. It was a time when the art director worked independently of the writer, and the illustrator, too, often demonstrated his independence. It was an era that generated such mindless yet irresistible headlines as ". . . and the trouble began with harsh toilet tissue" or "He loves your petal-soft girlish hands," the latter illustrated with a Steichen photograph.

The 1930s were also a time of innovation, however. For years I shared the mistaken assumption that it wasn't until the 1950s, when Jack Tinker came along, that the art director and the writer finally teamed up. Yet, a piece by William H. Schneider in the 38th Annu-

al had already singled out some pretty famous artist-writer teams: among them were Stanley Getchell and Jack Tarleton, William Esty and James Yates, and O. B. Winters and Paul Newman—and this was 1938. Of course, I had to find this out the hard way. Shortly after I first came to New York, I had the privilege of being invited to lunch at the Four Seasons by Bill Bernbach. Naturally, I was in awe, and so, eager to extend a compliment, I praised him as a genius for being the first to bring art directors and copywriters together as a team. Bill never corrected me.

Today, the 1930s seem very distant indeed. Yet the repercussions of that era's hardships can still be felt in our social fabric. It's hard to say why the prominent and well-remembered advertising of the day failed so thoroughly to reflect the reality of the times, and perhaps some of the more obscure ads did. Reality notwithstanding, the ads of the 1930s offer a colorful portrait of a remarkable era that is all too often forgotten.

Completely honest advertising—visual and copy! No innuendo, no double entendre. Just tell it straight, even if it doesn't win awards.

• • • • • **LOU DORFSMAN** / *CREATIVE DIRECTOR, MUSEUM OF TELEVISION & RADIO*

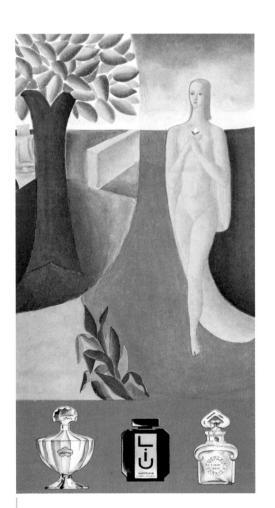

➤ **Guerlain Perfumes**
Artist: Eduard Buk Ulreich
Client: Guerlain

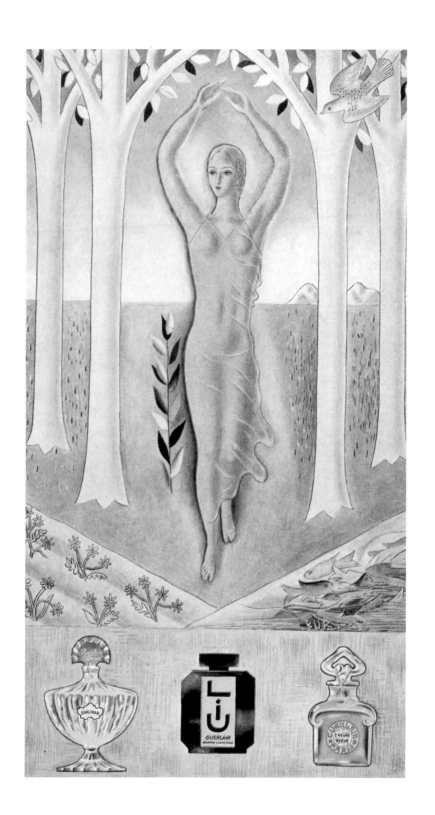

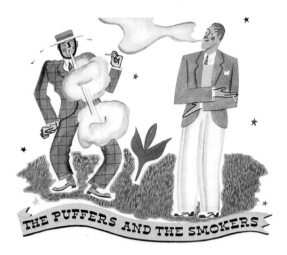

Puffers & Smokers
Artist: Jack Tinker
Agency: N.W. Ayer & Son
Client: R.J. Reynolds Tobacco Co.,

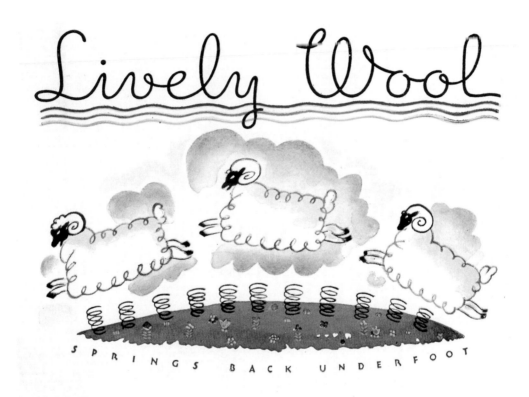

➤ **Lively Wool**
Artist: Unknown
Client: Bigelow-Sanford Carpet Co.

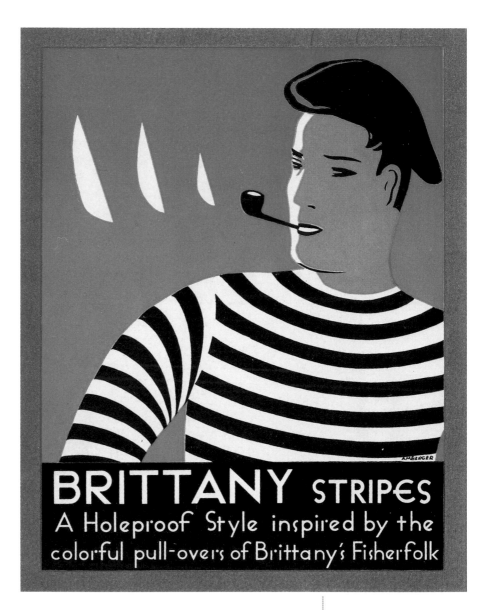

Brittany Stripes
Artist: F.L. Amberger
Client: Holeproof Hosiery Co.

Marx Brothers Make New Hit
Artist: Constantin Alajalov, for motion picture "Monkey Business"
Client: Paramount-Publix Corporation

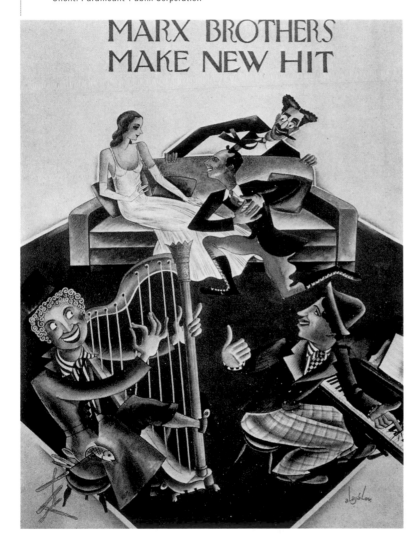

MARX BROTHERS
MAKE NEW HIT

Read a lot. Read everything. Read *Playboy* and *Harper's* and *Reader's Digest*. Read *Wired* and *Fast Company* and *Fortune*. Read the Bible. The person who doesn't read has no advantage over the person who doesn't know how. Read the papers. Read history. Read poetry. Read fiction. Replenish yourself. I never knew a wise man or woman who wasn't a big reader.

● ● ● ● ● STEVE FRANKFURT

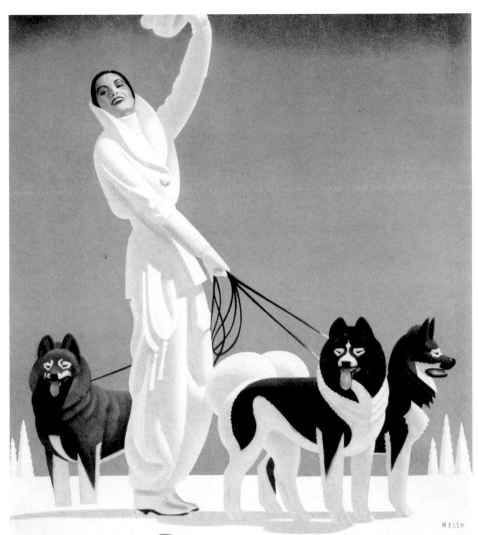

Pullman
Art Director: Arthur Sullivan
Artist: William P. Welsh
Agency: Charles Daniel Frey Co.
Client: The Pullman Co.

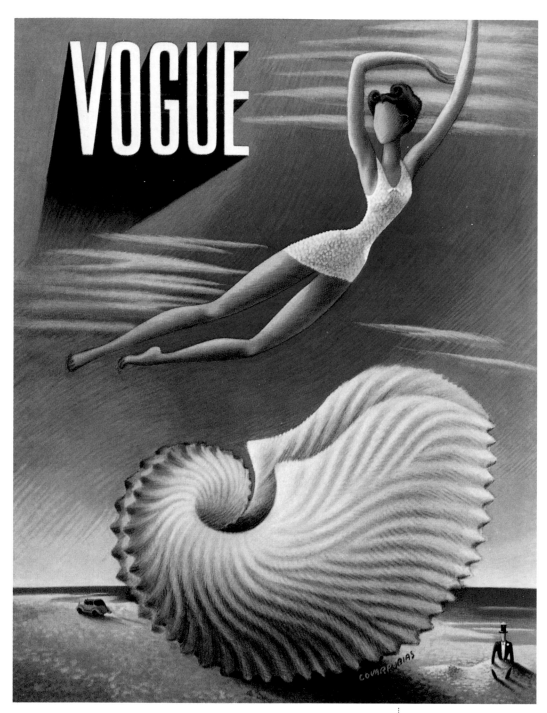

➤ **Vogue**
Art Director: Dr. M.F. Agha
Artist : Miguel Covarrubias
Client: Vogue

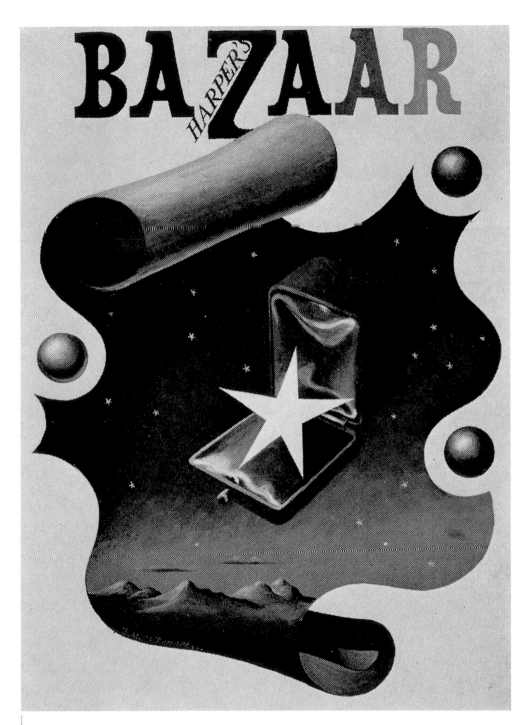

➤ **Harper's Bazaar**
Art Director: Alexey Brodovitch
Artist: A.M. Cassandre
Client: Harper's Bazaar

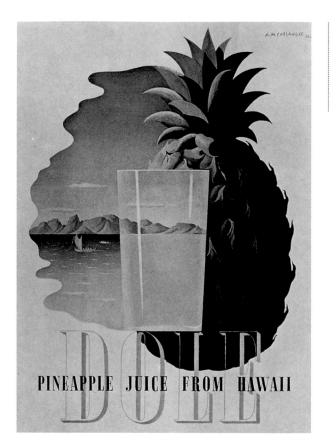

> **Dole**
> Art Director: Paul Froelich
> Artist: A.M. Cassandre
> Agency: N. W. Ayer & Son Inc.
> Client: Hawaiian Pineapple Co.

> **Optical**
> Art Director: Harry Harding
> Artist: Howard Hardy
> Agency: The Barta Press
> Client: American Optical Co.

Artist: Howard Hardy Art Director: Harry Harding Agency: The Barta Press Client: American Optical Co.

award for distinctive merit

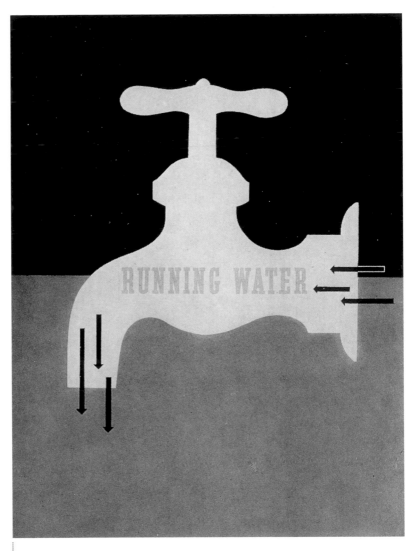

➤ **Running Water**
Art Director/ Artist: Lester Beall
Client: Rural Electrification Administration

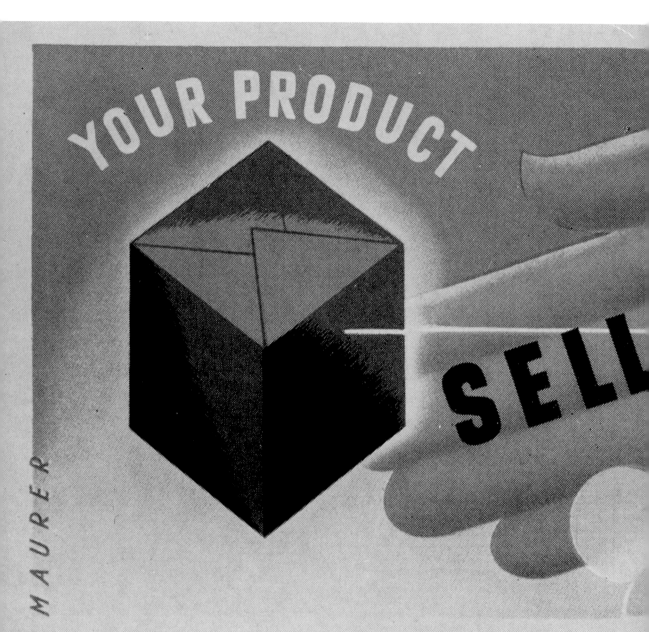

YOUR PRODUCT

SELL

MAURER

McCANDLISH LITHOGRAPH CO

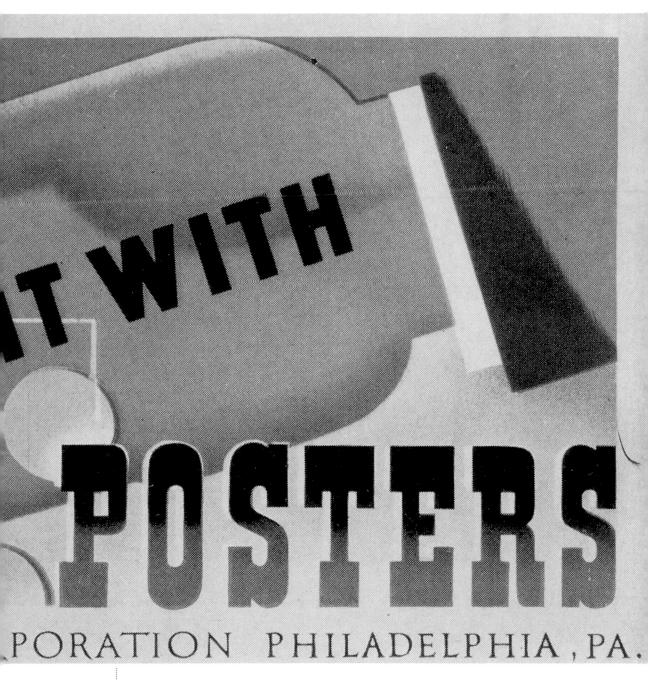

IT WITH POSTERS

PORATION PHILADELPHIA, PA.

➤ **Posters**
Art Director/Artist: Sascha A. Maurer
Client: McCandlish Lithograph Corporation

to cut costs of distribution

HOW

GEORGE BIJUR, INC · 9 ROCKEFELLER PLAZA · NEW YORK

➤ **How**
Art Director: Lester Beall
Artist: P. Nyholm
Agency: George Bijur, Inc.
Client: George Bijur, Inc.

➤ **Ballantine Poster**
Art Director: Burton E. Goodloe
Artist: Joseph Binder
Agency: J. Walter Thompson Co.
Client: Peter Ballantine & Sons

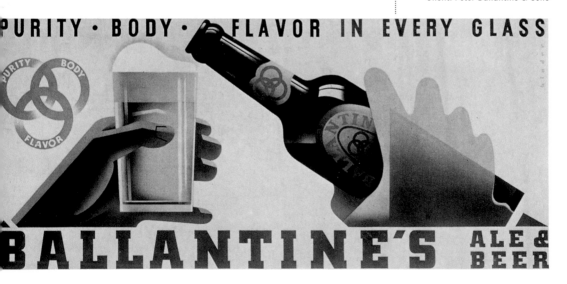

PURITY · BODY · FLAVOR IN EVERY GLASS

BALLANTINE'S ALE & BEER

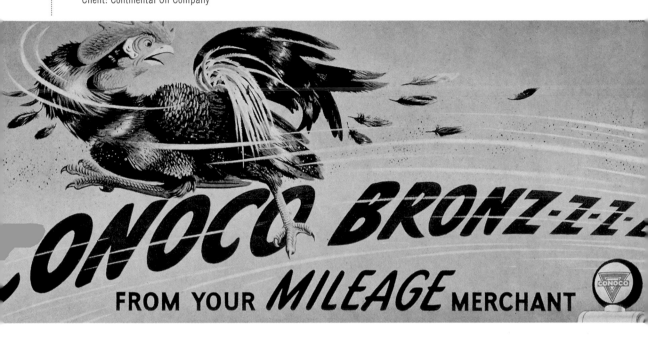

➤ **Low Cost Per Mile**
Art Director: Roy E. Washburn
Artist: Stanley Ekman
Agency: McCann-Erickson, Inc.
Client: Standard Oil Company

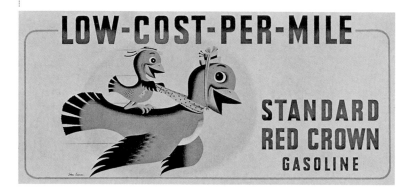

➤ **Time**
Art Director/Artist: Lester Beall
Agency: George Bijur, Inc.
Client: Time, Inc.

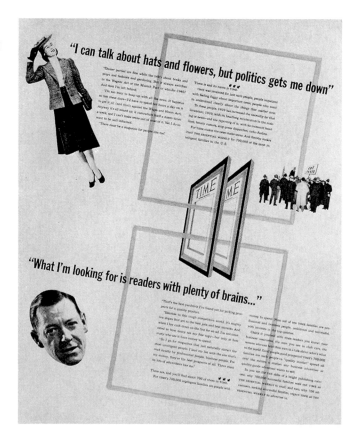

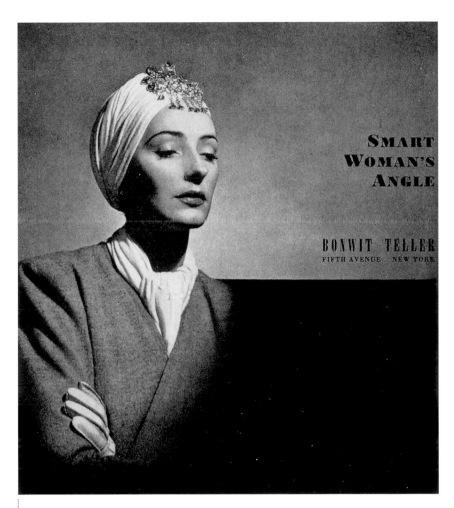

SMART
WOMAN'S
ANGLE

BONWIT TELLER
FIFTH AVENUE · NEW YORK

➤ **Bonwit Teller**
Art Director: Myron Kenzer
Artist: Hoyningen-Huene
Client: Bonwit Teller

"As the advertisers saw it, the war would end, the shortages would stop, and the reviving economy would turn from war material to consumer materialism. So, for the first time, manufacturers advertised simply to promote brand awareness—the very heart of brand advertising."

The War and Beyond: The Birth of Brand Advertising

SHELLY LAZARUS
CHAIRMAN AND CEO
OGILVY & MATHER WORLDWIDE

Now we come to the 1940s. The 1940s were not about advertising at all. In a decade that saw the Holocaust, World War II, Rosie the Riveter, the atom bomb, the start of the Cold War, and the birth of both television and the computer, advertising seems a trivial topic in a decade that was pivotal to the rest of the 20th century. What if the war had not happened, or its outcome had been different? What if women had not entered the workplace with such force and been so changed by it? What if the meaning of power had not been tested violently and in the extreme, frightening us enough to spend the rest of the century grappling to become a global village. And what if nascent communication technology had not had its birth then and there? Where would we be now?

Historically, the art of advertising is beside the point. In these years, nevertheless, a great deal of advertising, as well as significant developments in the field, did take place in that decade. In fact, advertising's robust growth finally returned ad expenditures to pre-Depression levels.

The War had the single biggest impact on advertising in all ways, directly and indirectly. For example, war bonds and the like were obvious, new products to be advertised. In addition, apologies and explanations had to be made for everything from late trains to product shortages. One of the greatest "reverse selling" advertisements was a print ad for the New Haven Railroad headlined "The Kid in Upper 4." It was written by a copywiter named Nelson Metcalf, who worked for the railroad. He was determined to make the war-related service shortages comprehensible to those who were being considerably inconvenienced by the frequent delays along the line.

"I vowed I would write an ad that would make everybody who read it feel ashamed to complain about train service," Metcalf wrote about crafting the ad. He spent weeks writing and rewriting the story, striving to capture the archetypal moment of a young soldier heading off to war, sleepless and scared in his train bunk. When it debuted, after considerable debate with his employer, it was greeted with the greatest slug of publicity ever

accorded an advertisement. It was a home run with train travelers and everybody else. It was read on radio shows. It was made into a popular song. It was pinned to thousands of bulletin boards and reproduced in magazines—even rival railroads picked it up and published it. "The Kid on Upper 4" never won an Art Directors award, but it captured the nation's heart.

That ad was a high-water mark for war-related advertising—quality in advertising went downhill from there. As advertisers strove to capitalize on the drama and excitement of world conflict for sales purposes, an odd assortment of merchandise used borrowed interest to sell everything from nuts and bolts to fur coats. The association was, more often than not, quite strained and the advertising offensive.

While the worst of these claims were tasteless but benign, the 1940s saw the first real crackdown by the Federal Trade Commission on specious advertising claims, especially for products such as headache medicine, weight-loss drugs, cold remedies, laxatives, cures for baldness, and vitamins. The tightened rein on advertising was a service to legitimate marketers and consumers alike.

On the other hand, some advertising didn't reference the war at all. Saks Fifth Avenue, for example, produced fine work throughout the war years without using the war as an advertising ploy. Perhaps the department store was in denial of the times, or perhaps they recognized the need for some normalcy—at least in one sector.

The war itself actually provided a new era in advertising. With much of the machinery of the country consumed with supplying war materiel, causing residual product shortages of all sorts, some advertisers became less concerned with the immediate sell and more concerned with keeping their brand names alive while their products were in abeyance. This was probably, in the purest sense, the beginning of brand advertising.

In advertising parlance, the "brand" is the relationship between the product and the consumer. Products are about tangible benefits: soap washes clothes, and toothpaste cleans teeth. A brand is about the intangible benefits between a consumer and a product; it's about emotional connections. During the absence of these products from people's lives, manufacturers struggled to maintain the emotional

connection between consumers and their brand.

As the advertisers saw it, the war would end, the shortages would stop, and the reviving economy would turn from war materiel to consumer materialism. So, for the first time, manufacturers advertised simply to promote brand awareness—the very heart of brand advertising.

Some manufacturers capitalized beautifully on the idea of a brand. The Jansen swimsuit ads of the 1940s were some of the most effective at tapping into the emotional context of a product. Their advertisements made people believe that swimsuits were not just functional garments but agents of physical freedom, athleticism, and a certain modern sexuality.

The best brand advertising of that era may well have been for Coca-Cola, demonstrated by the fact that we so clearly recognize the brand even today. In fact, a couple of those ads could still run today in their original form—they might be a little retro, but that would be in style only.

In the 1940s, advertising, whether by self-inflicted bad practice or societal suspicions, had a pretty bad name. Hollywood parodied the business with comedies like *Mr. Blandings Builds His Dream House*—"If It Ain't Wham, It Ain't Ham"—and showed its darkest side in the classic Clark Gable/Sydney Greenstreet drama *The Hucksters*, which included the famous advertising mantra, "Irritate, Irritate, Irritate."

The economist John Kenneth Galbraith of Harvard disparaged advertising, saying, "Advertising tempts people to squander money on unneeded possessions when they ought to be spending it on public works."

Whatever the provenance of its bad reputation, it was on the verge of a significant course correction caused directly by social changes that took place over the decade. During those war years, women became much more of a significant force as consumers. They not only worked—that wasn't new—but for the first time, they gained respect for working. Most important, it was when many women got their first taste of earning and managing their own money. This gave them enormous power in the marketplace; women became a force no smart advertiser could safely ignore.

It was in this world that David Ogilvy opened his agency in

1948. Through the success of his agency, the advertising he created, and the best-selling books he published on the practice of advertising, he dramatically escalated the professionalism and quality of the business. He did this by putting the consumer first.

Having worked for the legendary research pioneer George Gallup, Ogilvy was a believer in consumer research. He felt that his competitive edge would be to know and understand the consumer better than anybody else. Moreover, he believed in giving the consumer the facts—a novel idea at a time when puffery and exaggeration were accepted practice in advertising. He wrote, "Some copywriters write tricky headlines—puns, literary allusions, and other obscurities. This is a sin."

Central to this strategy, was the fact that Ogilvy recognized who the consumers were—those "Rosies" who controlled the vast majority of daily purchases. "The consumer is not a moron," David Ogilvy would warn, "She is your wife." David knew that his audience—primarily housewives—might not be well educated, but he didn't believe in talking down to or over them. One of his famous lines says it all: "You insult her intelligence if you assume that a mere slogan and a few vapid adjectives will persuade her to buy anything. She wants all the information you can give her. I pursue knowledge the way a pig pursues truffles."

David Ogilvy opened his agency with the idea that being smart, listening to the consumer, and having ideas anchored in true insight would make his company successful. He instilled a level of professionalism in the business as a whole and created a specific school of advertising practice that would, in time, become legendary.

➤ **Carson Pirie Scott & Co.**
Art Director: Eleanor Mayer
Artist: George Platt Lynes
Agency: Abbot Kimball Company
Client: Carson, Pirie, Scott & Co.

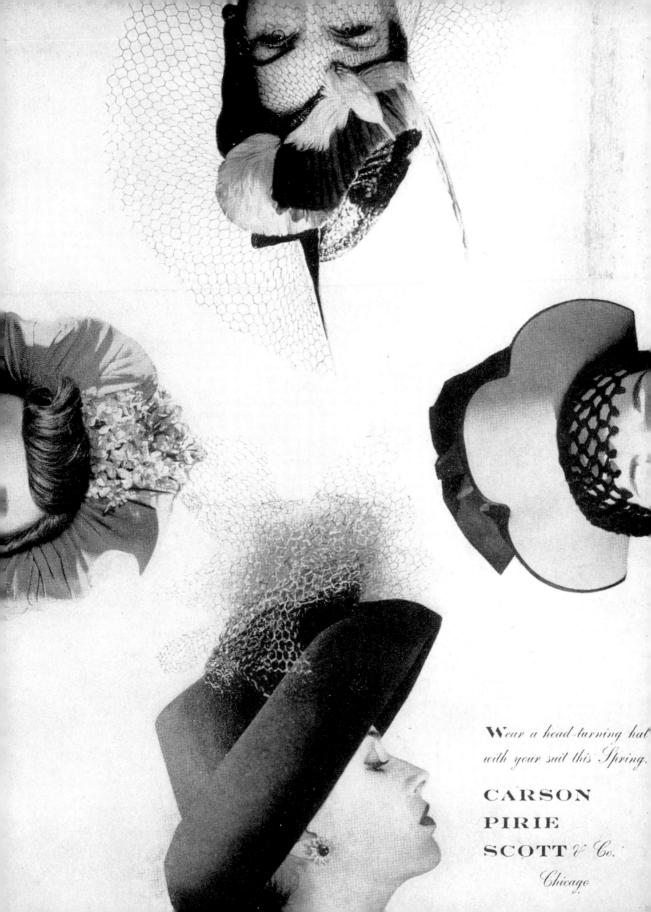

*Wear a head-turning hat
with your suit this Spring.*

CARSON

PIRIE

SCOTT & Co.

Chicago

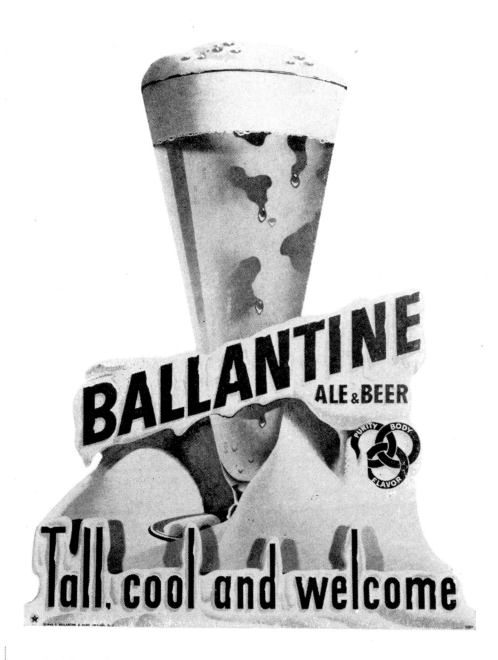

➤ **Tall, Cool and Welcome**
Art Director: Charles Barnes
Artist: Carl Paulsen
Agency: Einson-Freeman Co.
Client: P. Ballantine & Sons

➤ **Ballantine Ale & Beer**
Art Director: Charles Barnes
Artist: Edward Patston
Agency: Einson-Freeman Co.
Client: P. Ballantine & Sons

➤ **Guinness is Good for You**
Art Director: Eugene Payor
Artist: Robert Velie
Agency: Einson-Freeman Co.
Client: A. Guinness Son & Co. Ltd.

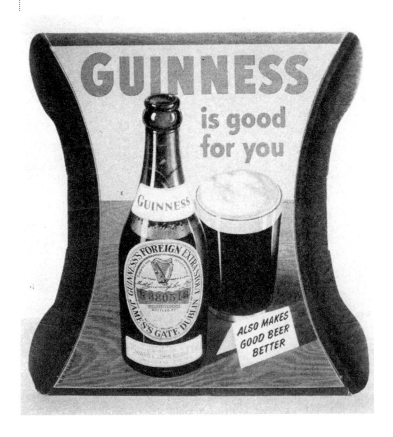

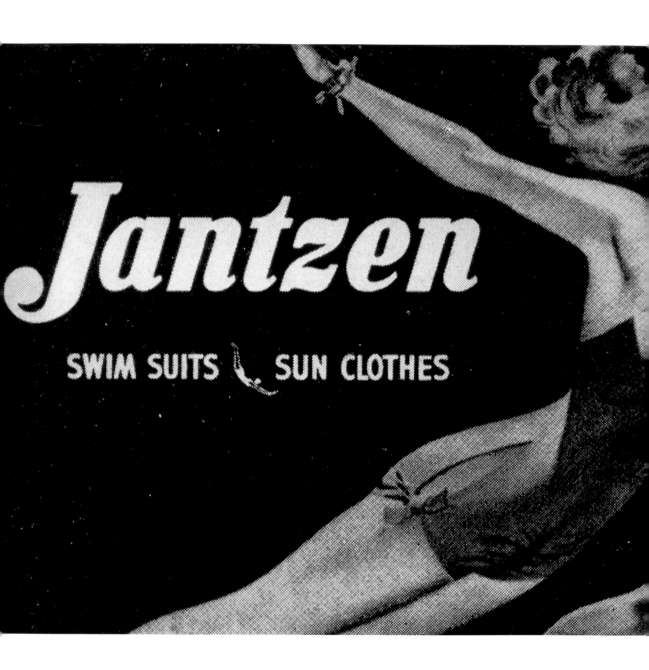

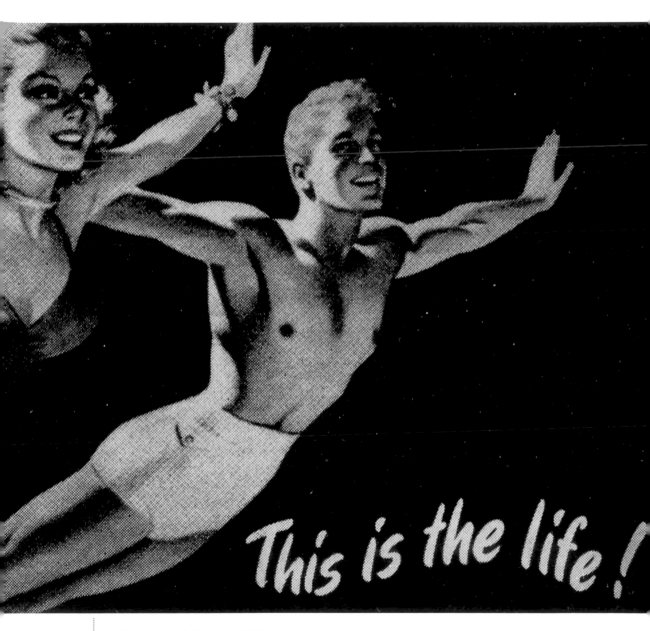

➤ **Jantzen Swim Suits and Sun Clothes**
Art Director: Elizabeth Everly
Artist: Jon Whitcomb
Agency: Botsford, Constantine & Garden
Client: Jantzen Knitting Mills

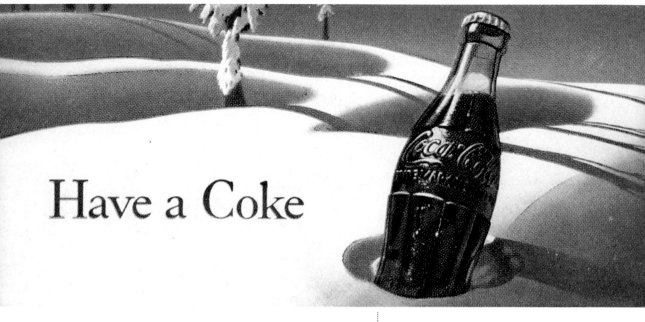

Have a Coke

Have a Coke
Art Director: Paul Smith
Artist: Kenneth W. Thompson
Agency: D'Arcy Advertising Company
Client: The Coca-Cola Company

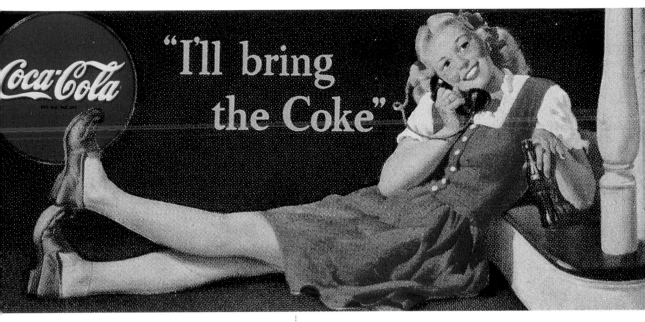

➤ **"I'll Bring the Coke"**
Art Director: Paul Smith
Artist: Haddon H. Sundblom
Agency: D'Arcy Advertısıng Company
Client: The Coca-Cola Company

Look at everything you can. Open your eyes. Watch the best television has to offer, and watch some of the worst as well. You can't opt for improvements unless you know first-hand what's wrong with what we've got. Look at Web sites. Look at posters, art exhibits, store windows, graffiti. Look through the peephole at the construction site. Look at what someone has printed on the little envelope that your theater tickets come in. Look at your kids' report cards and at the copy written on the back of the box of rice. Look at everything. Keep your eyes open—wide.

● ● ● ● ● STEVE FRANKFURT

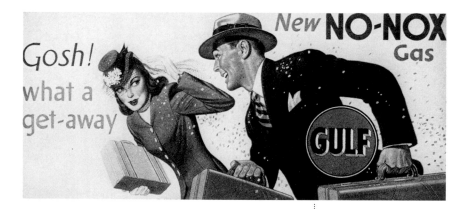

➤ **New No-Nox Gas**
Art Director: Réne Clarke
Artist: Nat White
Agency: Calkins & Holden
Client: Gulf Oil Company

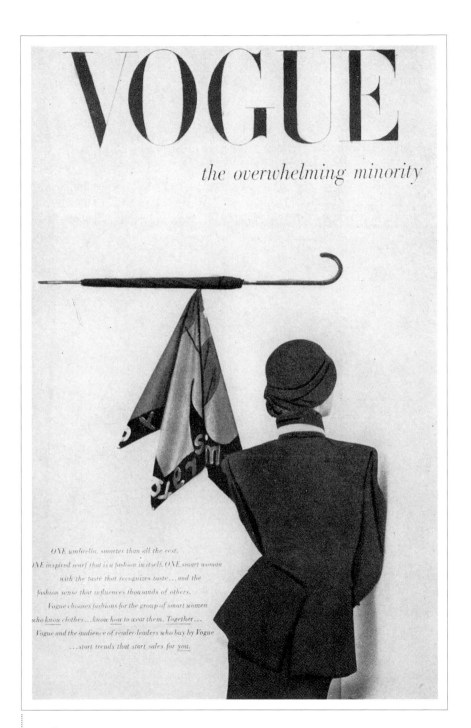

> **Vogue**
> Art Director: Alexander Lieberman
> Photographer: Irving Penn
> Client: The Condé Nast Publications Inc.

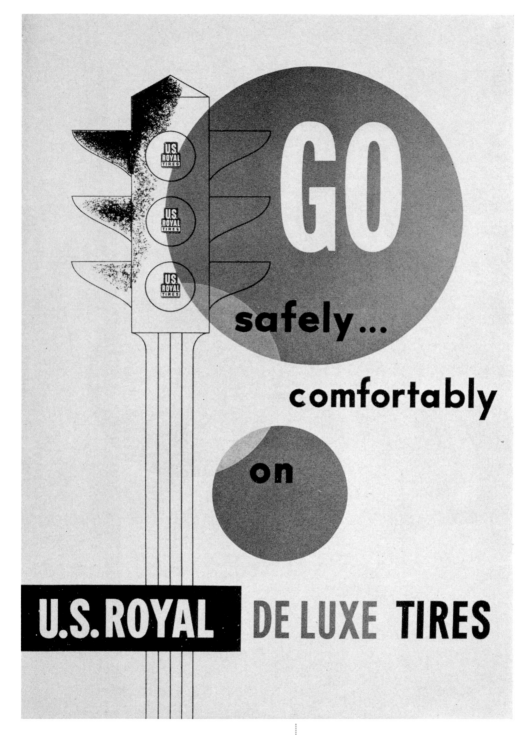

GO
safely...
comfortably
on
U.S. ROYAL DE LUXE TIRES

➤ **U.S. Royal Tires**
Art Directors: Hector A. Donderi, Wesley Heyman
Artist: Wesley Heyman, Roy Germanotta, Inc.
Client: United States Rubber Company

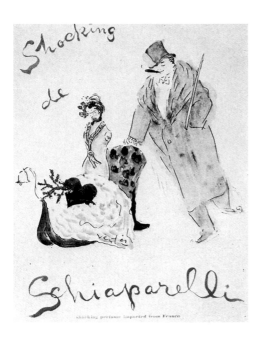

➤ **Shocking de Schiaparelli**
Art Director: Ted Sandler
Artist: Marcel Vertes
Agency: Robert W. Orr & Associates
Client: Parfums Schiaparelli, Inc.

➤ **Fear Begins at Forty**
Art Director: William Golden
Artist: Ben Shahn
Client: Columbia Broadcasting System, Inc.

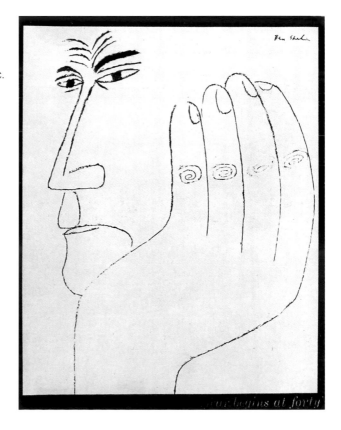

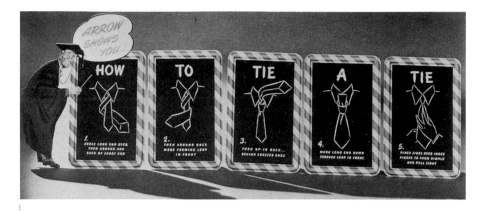

➤ **How to Tie a Tie**
Art Director: George A. Phillips
Artist: Otto Freund, Royer & Roger
Agency: Kindred, Maclean & Company
Client: Cluett, Peobody & Co., Inc.

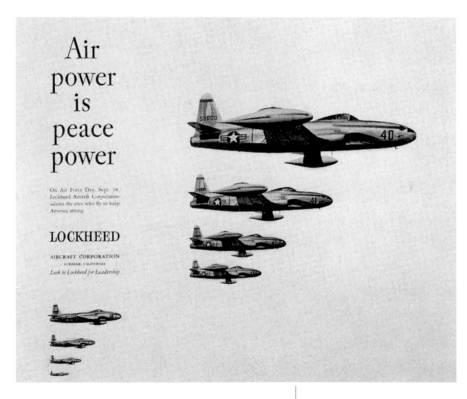

➤ **Air Power is Peace Power**
Art Director: John Groen
Artist: Erik Miller
Agency: Foote, Cone & Belding
Client: Lockheed Aircraft Corp.

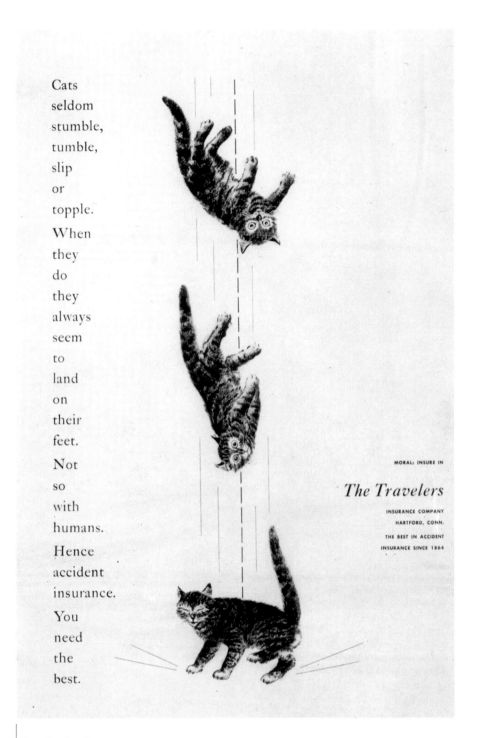

Cats seldom stumble, tumble, slip or topple. When they do they always seem to land on their feet. Not so with humans. Hence accident insurance. You need the best.

MORAL: INSURE IN

The Travelers

INSURANCE COMPANY
HARTFORD, CONN.

THE BEST IN ACCIDENT
INSURANCE SINCE 1864

➤ **The Travelers**
Art Director: Harlow Rockwell
Artist: Feodor Rojankovsky
Agency: Young & Rubicam
Client: The Travelers

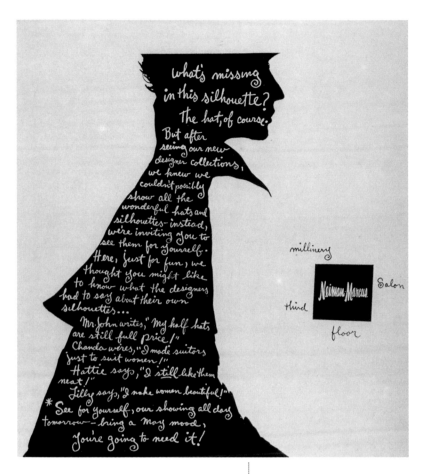

➤ **Neiman Marcus**
Art Director: Charles Gruen
Artist: Merle Basset
Client: Neiman Marcus Company

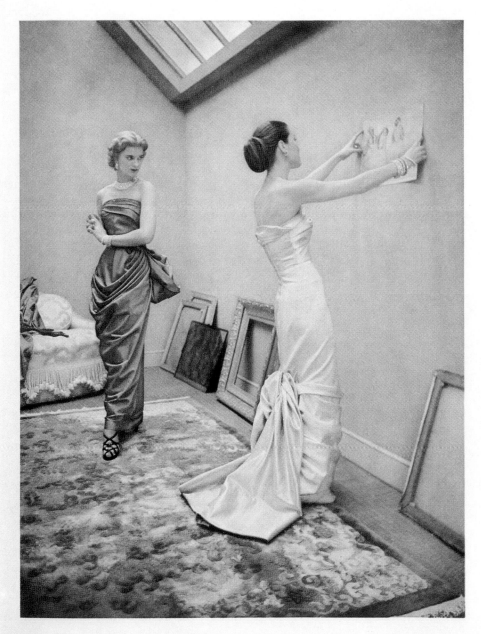

Modess *because*

➤ **Modess**
Art Director: James Elliot
Artist: Ruzzie Green
Agency: Young & Rubicam, Inc.
Client: Personal Products Corps.

"It is in the 1950s that we begin to see more provocative ideas that have a more profound psychological impact on viewers—ideas that compel consumers to think and feel. These were ads that benefitted from a new fusion of art and copy—each domain giving muscle to the other."

The Fifties: from the Emergence of "Concept" Advertising to the Advent of Television

ROY GRACE

CHAIRMAN AND CREATIVE DIRECTOR
GRACE & ROTHSCHILD

It's a formidable challenge to sit here in the waning days of the 1990s, trying to judge advertising created almost a half-century earlier—to teleport myself back to the days when it was created and slip into the minds of those who conceived it.

The whole process, quite honestly, made me feel like a kid again. Thumbing through a stack of Art Directors Club Annuals from the 1950s, I saw certain ads that I distinctly remembered seeing when I was young. Product names and slogans came flooding back—Life Savers, Hunts, "Modess . . . because." I found that, fifty years after they first ran, these ads still had a visceral effect on me. They had retained all their freshness and vitality.

Looking at these Annuals, it became clear to me that the 1950s were a time of tremendous change in graphic art. In the early years of the industry, illustration predominated and photography was relatively rare. By the end of the 1950s, however, the ratio had totally flipped. In the 1959 Annual, illustrated ads were few and far between. We can see a parallel shift in the medium of television, where animation eventually gave way to cinematography.

Approaches to typography also changed profoundly; type itself, long considered merely a tool to convey written messages, had by the 1950s become part (sometimes all) of the message. Its use became freer, more playful, more inventive.

While type had begun to enter bold new worlds, the copy itself, I found, was often lackluster. Granted, these Annuals were the work of art directors whose job was to judge art, and the strange chasm that used to exist between art and copy had not yet been bridged. No writers, in fact, were given credit in any of the Annuals. (It wasn't until 1960 that the Art Directors Club began to cite copywriters in its awards and shows.) Perhaps that's why there are so many one-dimensional ads in these Annuals; advertising, at least within the industry, was being judged from a single aspect. In his introduction to the 1953 Art Directors Annual, Walter Weir wrote that the art director and the copywriter have a "joint responsibility." This was a voice crying in the wilderness.

What we do see is a new, blossoming sense of style. In the early years of the decade, by far the freshest, most interesting, and most provocative

● ● ● ● ●

advertising being done was in the realm of fashion. It's probably no acci-
dent that art directors who would go on to become legends—among
them Bob Gage, Helmut Krone, Herbert Matter, Paul Rand, and Bill
Taubin—all cut their teeth on fashion advertising.

Perhaps even more important for the future of the industry was the
emergence of "concept" advertising—an approach that has since become
the touchstone of the whole business. It was in the 1950s that we began to
see more provocative ideas that had a more profound psychological impact
on viewers—ideas that compelled consumers to think and feel. These were
ads that benefitted from a new fusion of art and copy—each domain giv-
ing muscle to the other. In 1954, for example, viewers were treated to one
of the first concept television commercials: an ad for Levy's Real Jewish Rye
bread. A slice of bread, floating in limbo, disappears mouthful by mouthful
as the selling message appears on screen: "New York is eating it up."

Indeed, the advent of television as a mass-medium was a watershed
moment for the advertising industry. On the dust jacket of the 1950
Annual, a short notice dryly announces: "An entirely new section has been
introduced to cover the important medium of television." Three spots
were chosen for this section; no copy accompanied them, and you have no
idea what they are about. They all look awful—and they probably were.

This wouldn't be the case for long, for the "important medium
of television" was poised to change not only how advertising was
delivered, but also the very way the public experienced and perceived
it. The act of reading a print advertisement is a highly personal and
individual one, since you tend to be alone when you assimilate the
ad. Televised commercials are different. Watching them is a shared
experience; even if people are not watching TV in the presence of
others, they subconsciously understand that, somewhere, millions
are viewing the same images simultaneously. In the 1950s, for the
first time, people began to talk about advertising they had experi-
enced in common—how they loved or hated it.

Through television, advertising took hold of the collective public
consciousness as it never had before, and the potential seemed limitless.
Much to my surprise, all this happened in the 1950s—a decade so often
associated with dull, conservative trends in popular culture. I had always
been content to assume that advertising's great and glorious creative rev-
olution happened in the 1960s, that I would find a few scattered seeds
planted in the preceding decade, but little more.

What I found instead was a decade characterized by suprisingly vigorous creativity. I found that the revolution I so fondly looked back on had actually begun in the fifties and that, by the end of that decade, it was in full flower. I discovered that many of the great icons and slogans I had associated with the 1960s—Volkswagen's "Think Small," for example, or El Al's "Starting Dec. 23, the Atlantic Ocean will be 20% smaller"—actually appeared in the late 1950s.

The revolution may have really exploded in the 1960s, but the fuse was lit the decade before. By the end of the 1950s, major changes were afoot, and the world of advertising would never be the same.

HANDLE WITH CARE —IT'S EXPLOSIVE

Don't Touch It If You're Timid —It's Hotter than You Think

NOW IT'S STARTED WHO CAN STOP IT!

IGNITES, EXCITES WHATEVER IT TOUCHES

Loaded with Dynamite —Ready to Explode!

The Excitement's Spreading! Everyone's Breathless!

SPREADING LIKE WILDFIRE

READY TO BURST INTO FLAME

Sound the Alarms! Set off the Sirens!

Stand Back—It Might Explode

Continued From Page 1

It's TNT for Two!

It's Slightly Incendiary!

"where's the fire?"

➤ **Where's The Fire?**
Art Director/Designers: Paul Rand, Edward Rofheart
Artist: Onofrio Paccione
Agency: William H. Weintraub & Co.
Client: Revlon Products Corporation.

What's both exciting and scary about advertising is the effect it can have on our culture and our lives. We should demand the most positive thinking and best work possible from the people with the responsibility of creating it. ● ● ● ● ● **MIKE HUGHES** / PRESIDENT AND CREATIVE DIRECTOR, THE MARTIN AGENCY

➤ **Life Savers**
Designer/Art Director: Harlow Rockwell
Artist: Robert Geissman
Agency: Young & Rubicam
Client: Life Savers, Inc.

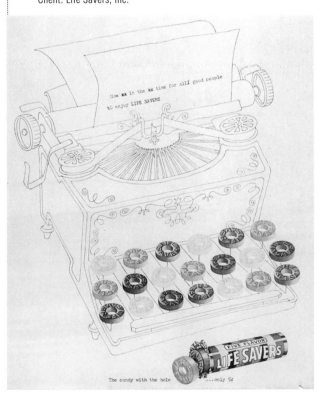

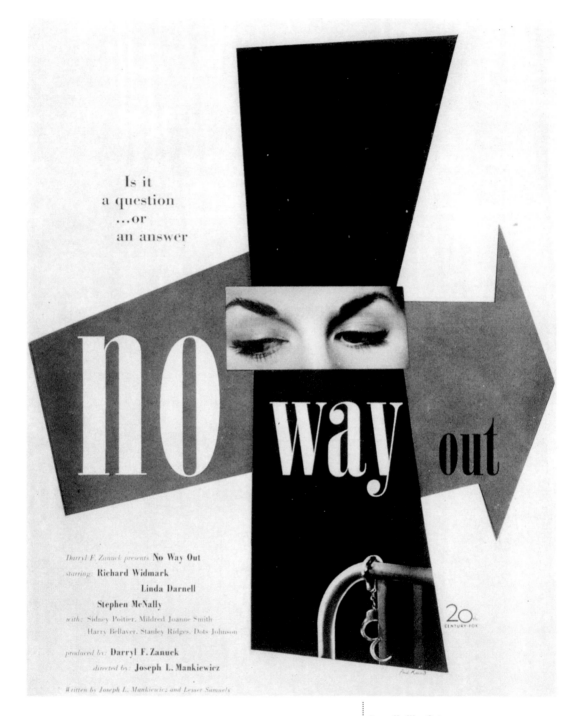

Is it
a question
...or
an answer

no way out

Darryl F. Zanuck presents **No Way Out**
starring: **Richard Widmark**

Linda Darnell

Stephen McNally
with: Sidney Poitier, Mildred Joanne Smith
Harry Bellaver, Stanley Ridges, Dots Johnson

produced by: **Darryl F. Zanuck**
directed by: **Joseph L. Mankiewicz**

Written by Joseph L. Mankiewicz and Lesser Samuels

20 CENTURY-FOX

➤ **No Way Out**
Art Directors: Victor Sedlow, Paul Rand
Artist/Designer: Paul Rand
Agency: Charles Schlaifer & Co.
Client: 20th Century Fox Film Corporation

➤ **Ohrbach's Cashmere**
Art Director/Designer: Robert Gage
Artist: Joe De Casseres
Agency: Doyle Dane Bernbach
Client: Ohrbach's Inc.

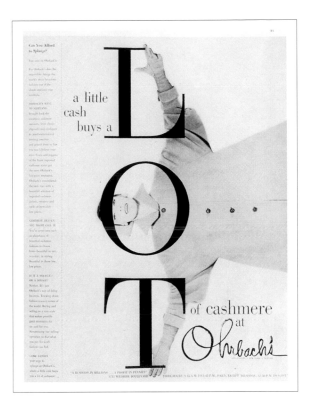

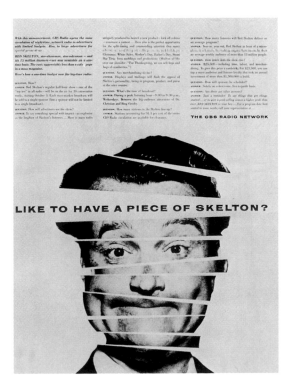

➤ **Like to Have a Piece of Skelton?**
Designer/Art Director: Lou Dorfsman
Artist: Lou Dorfsman
Photographer: CBS Photography Dept.
Client: CBS Radio

He's moving!

ROBERT Q. LEWIS
and his famous talent showcase
THE SHOW GOES ON move to
SATURDAY
TONIGHT at 00:00
CHANNEL OO WAAA-TV

➤ **He's Moving!**
Art Director/Designer: William Golden
Artist: Kurt Weihs
Photographer: CBS Photography Dept.
Client: CBS

EDWARD A. MCCABE
HALL OF FAME COPYWRITER AND
CO-FOUNDER OF SCALI, MCCABE, SLOVES

WALKING AMONG GIANTS, DODGING DWARVES

AD DICE

12354

FILM DEPT

After forty-five years, I was beginning to look upon my life in advertising like a permanent residency in "The Roach Motel." You know, "you can check in, but you can't check out." I finally checked out for a combination of reasons—partly personal (forty-five years is a hell of a long time for anyone to do anything) and partly because of the business itself (it ain't what it used to be). And that's the part this is about.

I was in advertising at the best possible time, and boy was I lucky. In 1954, I was a fifteen-year-old high school dropout. Chicago was not exactly exploding with employment opportunities for folks such as me. I had been passed over by so many companies in so many categories that the employment agent who'd been sending me around finally blurted out in exasperation, "I've got it! I'll send you to an ad agency. They'll hire anybody!" (One of the companies she'd sent me to was a catalog producer who gave me an aptitude test for the position of copywriter. Weeks later, they told me that according to the results of the test my talents would be much better suited to a career as an auto mechanic. How were they to know that I would become a Hall of Fame advertising copywriter? I mention this not to boast of my accomplishments but to demonstrate the idiocy of over-reliance on research and testing.)

So she sent me to an ad agency, and I started in the mailroom for something like nothing per week. Gradually, I wormed my way into the art department, emptying waterpots for watercolor layout artists. Then the traffic department. Then the copy department. Art and copy were completely segregated then. Everything was different then. The advertising agency business, like me, was still in its adolescence. It had only begun about sixty years before, and its development had been arrested by two major World Wars and a lengthy depression. So it was still fertile ground. From the minute I got into it, I knew I had found my place.

In the agency there was an attractive woman named Karen, an art buyer, who unwittingly launched my career as an advertising copywriter. The art file room was in the middle of the art and copy departments, and a few times a day Karen would ascend the ladder to put away or take down some piece of artwork while we all stood around pretending to have our minds, and eyes, on something other than up her skirt. Had this been the 1960s instead of the 1950s, some efficiency expert would no doubt have come in and seen to it that the most frequently used art files were placed on the bottom for easy access instead of the top, which required a long, long stretch, and in so doing destroy the morale of an entire company.

From my lofty perch at the bottom of the traffic department I could see pretty much everything else that was going on above me in the agency. One of the things I saw was a copywriter with an overwhelming workload, who, along with the rest of the company, had the hots for Karen. One day I went into his office and commiserated with him. I knew that

➤ **Ocular Infections**
Art Director: Harry Zelenko
Artists: Harry Zelenko, Peter Adler
Agency: W.M. Douglas McAdams
Client: Chas. Pfizer & Co.

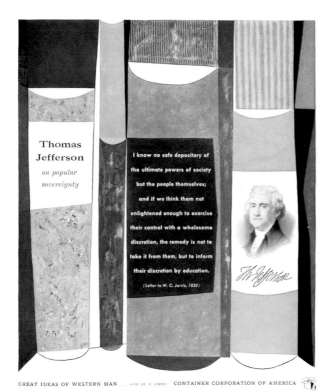

GREAT IDEAS OF WESTERN MAN . . . ONE OF A SERIES CONTAINER CORPORATION OF AMERICA

PFIZER LABORATORIES Division, Chas. Pfizer & Co., Inc.

O
CU
LAR

INFEC
TIONS
RESPOND
TO BROAD
SPECTRUM
TERRAMYCIN*
BRAND OF OXYTETRACYCLINE

➤ **Great Ideas of Western Man**
Art Directors: Walter Reinsel, S. Neil Fujita
Designer: S. Neil Fujita
Agency: N.W. Ayer & Son
Client: Container Corporation of America

he'd much rather be going out to lunch with Karen than working on the trade ad he had due that afternoon. I suggested he let me take a crack at writing the ad so he'd have the afternoon free. I worked through lunch with the art director, and the ad got produced and ended up winning an award. So began my life as a copywriter.

Of course that wasn't all there was to it. At nights I read the dictionary. And the Harvard Classics. And every book about advertising or about anybody who was in advertising. And all the books by Strunk and White on writing and structure. For practice I would take a sentence, any sentence—say, "The quick brown fox jumped over the lazy dog." I'd rework it dozens of times. At first, I was careful not to change the meaning, just trying to make it cleaner, smoother, tighter, until it was elegant in its economy and taut with power. Gradually, I would shape it into something that approached advertising, shifting meaning, building in a sales pitch, until, maybe hundreds of lines later, out came something like "Outjump any dog! Get a fox." To many of today's creative people I'm sure this kind of exercise would seem unnecessary, even silly. Nowadays they go to a school that teaches them how to put together a portfolio that will get them nice-paying jobs in advertising. They come out knowing how to get the jobs without really knowing how to do the jobs.

When I arrived in New York in 1959, I was eager to find a copy job in advertising, but I had to settle for work as a cashier in a Schrafft's. After finally landing jobs in agencies here and there and putting together a pretty nice portfolio, I secured a position in one of the most creative of the bigger agencies, and, even though I was making good money and doing some good work, I was extremely frustrated. I wanted to do all good work. I really wanted to work at the most vaunted creative agency of the day—Doyle Dane Bernbach. I had applied thrice and been turned down twice. The third time I got a "maybe" but with a salary proposal even lower than I was prepared to stoop.

Two things then happened that changed my life. First, I received my Christmas bonus, a check for many thousands of dollars. I got really angry because I felt it was way too much. I reasoned that if I had received such a fat bonus for having been there only six months and doing relatively little, there must be people there amassing obese bonuses for doing even less. I didn't want to be involved with such a screwed-up place. I couldn't survive in a company that didn't understand the value of contribution or of a hard-earned buck. So I tried to give the bonus back. My boss laughed at me and said I couldn't give it back.

A couple of months later, I heard of a job opening at a new small agency called Carl Ally, Inc. It paid exactly half of what I was then making, but I'd worked with one of the principals there and knew we shared similar beliefs about advertising, so my interest was piqued. I immediately called to apply for the job, met the key people at their offices after

Epictetus On Philosophy
Art Director: Walter Reinsel
Artist: Leo Lionni
Agency: N.W. Ayer & Son
Client: Container Corporation of America

work the next day, and had the job the day after that. Of course I couldn't tell anyone else that I had taken such a massive paycut. They would have thought I was completely nuts. No one I know of in advertising has ever moved so quickly forward by going so steeply backwards. Within two years I had tripled my salary, owned stock in the agency, and my work was becoming famous. I owe much to Carl Ally for that.

Carl flew at the advertising business the same way he flew his plane, with bravado and derring-do. He was not always sensible or politically correct, and some people thought him crude. He often referred to himself as a "belly-bumper." That is, he was a highly physical communicator, and he and I "spoke" physically on more than one occasion. He was a veritable fountain of hare-brained ideas and schemes, some of them absolutely brilliant, some utterly ridiculous. His mantra hung on the wall, over his desk: "Comfort the afflicted. Afflict the comfortable," and he lived true to it. In the three years I spent there I did some of the most exciting work of my life and worked with some of the greatest art directors ever: Bob Wilvers, Amil Gargano, Ron Barrett, Ralph Ammirati, just to mention a few. I also got to hire and train some significant copy people such as Martin Puris, David Altschiller, and others, a great many of whom went on to build terrific agencies of their own. Years later, I was discussing this with one of the principals of another agency. When I mentioned that I had trained Martin Puris, he snapped, "No, you didn't!" Have you noticed how some people who can't conceive of doing something themselves make sure you can't either? Dodge them at all costs. But back to giants....

One evening at Carl Ally my phone rang, and a very softspoken voice said, "Ed? This is Bill, Bill Bernbach." This was the advertising equivalent in today's currency of getting a call from the Dalai Lama or the Pope. He had heard there might be a possibility I would leave Ally if the right opportunity presented itself. He invited me to his office for lunch.

I don't remember what we ate, but I remember all we discussed. He had a plastic paperweight on his desk commemorating the hundredth anniversary of one of his clients. He said, "You see that, Ed? The client wanted us to put that into all their ads as part of the signature." I looked at it more closely. It just had the clients' name on it and the dates "1865–1965." "What do you think I told them?" he asked me. "That it would look like they'd died," I answered. He winced, a little taken aback. "Well, yes," he said, "that's exactly what I told them, so we never did put it in." For years after that we had regular lunches, and he would often ask me similar questions, which I would answer. He always winced, then confirmed the correctness of my answer. Just after his funeral, I told one of his confidants about this and asked him, "What was with the wince?" He said, "Oh. He hated it whenever someone would answer one of his rhetorical questions, because it stole his thunder." I thought he was just trying to find out how smart I was.

... read as they will

(or can) most people

still find it easier to listen ...

Once upon a time, the world was a much smaller place. And whenever someone had something to say, all he did was speak up.

But soon people began to get out of earshot. And Communication became more and more difficult.

Till one day one man sat down on his stone, and chipped out something called writing. Then someone else passed along, decoded this sculpture, and reading came into the world. Lo! The primitive one-step process of talking and listening had been replaced with something more complex.

But it wasn't replaced after all. For read as they will (or can) most people still find it easier to listen. And people who want to get a message across still find it easier, and more effective, to talk.

Especially now that one medium of communication can carry a message to everyone: Radio. In 115 million places. The easiest, yet most forceful means of selling everybody that's ever been devised.

Radio is intimate, personal, persuasive. And when it's the voice of an old friend, people respect what they hear.

Radio is rhythm, music, sound effects—all the things that are fun to hear over and over. Things that are hard to forget.

Radio, in short, is sound. And being sound, radio moves one

step

at

a

time. As soon as the entertainment comes to a stop, the sales message immediately begins. The message is hard to miss. And since radio moves one group of words at a time, the sales points can't be skipped over.

Today, there's one place in radio where sound sells best, and that is CBS Radio. Presenting more of America's top programs ... over more of the nation's best stations ... CBS Radio is heard by bigger audiences than anywhere else in radio.

And offering the lowest cost for every sales message delivered, it's CBS Radio where more of the top national advertisers are heard. So many, with so much to say, that CBS Radio leads all other networks in billings for the fifth consecutive year.

RADIO

➤ **Hearing**
Art Director: Lou Dorfsman
Artist: unknown, engraving
Producer: CBS Radio
Client: CBS Radio

I never did work for DDB. Bill offered me an amazing creative director's job, and I accepted it. But somehow word spread all over DDB, and there was a great deal of moaning and objection in the mid-ranks among people who had worked there for years and who thought such a job should rightly go to one of them. When I went into my office at Carl Ally the next morning, one of the writers working for me ran breathlessly into my office and asked if all the rumors were true. I said they weren't true, closed my door, and called Bill. I told him that I wasn't going to take the job I had already accepted. I said, "Bill, it sounds like you're going to have a revolt on your hands, and I don't think it's worth it for you to disrupt everything you've worked so hard to build. Also, I think it would make it very difficult for me to perform at my best in the face of antagonism instead of total cooperation. Why don't you find somebody you can promote from within?" He thanked me for my candor and said he was sorry we wouldn't be working together but that he respected my decision and offered his friendship and advice.

Shortly thereafter I became a partner in my own agency, Scali, McCabe, Sloves, and I would call upon Bill for advice many times over the next few years. One bit of advice he gave me I followed, and he dined out on it for years. At lunch one day I complained to him how we'd been in business three or four years and that we just weren't growing fast enough. He said, "Ed, you're doing fabulous work on Volvo. But that's not enough. You need three visible accounts with work that good."

Not long after, we got the Barney's Men's Store account and Perdue Chicken. The work we did for them was noticed, talked about, and very successful. Finally, my agency began to soar. Every time I had lunch with Bill Bernbach after that he would turn to everyone at the table and tell the story of the time I had asked his advice and how he had told me we needed three visible accounts with great work. He'd always ask, rhetorically, of course, "And then what do you think he did?" Everyone at the table would sit silently, respectfully, including myself, waiting. "He did it!" Then I'd blush and he'd beam.

David Ogilvy was another story altogether. When my name came up in conversation, he'd tell people, "Ed McCabe. He's made more money off of David Ogilvy than David Ogilvy made off of David Ogilvy." David was the only guy I ever met who could mention himself three times in the same sentence while talking about me.

It's true we sold Scali, McCabe, Sloves to Ogilvy & Mather for a goodly amount of money, but really, David Ogilvy and I never did quite see eye to eye. I don't say he wasn't a gifted salesperson. He knew his audience and pandered to it brilliantly. With all the rules and research he was forever propounding, I just felt he was something of a traitor to the creative cause, the businessman's creative man. Nonetheless, he did some great advertising and built a fine agency that prospered.

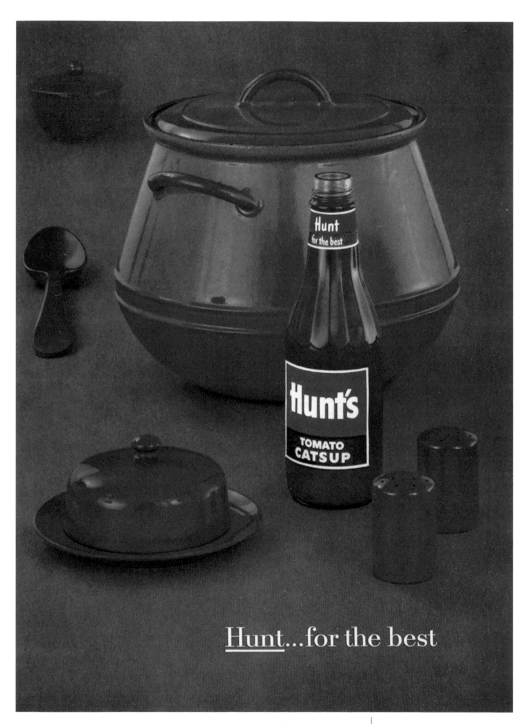

Hunt...for the best

➤ **Hunt's Catsup**
Art Director: Robert Wheeler
Photographer: Max Yavno
Agency: Young & Rubicam
Client: Hunt's Food, Inc.

Rosser Reeves was another unique individual. Of all the titans I tête-à-têted with, Rosser was my favorite. It was Rosser Reeves who most closely defined the word "cool." He was an anomaly to me because what Rosser stood for in most people's minds was the old school. In advertising he was the archetypical "bad guy," the man who advocated hammers pounding in people's heads and splitting stomachs on America's TV screens. He was the head of Ted Bates, and he found himself defending what was then the last bastion of tastelessness in advertising. He was the one person in advertising I thought that I would least like to meet. I couldn't have been more wrong.

Everything about Rosser was the reverse of my expectations. I expected that he'd hate me and everything I stood for. He came up to me at a beach bar in Jamaica and said, "You're Ed McCabe aren't you?" He immediately shocked me by saying, "I love your work." And then we talked for what seemed like hours. Reeves was larger than life in every way. Tall, heavy-set but not fat, a courtly southern gentleman, who also liked to drink, drive fast, gamble, carouse, and write serious novels in the "beat" genre. He confessed that he started out hating my work and had sought to disprove its efficacy by secretly testing much of it. But when his testing showed the validity and power of the advertising I'd done, he'd become a secret convert. But as head of the agency most committed to the "hard sell," he had to maintain a certain posture that I could clearly see he was uncomfortable maintaining. As he put it at the time, "I'm overpositioned."

Including Reeves, most of the giants I worked with are gone or retired. Even clients such as Charles Revson, Fred Pressman of Barney's, and Frank Perdue aren't around anymore. It may not have all been roses, but my experience with such greats on the agency side as well as clients has left me with the distinct feeling you'd be hard pressed finding anyone comparable today. The trade press bemoans the fact that there are no giants in advertising anymore. There are few giants anywhere anymore. It's easy to see why not. Few people today seem to stand for anything.

What are my feelings about advertising today? I still love it. I still love making advertising. I love understanding what advertising is and what it isn't. But I've grown intolerant of what the business of advertising has become. I feel like a former revolutionary who isn't much stimulated by mere evolution.

Advertising has evolved into a business driven by megalomaniacs who know a lot about making money but little or nothing about making advertising. In some respects it's also being driven by "creatives," who have it wrong to the opposite extreme. They believe the ad or commercial is everything and that winning awards is something. They've lost sight of the fact that advertising, in and of itself, isn't anything. Adver-

491 Special Art Directors Club Medal Award

➤ **PIEL'S**
Art Director: Jack Sidebotham
Artists: Gene Deitch, Christ Ishi
Producer: UPA Pictures, Inc.
Agency:Young & Rubicam
Client: Piel Brothers

tising's sole purpose is to be the cause of something else. To cause a sales increase. To cause a shift in perception. To cause the creation of an edifice of imagery that allows a product or service to be something. But advertising itself is nothing. Nothing but a means to an end. Only fools believe the means is as important or significant as the end.

Also, advertising has become one of those many things in this world that there's just too damned much of. Few people take it very seriously. Sure, they'll sometimes talk about it at dinners and cocktail parties, but only when they can't think of something important to say. As for me, I might write another book or two. All I can tell you now is what they won't be about. Here, I intend to follow the advice of one of the many giants I have known and been blessed to call a friend. Rosser Reeves, so disheartened at the narrow and literal interpretation many people gave to his book *Reality in Advertising* once lectured me, "Ed, don't ever write a book about advertising, because they'll believe it and never let you forget it."

Marshan McLuhan had a good quote: "Advertising is the cave art of the twentieth century." I never said anything that good. ● ● ● ● ● **CARL FISCHER** / PHOTOGRAPHER

If you spend enough time in the advertising business you realize the enormous influence you've had on taste, culture, values, and the ways people think.

● ● ● ● ● **KARL H. STEINBRENNER** / PRESIDENT, STEINBRENNER & CO.

➤ **Lavore's Index**
Art Director: Walter Van Bellen
Artist: Walter Lefman, Bettman Archives
Client: M.H. Lavore Company

Bert Stern, *photographer*
Hershel Bramson, *art director*
Lawrence C. Gumbinner Advertising Agency, Inc., *agency*
Ste. Pierre Smirnoff Fls. (Division of Heublein), *advertiser*

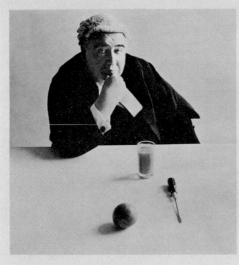

➤ **Smirnoff**
Art Director: Hershel Bramson
Photographer: Bert Stern
Agency: Lawrence C. Gumbinner Advertising Agency
Client: Ste. Pierre Smirnoff Fls. (Division of Heublein)

➤ **Small Size Shoes**
Art Director/Designer: Peter R. Palazzo
Client: I. Miller & Sons

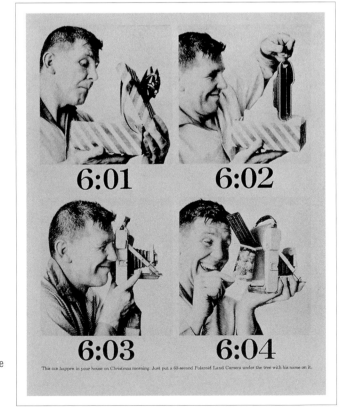

➤ **Polaroid**
Art Director/Designer: Helmut Krone
Photographer: Howard Zieff
Agency: Doyle Dane Bernbach
Client: Polaroid Corporation

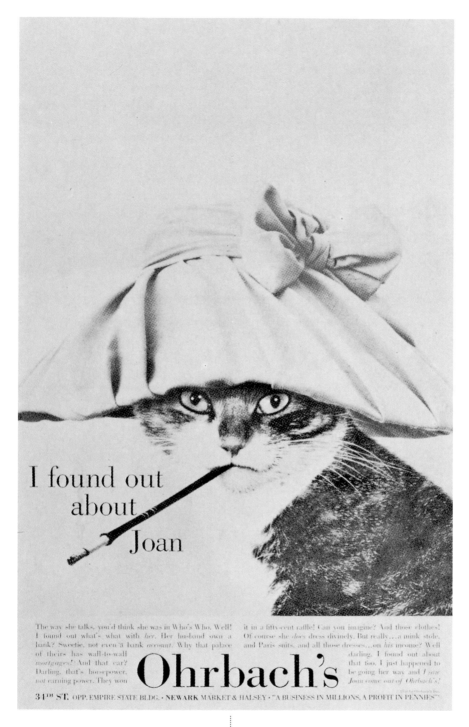

I found out
about
Joan

The way she talks, you'd think she was in Who's Who. Well! I found out what's what with *her*. Her husband own a bank? Sweetie, not even a bank *account*. Why that palace of theirs has wall-to-wall *mortgages!* And that car? Darling, that's horsepower, *not* earning power. They won it in a fifty-cent raffle! Can you imagine? And those clothes! Of course she *does* dress divinely. But really...a mink stole, and Paris suits, and all those dresses...on *his* income? Well darling, I found out about that too. I just happened to be going her way and *I saw Joan come out of Ohrbach's!*

Ohrbach's

34TH ST. OPP. EMPIRE STATE BLDG. • NEWARK MARKET & HALSEY • "A BUSINESS IN MILLIONS, A PROFIT IN PENNIES"

➤ **Ohrbach's**
Art Director/Designer: Robert Gage
Photographers: Wingate Payne, Walter Chandola
Agency: Doyle Dane Bernbach
Client: Ohrbach's

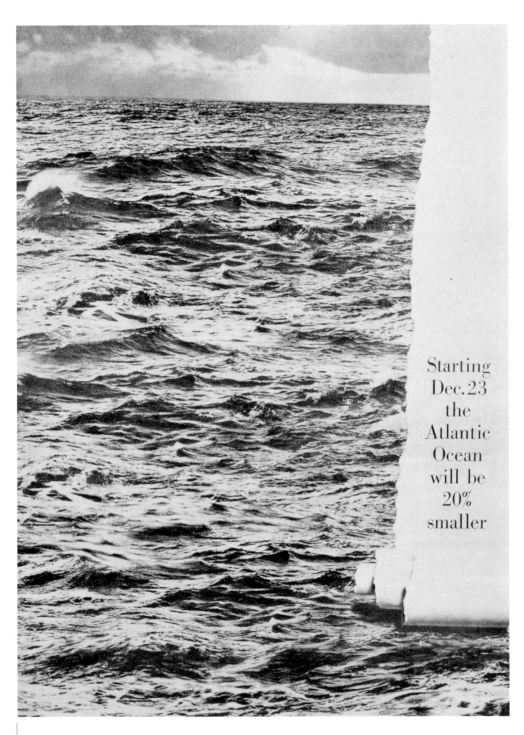

Starting
Dec. 23
the
Atlantic
Ocean
will be
20%
smaller

➤ El Al
Designer/Art Director: William Taubin
Photographer: Ewing Galloway
Agency: Doyle Dane Bernbach, Inc.
Client: El Al Israel Airlines Ltd.

•••••

"The maverick art director–copywriter teams of the 1960s achieved an audacious new fusion of image and word; there was a veritable fury to communicate."

1960

►► The Sixties: Madison Avenue's Creative Revolution

The 1960s were the golden age of advertising, and the first gold miner in them thar streets of New York was a visionary young copywriter named Bill Bernbach. In the 1950s, when this mild-mannered but tough-as-nails Brooklynite first teamed up with graphic pioneer Paul Rand, there was a veritable chemical reaction. At first, the irascible Rand didn't cotton much to a creative partnership with any human, let alone this eager young copywriter. Yet Bill Bernbach, in an epiphany that would change the course of advertising, conjured up a new model that would eventually stick: a creative team consisting of exactly one talented copywriter and exactly one of those emerging, image-driven graphic designers.

Soon, however, one and one made three, for Paul Rand rebuffed the idea of starting an ad agency only with the young, entrepreneuring Bernbach. "For chrissakes," Rand had said, "There's a young punk just around the corner in Grey Advertising's promotion department who's got talent. Go get him." The rest is history. That "young punk" was Bob Gage, who would go on to become an ad industry folk hero—the first truly "modern" advertising art director, the creative rock on which Bill Bernbach built his revolutionary new agency.

With the exception of a few unheard voices, the practice of using artist-writer teams as the prime source of advertising content was hitherto unheard of. So was the unprecedented level of creative collaboration—art directors would sometimes have a hand in creating copy and writers would often have a hand in layout. The thrilling successes of this concept were driven by the dream-teams at Doyle Dane Bernbach—namely, Bob Gage and Phyllis Robinson; Bill Taubin and Dave Reider; Helmut Krone and Julian Koenig. As the 1950s came to a close, they foretold the advent of a looming creative revolution.

From this extraordinary union of creative forces, the New Advertising was born, and Madison Avenue would never be the same. Appropriately enough, on the very first working day of the year 1960, Julian Koenig and I, despite some vocal objections on the part of many industry professionals, went ahead and started what would come to be known as the "second creative agency in America"— Papert Koenig Lois. Even Bernbach was aghast at our arrogance; he knew that his agency, DDB, was perceived by Madison Avenue as a

freakish, once-in-a-lifetime success story, and that the philosophy and ethos of the agency were defined by himself, Bernbach, and could never be duplicated. We were climbing a stone wall of skepticism, true. Yet PKL grew out of the fertile ground laid by DDB to become a new kind of agency—one run by a full-fledged creative team that included the art director on the masthead. Soon, new forces were springing up alongside us, and the creative revolution was truly underway.

"Pre-revolutionary" advertising had been largely a verbal medium in which the industry's creative powers were copywriters—art directors being considered subordinate "layout men." The maverick art director–copywriter teams of the 1960s achieved an audacious new fusion of image and word; there was a veritable fury to communicate. The fledgling ad agencies started by these creative teams proved by their success that the art of advertising was substantially more than writing headlines or crafting exquisite designs. And succeed they did. The breakaway team of Koenig and Lois, for example, showed art directors and copywriters that becoming a commercial success in the ad world was as simple as deploying one's creative talents to their fullest extent.

Still, Bill Bernbach was convinced that "there can only be one creative agency in the world." Before the decade was over, however, there were a dozen. By the time the Vietnam War was fully under way, new agencies were spinning off of the DDB and PKL core at a dizzying rate. They included Jack Tinker & Partners, Carl Ally, Delehanty, Kurnit & Geller, Leber Katz Paccione, McCaffery & McCall, Wells Rich Greene, AC & R, Scali McCabe Sloves, Della Femina Travisano & Partners, Lord Geller Federico Einstein, Rosenfeld Sirowitz & Lawson, and as the decade closed, Chiat/Day on the West Coast. Even some traditional agencies, intrigued or concerned by what was happening, embraced new talent and gave young creative teams a shot at big campaigns. The decade of the Big Idea was in full swing.

The 1960s was arguably the most vibrant, and certainly the most tempestuous, decade in the history of advertising. Spearheading the new movement were in-your-face, tough-talking personalities, most of them from the hip, gritty streets of New York. The 1960s left an astonishing legacy of art directors, many of them veterans of the Bernbach atelier. Among those, ten have been inducted into the Art Director's Hall of Fame. In order of acceptance, they are: Bob Gage, George Lois, Helmut Krone, Gene Federico, Bill Taubin, Sam Scali, Len

Sirowitz, Roy Grace, Bert Steinhauser, and Rick Levine.

One of the mantras of this new generation of talent was "simplify"—slice off the fat and leave only the meat. The new ground rule was to grab viewers' and readers' attention via clean and evocative cause-and-effect concepts. In an industry ruled by the whim of conservative clients and cautious ad men, where committees reign and lawyers restrain, these heretics introduced alien qualities like clarity, intelligence, and taste into American advertising. The role of the art director had tranformed from that of design artisan to that of shaper of ideas. The new creative teams of the 1960s overturned the common perception of advertising as hucksterism, hidden persuasion, and subliminal manipulation.

Building on the postwar trend toward design experimentation, and infused with the latest musings of pundits like Marshall McLuhan, advertisers had at long last cut through all the trappings of the medium to get to the message. Our new audacious art became a new kind of language: a fusion of image and word, ignited by ideas and concept and driven by an obsession to move from ad to action. The creative revolution took advertising beyond design and beyond the normal channels of communication. It is in the work created during this golden age that we first begin to see the stirrings of the brilliant, almost mesmerizing concept ads that have become the hallmark of today's advertising.

I have my own theory. It's basically a very simple one. My suggestions for stimulating your own creative juices include the following. Travel—not only by jet. Take a bus somewhere. Stay in a motel. Watch the gamblers' faces in Las Vegas or the Bahamas. Shoot the rapids in Colorado. Take a boat ride around Manhattan Island. Take the Amtrak to Washington, D.C. and renew your pride in the U.S. of A. Travel on the subway—if you don't know what today's subways are like, you don't know the difference between New York, Toronto, Moscow, and London.

● ● ● ● ● STEVE FRANKFURT

➤ **What year car do the Jones drive?**
Art Director: Helmut Krone
Copywriter: Julian Koenig
Photographer: Frank Cowan
Agency: Doyle, Dane, Bernbach
Client: Volkswagen

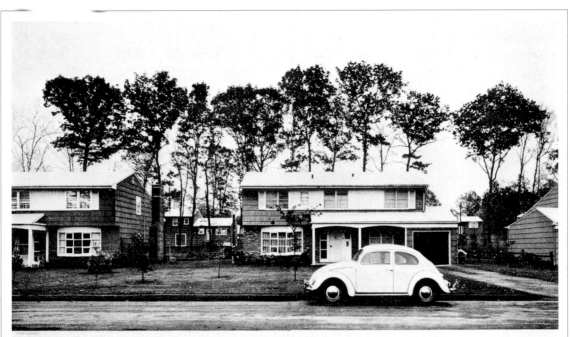

What year car do the Jones drive?

The Jones drive a Volkswagen and Volkswagens look alike from year to year.

A Volkswagen is never outdated. Indeed, no one knows how long a Volkswagen lasts; the first VWs made have not worn out. We hear from VW owners who have clocked over 100,000 miles without engine repair. If they ever should need it, they will find VW service is as good as the car.

The Volkswagen does change — where it counts. An anti-sway bar has just been added to the front suspension to make curves even smoother. New insulation deadens engine and roadway noise.

Over the years almost every part in the Volkswagen has been changed (but not its head or face).

Volkswagen owners find this a happy way to drive — and to live. How about you?

ARE YOU ALLERGIC to cats, dogs, dust, pillow feathers, make-up, pollen, et cetera? Take Allerest. Do you have allergic colds? (Many colds are really allergies.) Take Allerest. Do you wake up sneezing? Take Allerest. This new tablet calms the cough, the sneeze, the runny nose, the itchy eye of allergy. Allerest is the first drug of its kind available without prescription; no cold tablet can work as well. Ah-ah-ah-choo! I better **TAKE ALLEREST.**

ALLEREST

Allergy Tablets: designed to relieve the symptoms of upper respiratory allergies

➤ **Are you allergic**
Art Director: George Lois
Copywriter: Julian Koenig
Photographer: Carl Fischer
Agency: Papert, Koenig, Lois
Client: Pharmacraft

One punch or two?
Art Director: William Taubin
Copywriter: Dave Reider
Photographer: Harold Krieger
Agency: Doyle, Dane, Bernbach
Client: West End Brewing

A Fire Sale
Designer/Art Director: Arnold Varga
Copywriter: Frank Haller
Artist: Arnold Varga
Photographer: Ed Korbett
Client: Cox's

➤ **"John is that Billy coughing?"**
Art Director: George Lois
Copywriter: Julian Koenig
Agency: Papert, Koenig, Lois
Client: Pharmacraft

➤ **You don't have a cold!**
Art Director: George Lois
Copywriter: Julian Koenig
Photographer: Carl Fischer
Agency: Papert, Koenig, Lois
Client: Pharmacraft

➤ **Ignore it**
Art Director/Designer: Dan Cromer
Copywriter: Jay Folb
Agency: Benton & Bowles
Client: Western Union

"You sweet doll, I appreciate you. I've got taste. I'll bring out the real orange in you. I'll make you famous. Kiss me."

"Who was that tomato I saw you with last week?"

Wolfschmidt Vodka has the touch of taste that marks genuine old world vodka. Wolfschmidt in a Screwdriver is an orange at its best. Wolfschmidt brings out the best in every drink.

➤ **Wolfschmidt's**
Art Director: George Lois
Copywriter: Julian Koenig
Photographer: Carl Fischer
Agency: Papert, Koenig, Lois
Client: Seagram

Get noticed, make sense. I have been the "preachee" and the "preachor" (okay, preached to and preacher) of this philosophy. I guess I wasn't the only one.

● ● ● ● ● **STANLEY R. BECKER** / FORMER CHIEF CREATIVE OFFICER, SAATCHI & SAATCHI

➤ **This is Braille**
Art Director: Len Sirowitz
Copywriter: Leon Meadow
Photographer: Paul Elfenbein
Agency: Doyle, Dane, Bernbach
Client: Better Vision Institute

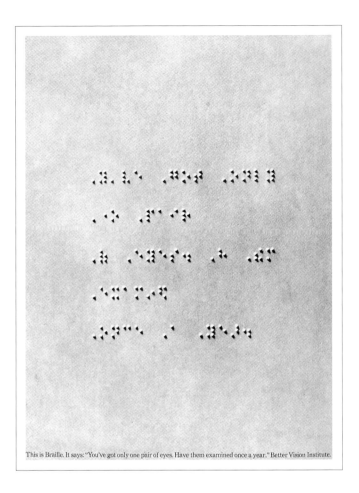

This is Braille. It says: "You've got only one pair of eyes. Have them examined once a year." Better Vision Institute.

Brilliant, creative advertising is one of the last remaining legal things you can use to gain an unfair advantage over your competition. ● ● ● ● ● EDWARD A. MCCABE / CO-FOUNDER, SCALI MCCABE, SLOVES

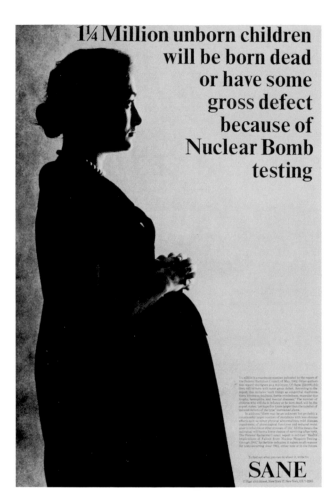

1¼ Million unborn children will be born dead or have some gross defect because of Nuclear Bomb testing

1¼ million is a maximum number published by the report of the Federal Radiation Council of May, 1962. Other authoritative report this figure as a minimum. Of these, 230,000 children will be born with some gross defect. According to the report, this includes "such things as congenital malformations, blindness, deafness, feeble-mindedness, muscular dystrophy, hemophilia, and mental diseases." The number of children who will die in infancy or be born dead, will be, the report states, "perhaps five times larger than the number of serious defects of the type" mentioned above.

In addition, "there may be an unknown but probably a considerable larger number of mutations with less obvious effects such as minor physical abnormalities, mild diseases, impairment of physiological functions and reduced mental powers, reduction or shortening of life." All this means the individual will have a lower chance of surviving after birth. The Federal Radiation Council report is entitled "Health Implications of Fallout from Nuclear Weapons Testing through 1961." In the fire catalysis it raises small reasons for not concerning over 1962, either now or in the future.

To find out what you can do about it, write to

SANE

15 East 40th Street, New York 17, New York, OX 7-2390

➤ **1 1/4 Million Unborn Children**
Art Director/Designer: George Lois
Photographer: Carl Fischer
Agency: Papert, Koenig, Lois
Client: Committee for a Sane Nuclear Policy

➤ **The Rocket's Red Glare**
Art Directors/Designers: Louis Dorfsman, Al Amato
Copywriter: Robert Strunsky
Artist: Al Amato
Photographer: CBS Photo
Client: CBS Television Network

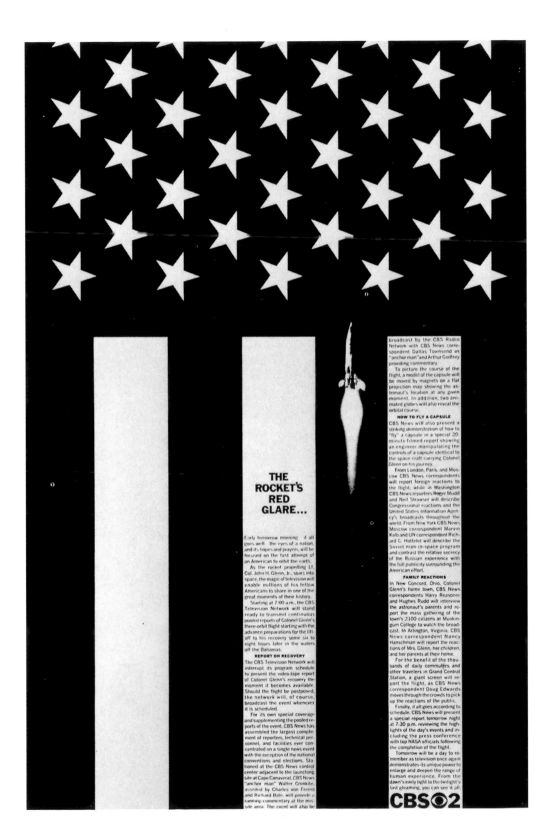

THE ROCKET'S RED GLARE...

Early tomorrow morning, if all goes well, the eyes of a nation, and its hopes and prayers, will be focused on the first attempt of an American to orbit the earth.

As the rocket propelling Lt. Col. John H. Glenn, Jr., soars into space, the magic of television will enable millions of his fellow Americans to share in one of the great moments of their history.

Starting at 7:00 a.m., the CBS Television Network will stand ready to transmit continuous pooled reports of Colonel Glenn's three-orbit flight starting with the advance preparations for the lift-off to his recovery some six to eight hours later in the waters off the Bahamas.

REPORT ON RECOVERY

The CBS Television Network will interrupt its program schedule to present the video-tape report of Colonel Glenn's recovery the moment it becomes available. Should the flight be postponed, the network will, of course, broadcast the event whenever it is scheduled.

For its own special coverage and supplementing the pooled reports of the event, CBS News has assembled the largest complement of reporters, technical personnel, and facilities ever concentrated on a single news event with the exception of the national conventions and elections. Stationed at the CBS News control center adjacent to the launching site at Cape Canaveral, CBS News "anchor man" Walter Cronkite, assisted by Charles von Fremd and Richard Bate, will provide a running commentary at the missile area. The event will also be

broadcast by the CBS Radio Network with CBS News correspondent Dallas Townsend as "anchor man" and Arthur Godfrey providing commentary.

To picture the course of the flight, a model of the capsule will be moved by magnets on a flat projection map showing the astronaut's location at any given moment. In addition, two animated globes will also reveal the orbital course.

HOW TO FLY A CAPSULE

CBS News will also present a striking demonstration of how to "fly" a capsule in a special 20-minute filmed report showing an engineer manipulating the controls of a capsule identical to the space craft carrying Colonel Glenn on his journey.

From London, Paris, and Moscow CBS News correspondents will report foreign reactions to the flight, while in Washington CBS News reporters Roger Mudd and Neil Strawser will describe Congressional reactions and the United States Information Agency's broadcasts throughout the world. From New York CBS News Moscow correspondent Marvin Kalb and UN correspondent Richard C. Hottelet will describe the Soviet man-in-space program and contrast the relative secrecy of the Russian experience with the full publicity surrounding the American effort.

FAMILY REACTIONS

In New Concord, Ohio, Colonel Glenn's home town, CBS News correspondents Harry Reasoner and Hughes Rudd will interview the astronaut's parents and report the mass gathering of the town's 2100 citizens at Muskingum College to watch the broadcast. In Arlington, Virginia, CBS News correspondent Nancy Hanschman will report the reactions of Mrs. Glenn, her children, and her parents at their home.

For the benefit of the thousands of daily commuters, and other travelers in Grand Central Station, a giant screen will report the flight, as CBS News correspondent Doug Edwards moves through the crowds to pick up the reactions of the public.

Finally, if all goes according to schedule, CBS News will present a special report tomorrow night at 7:30 p.m. reviewing the highlights of the day's events and including the press conference with top NASA officials following the completion of the flight.

Tomorrow will be a day to remember as television once again demonstrates its unique power to enlarge and deepen the range of human experience. From the dawn's early light to the twilight's last gleaming, you can see it all.

CBS◉2

Advertising has gone from something that reflects popular culture to becoming a part of popular culture, from something that's influenced by popular entertainment to being popular entertainment. ● ● ● ● JIMMY SIEGEL / SENIOR CREATIVE DIRECTOR, BBDO

If your Harvey Probber chair wobbles, straighten your floor.

My son, the pilot.

➤ **If your Harvey Probber Chair Wobbles...**
Art Director/Designer: George Lois
Copywriter: Julian Koenig
Photographer: Carl Fischer
Agency: Papert, Koenig, Lois
Client: Harvey Probber Inc.

➤ **My son, the pilot**
Art Director: Sidney Myers
Copywriter: Bob Levenson
Photographer: Paul Elfenbein
Agency: Doyle, Dane, Bernbach
Client: El Al Airlines Ltd.

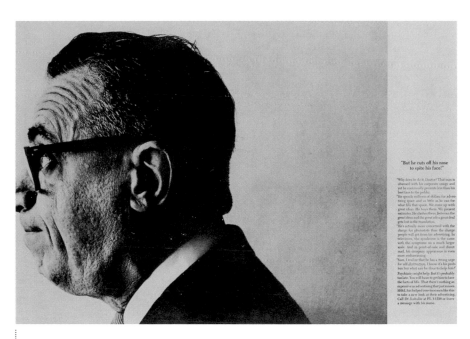

➤ **"But he cut off his nose..."**
Art Director/Designer: Herb Lubalin
Copywriter: Larry Muller
Photographer: Carl Fischer
Agency: Sudler & Hennessey
Client: SH&L

➤ **No, No, Stupido, We Said Fiesta...**
Art Director/Designer: George Lois
Copywriter: Ron Holland
Photographer: Carl Fischer
Agency: Papert, Koenig, Lois
Client: Restaurant Associates

DETAIL OF HAND-PAINTED FAMILY GROUP FROM LA FONDA'S FOLK ART COLLECTION, IN DISPLAY CASE ON EAST WALL OF ADOBE BAR.

No, No, Stupido, we said Fiesta at La Fonda del Sol, not Siesta.

Every Sunday, from one o'clock on, La Fonda has Fiesta. We have the Canela Trio. A Mariache band. The Jose Montalvo Trio. Mexican Hat Dancers. Jose Bettencourt's Marimba Band. A flamenco guitarist. Free granizados (ices) for the kids. And food! Well, you know those La Fonda portions. La Fonda del Sol, 123 W. 50th St., PLaza 7-8800

In November of 1969 I ushered my trusting wife and young daughter and son onto a Venezuelan Airlines 707 and flew to Caracas, Venezuela. I had taken a position as the vice president and creative director of McCann-Erickson Venezuela, a position that turned into a ten-year odyssey. It changed my life and my family's lives as well as the lives of many other people whom I met and interacted with along the way. The experience was wonderful, exciting, and fulfilling, yet it was also hateful, frustrating, humbling, and, ultimately, an experience I wouldn't trade for any other in my profession. It matured me and allowed me the pleasure of making friends all over the world—the time I spent overseas can never be forgotten.

In the mid-1960s, Gene Kummel left his agency and took over as head of McCann-Erickson International (now McCann Worldwide). He was perhaps the single most influential force in causing the American advertising industry to expand beyond the borders of Madison Avenue. He recruited people like me, as well as client-service and management professionals, to go forth and build what was to become the most dynamic and, for a time, the most influential and successful international advertising agency network.

The story goes that Kummel promised the board of Interpublic that he would double the agency's income within five years, which he did and then some. He built the international division into a revenue source that far outstripped domestic McCann. But the story really began back in the 1930s, when H. K. McCann told his main U.S. client, ESSO (now Exxon), that wherever in the world they did business, he would open an office to serve their advertising needs. McCann became only one of three major agencies that had international offices after World War II—Young and Rubicam and J Walter Thompson were the other two.

During the late 1950s and early 1960s, more and more major U.S. corporations were opening plants and offices in developing markets in Europe, Asia, and South America. They understood the potential for growth in those markets and the goods and services that U.S. consumer companies could provide. Companies such as P&G, Colgate, Lever, General Motors, Chrysler, Del Monte, Nestle, Gillette, and Coca-Cola sent production and marketing people into select markets to establish themselves and to take leadership market positions. Consumerism was on its way. The catch was that, in those markets, there were few, if any, advertising agencies with the skills and personnel to support multinational U.S. companies in the style to which they were becoming accustomed. These companies were demanding U.S.-style marketing and advertising support.

What was interesting back in the 1960s was that as Madison Avenue grew into the dynamic force it has since become, there was the beginning of a shift away from that legendary street to other locales. As the real-estate boom in New York grew, square-footage prices in midtown New York became increasingly prohibitive. Only the big ten or twenty firms seemed able to afford to stay put, due to their growth and increased revenues. In addition, as new agen-

Shut up, whites, and listen.

Whites do a lot of talking about Negroes, but hardly ever listen to them.

The Herald Tribune National Correspondent, Robert Bird decided to listen hard.

He sought out 10 Negroes, some at the summit of Negro life, others unknown, and simply let them talk. Then, he asked other Negroes to comment on what the 10 said.

In a new, 10-part series (starting April 30th in the Herald Tribune) you hear what Bird heard. You don't get comfortable, White clichés about Negro life. Instead you get what Negroes themselves think, and get it in their own words.

For instance:

The publisher of Ebony describes the new "Negro sophisticates" and the "talented tenth" of the Negro world.

A twenty-eight-year-old New York secretary tells what a simple dinner and theatre date can be like when you're colored.

Elijah Muhammad, the leader of the Black Muslims (in his first interview) outlines his program of violence.

Martin Luther King beautifully describes the power of non-violence.

A Negro English Professor, who calls himself an "Angry Old Man," sadly reminisces about 30 years of fruitless struggle.

An undergraduate at Howard University explains why he wants to go into politics and why he thinks he'll be president of the United States in 25 years.

A constitutional lawyer claims that there is no such thing as "Negro crime" or "Negro backwardness."

A 19-year-old college sophomore tells what it's like to be in a Georgia jail.

The aim of Bird's series is not to make headlines or to present the ordinary "Survey of Negro Life." In its quiet, truthful way, it attempts to show you what the world looks like through Negro eyes.

10 NEGROES BY ROBERT BIRD STARTS APRIL 30.

NEW YORK
Herald Tribune

> **Shut Up, Whites, and Listen.**
> Art Director/Designer: Kurt Weihs
> Copywriter: Monte Ghertler
> Agency: Papert, Koenig, Lois
> Client: New York Herald Tribune

> **Which is the $2,800 Picasso?**
> Art Director/Designer: Sam Scali
> Copywriter: Mike Chappell
> Photographer: Timothy Galfas
> Agency: Papert, Koenig, Lois
> Client: Xerox Corp.

Which is the $2,800 Picasso? Which is the 5¢ Xerox 914 copy?

XEROX

cies sprang up that were led by people who were spawned from the majors—all those ex-DDB hot shots—space became an issue. Mad Ave became Sixth Avenue, and then SoHo came calling, and then—horrors!—Mad Ave spread to Minneapolis, San Francisco, L.A., and even Atlanta, Dallas, and Portland, of all places! Leo Burnett had quietly been doing successful business in Chicago and, if we had been watching, was showing us how to reach the heartland of America with real warmth and effectiveness. But, all this while, xenophobic and arrogant New Yorkers were turning up their noses at anyone in the ad biz west of the Hudson River, let alone in a foreign land. Going to another country was often viewed as a failure to make it in the Big Apple.

Meanwhile, the international agencies were also expanding and becoming better at providing for their clients. People such as myself were recruited by people such as Gene Kummel to improve the product and train local talent in the fine art of U.S.-style marketing and advertising. We were changing the way populations perceived wants and needs. In the process, we—the outsiders, the foreign interlopers—were also being changed. Our local advertising colleagues were showing us how to integrate the way they thought and perceived the world with the way we Americans did—a sometimes tricky and sticky process, to be sure.

We were dealing with cultures we barely understood, profoundly affecting the way they lived and would continue to live. We were changing whole cultures into consumers, asking them to live differently, asking them to spend differently, to alter their values. We were asking people who never needed a deodorant before in their lives to be aware that they might "offend" others if they didn't use our products. This was occurring not only in "developing" markets, but in Europe as well. A whole American cultural ideal of personal hygiene was being overlaid on worldwide cultures by people like us.

The 1960s and 1970s were decades of great expansion. More people were needed to market products and services as more people were becoming consumers. Along with this, more products and technologies were being introduced that had effects on people's lifestyles and on their purses.

As all this was going on, the people who were being trained by us in far-flung offices in "exotic" places were becoming very good at our game. The English, French, Italians, Spanish, and Japanese began to put their own special spin on marketing and advertising, adapting the sometimes "in-your-face" American style of advertising.

Which country's advertising has surpassed America's is now a source of pride among our international advertising colleagues—it always starts a lively conversation among the international ad set at our favorite five-star hotel bar. The international ad contests, which owe their genesis to the Art Directors Club of New York's almost eighty years of life as well as to their yearly competition, demonstrate the quality of advertising now being practiced worldwide. As the pages of

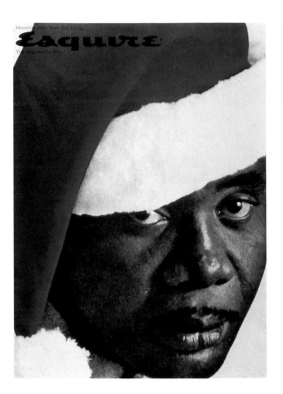

➤ **Esquire**
Art Director/Designer: George Lois
Photographer: Carl Fischer
Client: Esquire Inc.

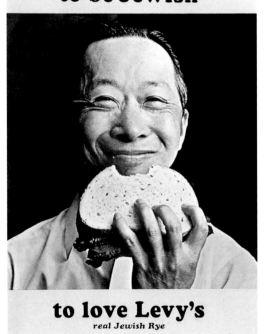

➤ **Real Jewish Rye**
Art Director: William Taubin
Writer: Judy Protas
Photographer: Michael Nebbia
Producer: Ernest Hartman
Production Company: Elliot, Unger & Elliot
Agency: Doyle Dane Bernbach
Client: Henry S. Levy & Son, Inc

this book attest, it is pretty impressive.

For those of us who served overseas, at least in the early years, we not only had to learn new languages but new relationships between men and women and classes. We had to learn who influenced the purchases, the lifestyles, the decisions. Who were we really talking to when we positioned our products—the housewife, the husband, or the maid? Where was the research that could help us create the right messages?

Television was in its infancy in many markets for years. Syndicated programming was imported from the U.S. and later from England and Australia—original programming was expensive. But television's subtle effect on lifestyle preferences was insidious. Governments, not commercial entities like our networks at home, affected content and even advertising. Production, to say nothing of casting, was challenging. Dialogue was overdubbed because blimped cameras and soundproof studios didn't exist, and the track had to be dubbed in four languages.

Radio—almost forgotten as an advertising medium in the 1960s here in the states—was still the major medium in many developing markets. We had to re-learn how to write and produce for that medium. It was fascinating and challenging to dig into your own personal resources and make something effective happen. That was fun!

Print advertising was affected as well. Think about the creative challenges of being an art director, with every kind of service available in the U.S., who suddenly has almost no typography available, less advanced photographic technology (no polaroids, no strobes), non-existent retouching, poor color reproduction, and limited print runs on inferior paper. We didn't think of those things when we signed on, but my, how we learned.

But that was then and this is now. Since that time there have been hundreds of agency mergers, acquisitions, and name changes in the crush to create international networks. Today, when Mad Ave exists all over the world and has become expert at marketing, production, and persuasion, the world has become much more of a global community. "Globalism" is the watchword, because people in developed and developing markets are speaking the same consumer language. Life, for the most part, is very good.

I always make a point of telling my students that their talents could be used for good or evil. It is their choice. Today's many public-service ads are proof of that. The reverse is also true—just watch enough TV and scan enough print media.

Instant global communication has changed the world, and Mad Ave has moved from its once fashionable location to everywhere in the world, including the information superhighway. I'm glad I was there when it was somewhere between 34th and 59th Streets on the real Madison Avenue. But, then again, I'm also glad I helped it move.

➤ **Alka-Seltzer On the Rocks**
Art Director/Designer: George D'Amato
Copywriter: Mary Wells
Photographer: Harold Becker
Agency: Jack Tinker & Partners
Client: Miles Laboratories

Alka-Seltzer On The Rocks

Pour a little water into an old fashioned glass. Add 2 Alka-Seltzers. Count to 10. Add chunks of ice. Add more water if you prefer. Then add a slice of lime. You've got Alka-Seltzer On The Rocks and it is great. It doesn't taste like Alka-Seltzer. More like a melted iceberg. Even cold, Alka-Seltzer relieves upset stomach, indigestion and headaches better than anything you can buy without a prescription. Anything. Next time ... try it On The Rocks.

Summer Upset? Cool it!

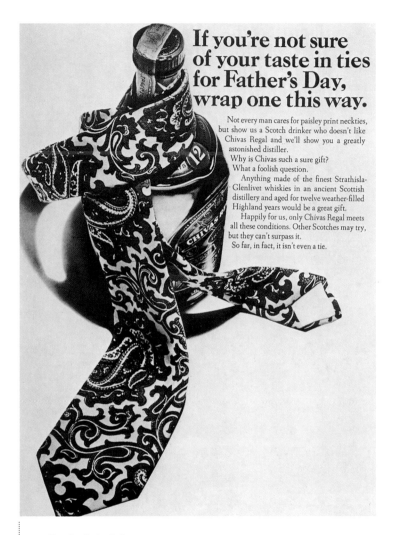

If you're not sure of your taste in ties for Father's Day, wrap one this way.

Not every man cares for paisley print neckties, but show us a Scotch drinker who doesn't like Chivas Regal and we'll show you a greatly astonished distiller.

Why is Chivas such a sure gift? What a foolish question.

Anything made of the finest Strathisla-Glenlivet whiskies in an ancient Scottish distillery and aged for twelve weather-filled Highland years would be a great gift.

Happily for us, only Chivas Regal meets all these conditions. Other Scotches may try, but they can't surpass it.

So far, in fact, it isn't even a tie.

➤ **Ties for Father's Day**
Art Director: Bert Steinhauser
Copywriter: David Herzbrun
Photographer: Donald Mack
Agency: Doyle Dane Bernbach
Client: General Wine & Spirit Co.

➤ **Tummy Television**
Art Director: Len Sirowitz
Copywriter: Ronald Rosenfeld
Photographer: Howard Zieff
Agency: Doyle Dane Bernbach
Client: Sony Corp.

Tummy Television

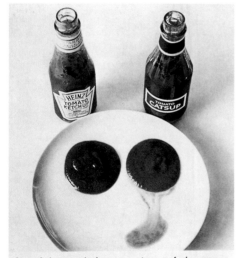

(Actual photograph of water running out of other catsup,
3 minutes 39 seconds after both were poured.)

One reason you may pay a little more for Heinz.

➤ **One Reason You May Pay a Little More for Heinz**
Art Director: Bert Steinhauser
Copywriter: Fran Wexler
Photographer: Donald Mack
Agency: Doyle, Dane, Bernbach
Client: H.J. Heinz Company

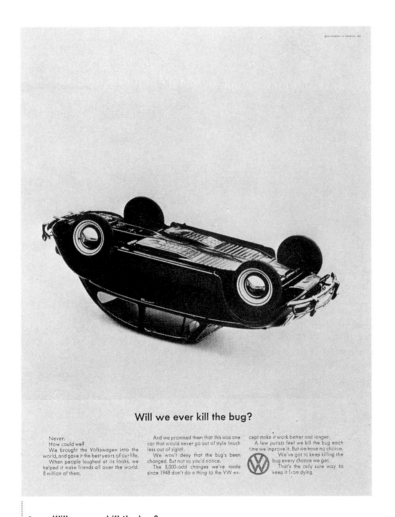

Will we ever kill the bug?

Never.
How could we?
We brought the Volkswagen into the world, and gave it the best years of our life. When people laughed at its looks, we helped it make friends all over the world. 8 million of them.

And we promised them that this was one car that would never go out of style (much less out of sight).
We won't deny that the bug's been changed. But not so you'd notice.
The 5,000-odd changes we've made since 1948 don't do a thing to the VW ex-

cept make it work better and longer.
A few purists feel we kill the bug each time we improve it. But we have no choice.
We've got to keep killing the bug every chance we get.
That's the only sure way to keep it from dying.

➤ **Will we ever kill the bug?**
Art Director: Leonard Sirowitz
Copywriter: Hal Silverman
Photographer: Wingate Paine
Agency: Doyle Dane Bernbach
Client: Volkswagen of America

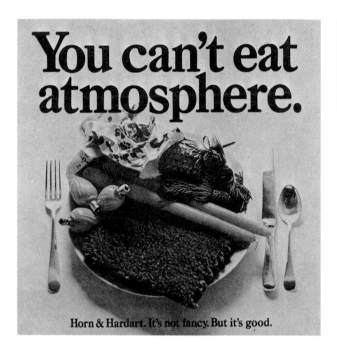

You Can't Eat Atmosphere
Art Director: Ron Barrett
Copywriter: Edward McCabe
Photographer: Elbert Budin/Dick Richards
Agency: Carl Ally
Client: Horn & Hardart

No.2ism. The Avis Manifesto
Art Director: Helmut Krone
Copywriter: Robert Levenson
Photographer: Faller-Wood
Agency: Doyle Dane Bernbach
Client: AvisRent-A-Car

No. 2ism.
The Avis Manifesto.

We are in the rent a car business, playing second fiddle to a giant.

Above all, we've had to learn how to stay alive.

In the struggle, we've also learned the basic **difference** between the No.1's and No.2's of the world.

The No.1 attitude is: "**Don't do the wrong thing.** Don't make mistakes and you'll be O.K."

The No.2 attitude is: "Do the right thing. Look for new ways. Try harder."

No.2ism is the Avis doctrine. And it works.

The Avis customer rents a clean, new Plymouth, with wipers wiping, ashtrays empty, gas tank full, from an Avis girl with smile firmly in place.

And Avis itself has come out of the red into the black. Avis didn't invent No.2ism. Anyone is free to use it. No.2's of the world, arise!

We designed a seat for Wilt Chamberlain.

you're tall, really tall, you get used to people
ing at you and asking dumb things.
"How's the weather up there, Shorty?" and
r, what are you standing on?"—after awhile such
ions bother you as much as a good night's sleep.
What does bother you though, is finding a bed
ough so you can get a good night's sleep.
Or finding a doorway high enough so you
t through without banging your nose.
Or finding a seat on a bus or a plane roomy
gh for you to stretch your legs.

These are big problems when you're big.
Now one of these problems has been solved.
BOAC—for its great new jet, the Super VC 10—has
developed a new kind of airplane seat that the biggest
of pivot men can be comfortable in.
It wasn't built in a day. It took two years

of fussing with new materials, checking medical data,
studying the sitting habits of hundreds of people.
It meant throwing out all the old principles
of seat design. No more metal frames. Too bulky.
(For extra leg room, the seat would have to be thin.)
No more conventional woolen padding. Too
soft. (For real comfort, the padding should shape itself
to the body.)
After $150,000 worth of experimenting, we
hit it. A seat with a light, very strong, molded plastic
shell, cushioned with a new kind of synthetic foam.

If you're going to London, Bermuda, Nass
or Jamaica, take a BOAC Super VC 10. You'll
able to stretch out in the roomiest, most comforta
economy-class seat ever built.
Wilt Chamberlain says it's the best he's e
sat in.
And if he liked it, we have a feeling you will t

The Super VC 10.

BOAC
AND BOAC CUNAR

➤ **Wilt Chamberlain**
Designer/Art Director: Ron Brello
Copywriter: Gerry Weinman
Artists: Ron Brello, Timothy Galfas
Photographer: Timothy Galfas
Agency: Pritchard Wood
Client: BOAC

...

➤ **Eastern**
Art Director/Designer: Stanley Dragoti
Copywriter: Myron Slosberg
Photographer: Tom McCarthy
Agency: Young & Rubicam
Client: Eastern Airlines

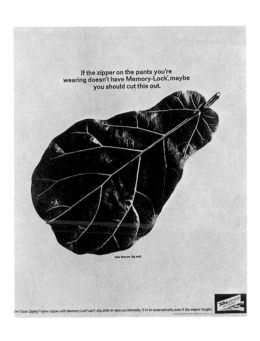

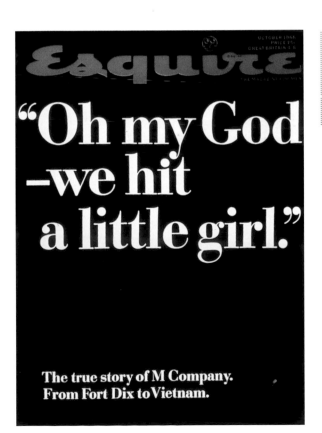

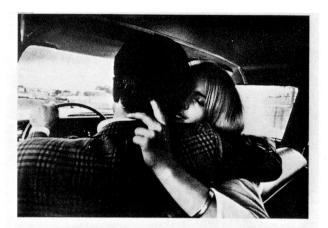

Till death us do part.

It may be beautiful to die for love in a poem.

But it's ugly and stupid to die for love in a car.

Yet how many times have you seen (or been) a couple more interested in passion than in passing? Too involved with living to worry about dying?

As a nation, we are allowing our young to be buried in tons of steel. And not only the reckless lovers—the just plain nice kids as well.

Everyone is alarmed about it. No one really knows what to do. And automobile accidents, believe it or not, continue to be the leading cause of death among young people between 15 and 24 years of age.

Parents are alarmed and hand over the keys to the car anyway.

Insurance companies are alarmed and charge enormous rates which deter no one.

Even statisticians (who don't alarm easily) are alarmed enough to tell us that by 1970, 14,450 young adults will die in cars each year.

(Just to put those 14,450 young lives in perspective, that is about 4 times the number of young lives we have lost so far in Viet Nam.)

Is it for this that we spent our dimes and dollars to all but wipe out polio? Is it for this that medical science conquered diphtheria and smallpox?

What kind of society is it that keeps its youngsters alive only long enough to sacrifice them on the highway?

Yet that is exactly what's happening. And it's incredible.

Young people should be the best drivers, not the worst.

They have the sharper eyes, the steadier nerves, the quicker reflexes. They probably even have the better understanding of how a car works.

So why?

Are they too dense to learn? Too smart to obey the obvious rules? Too sure of themselves? Too un-sure? Or simply too young and immature?

How can we get them to be old enough to be wise enough before it's too late?

One way is by insisting on better driver training programs in school. Or after school. Or after work. Or during summers.

By having stricter licensing requirements. By rewarding the good drivers instead of merely punishing the bad ones. By having uniform national driving laws (which don't exist today). By having radio and TV and the press deal more with the problem. By getting you to be less complacent.

Above all, by setting a decent example ourselves.

Nobody can stop young people from driving. And nobody should. Quite the contrary. The more exposed they become to sound driving techniques, the better they're going to be. (Doctors and lawyers "practice;" why not drivers?)

We at Mobil are not preachers or teachers. We sell gasoline and oil for a living and we want everyone to be a potential customer.

If not today, tomorrow. And we want everyone, young and old, to have his fair share of tomorrows.

Mobil
We want you to live.

➤ **Till Death Us Do Part**
Art Director/Designer: Len Sirowitz
Copywriter: Bob Levenson
Photographer: Mike Cuesta
Agency: Doyle Dane Bernbach
Client: Mobil

➤ **Volkswagen Builds Strong Bodies 8 Ways**
Art Director/Designer/Artist: Roy Grace
Copywriters: Charles Ewell, John Noble
Photographer: Henry Sandbank
Agency: Doyle Dane Bernbach
Client: Volkswagen of America

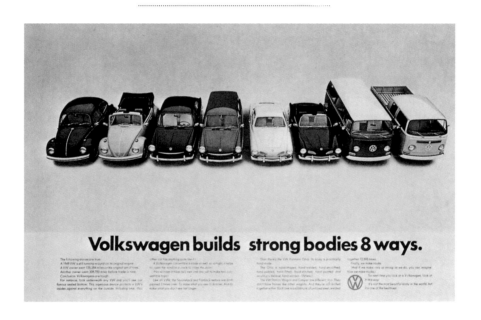

➤ **Benson & Hedges 100's**
Art Director/Designer: George D'Amato
Copywriter: Herb Green
Photographer: Harold Becker
Agency: Wells, Rich, Greene
Client: Philip Morris Company

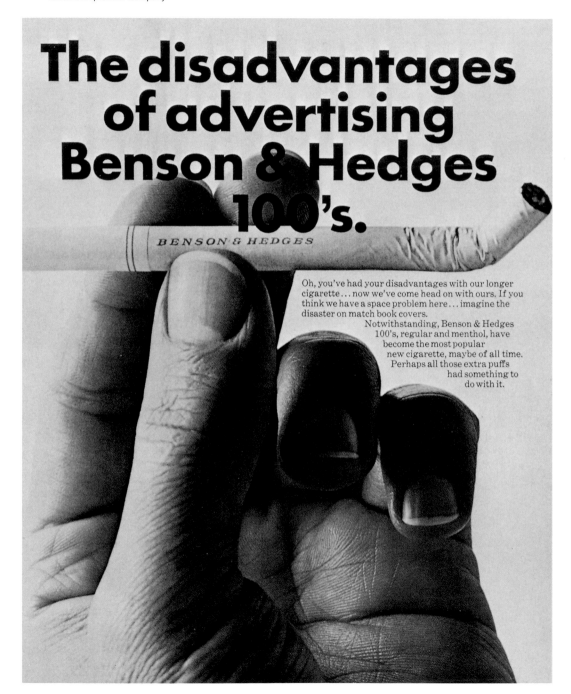

The disadvantages of advertising Benson & Hedges 100's.

Oh, you've had your disadvantages with our longer cigarette...now we've come head on with ours. If you think we have a space problem here...imagine the disaster on match book covers.

Notwithstanding, Benson & Hedges 100's, regular and menthol, have become the most popular new cigarette, maybe of all time. Perhaps all those extra puffs had something to do with it.

➤ **If Enough People Would Stop Smoking...**
Art Director/Designer: Ralph Ammirati
Copywriter: David Altschiller, Edward McCabe
Photographer: Mike Cuesta
Agency: Carl Ally, Inc.
Client: Schieffelin & Co.

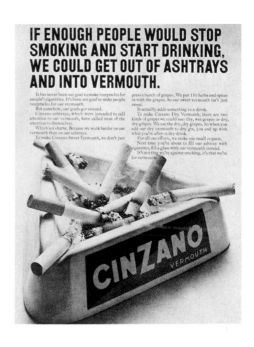

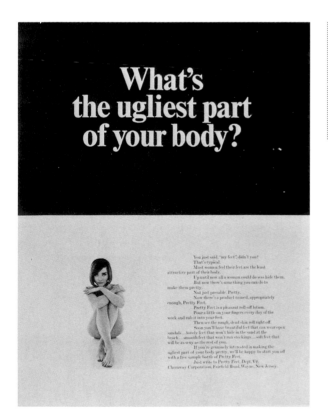

➤ **What's the Ugliest Part of Your Body?**
Art Director/Designer: Peter Hirsch
Copywriter: Jerry Della Femina
Photographers: Len Heicklen, Bill Helburn,
Mel Sokolsky, Mike Cuesta
Agency: Delehanty, Kurnit, & Geller
Client: Chemway Corporation

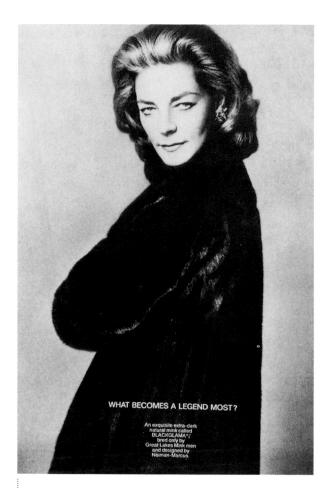

WHAT BECOMES A LEGEND MOST?

An exquisite extra-dark
natural mink called
BLACKGLAMA®,/
bred only by
Great Lakes Mink men
and designed by
Neiman-Marcus.

➤ **What Becomes a Legend Most?**
Designer/Art Director: Henry Wolf
Copywriter: Jane Trahey
Photographer: Richard Avedon
Agency: Trahey-Wolf
Client: Great Lakes Mink Association

Have the courage to assume responsibilities and to see them through as well as the courage to discard your own creative inventions if they don't live up to the standards you've set for yourself. Have the courage to speak up and speak out, even if it's only in a letter to the editor. And have the courage to be honest—most of all to yourself. ● ● ● ● ● STEVE FRANKFURT

"Edwards & Hanly-Where Were You..."
Art Director/Designer: George Lois
Copywriter: Ron Holland
Photographer: Timothy Galfas
Agency: Lois, Holland, Callaway
Client: Edwards & Hanly

"Edwards & Hanly—where were you when I <u>needed</u> you?"

We've got some terrific pictures of Joe Louis
taken when he was the Young Champ.
To get one, signed by Joe, send us this coupon.

NAME

ADDRESS

SEND COUPON TO EDWARDS & HANLY
280 BROADWAY, NEW YORK CITY

➤ **Give a Damn.**
Art Director/Designer: Marvin Lefkowitz
Copywriters: Anthony Isadore, Robert Elgort
Agency: Young & Rubicam
Client: New York Urban Coalition

Give a
damn.
Support the New York Urban Coalition.

I, Maxwell E. Snavely, hereby bequeath

To my business partner Jules...

nally, to my nephew Harold...

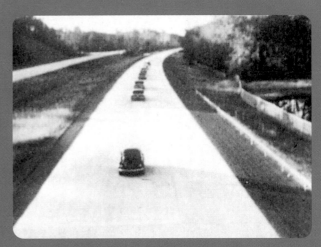

I leave my entire fortune...

➤ **Volkswagen/Funeral**
Art Director/Designer: Roy Grace
Director: Howard Zieff
Writer: John Noble
Producer: Don Trevor
Production Company: Howard Zieff Productions
Agency: Doyle Dane Bernbach
Client: Volkswagen

Alka-Seltzer/Penitentiary
Art Director: Sal Auditore
Director: N. Lee Lacey
Writer: Charlie Ewell
Producer: Joanne Ruesing
Production Company: N. Lee Lacy
Agency: Jack Tinker & Partners
Client: Miles Laboratories

(SFX: Voices) (SFX: Slamming of cup) Alka-Seltzer, Alka-Seltzer. Alka-Seltzer...

Remington/Medicine Cabinet
Designer/Art Director: Allan Beaver
Director: Howard Zieff
Writer: Larry Plapler
Producer: Bertelle Selig
Production Company: Howard Zieff Prod.
Agency: DKG, Inc.
Client: Remington Electric Shaver, Division/Sperry Rand Corp.

Father: Be sure your water is hot. Put on a lot of lather. When you work over here, be careful. This thing is a styptic pencil.

Esquire
Art Director/Designer: George Lois
Photographer: Carl Fischer
Agency: Lois, Holland, Callaway
Client: Esquire Magazine

Esquire

THE MAGAZINE FOR MEN

The final decline and total collapse
of the American avant-garde.

See page 142

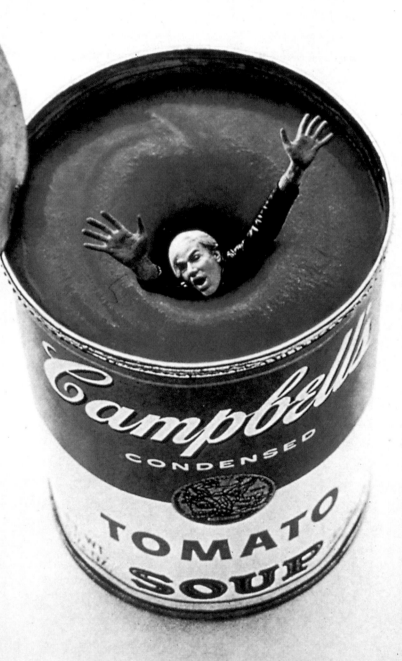

"The language of ads and entertainment in the 1970s was wonderful—simple, clever, and smart. It was information and entertainment through ideas."

1970

➤➤ The seventies: I'll never forget tomorrow

What a trip—a journey through the 1970s and a totally enjoyable look at some of the best of what advertising can achieve. We don't make truly creative stuff like that anymore, we make big, we make fast, we make different, and we make "now." And even though "then" was once "now," the 1970s and the 1990s are light years apart.

The language of ads and entertainment in the 1970s was wonderful—simple, clever, and smart. It was information and entertainment through ideas. An idea—merely a "notion in the mind," according to Webster. So where have they all gone? Probably the same place the laughter has.

Then there's sarcasm: Once such a soulful part of communicating, it seems to have given way to moderation. It's just not politically correct to be a wise-ass with words anymore, apparently. Poverty stalks the copywriter or art director who chooses to be cynical.

Now, however, is the time for me "to be perfectly clear," to borrow a phrase from a 1970s presidential icon. The fact is that I love the here-and-now and everything yet to come, as well as the new talent and technology that keep us in constant motion. We are enjoying a creative bonanza, and I'm certainly not comfortable glorifying the past by putting down the present—at least not too much.

In my own life experience, I've never thought of myself as one of those guys who prefers to live in the past. Rather, I've made a conscious effort to try and keep my work contemporary, to keep "reinventing" myself—to employ a word that is, next to "edgy," my least favorite of the 1990s. "Reinvent"—how pretentious.

Humility is out the window and silly is cool. Why? Because you either keep up-to-date or you die. Fortunately, the present has been good to me, and I don't lament the past, though I do miss it. Strangely, one of the interesting things about revisiting the past is that most of the creative stars of yesterday aren't around today to help me complain. I'm not talking deceased; I'm sure they're mostly living. It's just that they aren't bothered with trying to stay hip and trendy. They don't care about hanging with the next generation. Wherever they are, whatever they're doing, I bet they are loving it.

And they deserve to feel proud. The work they did in the 1970s sent a lot of valuable information and laughter—incredible imagi-

BOB GIRALDI
PARTNER AND DIRECTOR
GIRALDI SUARE PRODUCTIONS

• • • • •

nation actually—through the airwaves with their unique brand of concept language. They invented our business. It makes perfect sense that the pioneering television commercials of the 1970s, like the print ads before them, would be created by the best print writers and art directors. They insured that copy and ideas would always come before technique. The visual, however tasty and beautifully photographed, and the words, however witty or emotional, were always a complement to the main course—the concept. It was the idea that got you interested. Who knew that eventually those idea pioneers would give way to today's effects-oriented digital artists—those wunderkinds who are making visuals the new language of the brain?

So for now, the advertising business has become overwhelmingly electronic, a digital destiny on the horizon. It has welcomed frozen moments, morphing, flaming, ramping, processing, off-lining, on-lining, Harrying, and Henrying—speaking to a nation not with subtlety but at deafening sound levels. In this world, "new ideas" range from special effects to celebrity walk-ons. In an age of minimalism, frequent-flier miles, and celebrity worship, the current mantra of style is "everything is nothing," and all that "nothing" is available on a tiny digital screen.

I may be overstating matters, but, as I've come to learn in our business, why be subtle when you can use a sledgehammer. I'm a part of all this, of course, but I'm also a product of seventies style. Naturally, then, I felt sort of proud when I looked back and saw all the fine work from that decade. It was work that seemed to jump off the page or the screen to ask the viewer, in the nicest way, to use his or her imagination, to take a cue from the imagination of the ad's creator.

Then again, in some ways the 1970s is simply repeating itself. They had Nixon; we have Clinton. They had Aaron; we have McGwire. They had Travolta; . . . we have . . . Travolta. Things are both good and not so good. Agencies seem to be in trouble, or at least agency people do; they are getting bought up, fed up, plowed over, and basically replaced, by the entrepreneurial wave and the age of direct response. Who needs the baggage of an agency when the beloved client can go directly to all those talented people it now takes to make a successful marketing choice? To reluctantly employ a "food pun," this country could use a return to some basic ingredients.

Actually, to understand the 1970s and enjoy the 1990s, I have to go back to the 1960s and remember the feeling I had when I came across one memorable full-page magazine ad. The whole page was pure black, and a line of small white type running across the bottom of the page read: "This is how yellow daisies on green fields against a blue sky look to many Americans." It was a public-service ad from The Better Vision Institute, and it was created by Len Sirowitz. At that moment I remember thinking to myself, "I'm in the right business."

What did those old ads have that today's do not? Why was that new generation of print ads and TV commercials more enjoyable— and more revered? Maybe it lies in the simple fact that a creative person could still go on instinct and gut feeling and not be afraid. What resulted were advertisements that were witty, clear, uncluttered, to-the-point, and just plain inviting. In the end, what more can the public ask of an unwanted guest?

Man: The star of the 1949 Auto Show...

Not to keep in style with the times...

➤ **Volkswagen/Auto Show**
Art Director/Designer: Bob Kuperman
Director: Howard Zieff
Writer: John Noble
Producer: Lou Puopolo
ProductionCompany: Zieff Films
Agency: Doyle Dane Bernbach
Client: Volkswagen

➤ **American Tourister/Gorilla**
Art Director Designer: Roy Grace
Director: Dick Stone
Writer: Marcia Bell Grace
Photographer: Irv Deutsch
Producer: Susan Calhoun
Production Company: Directors Studio
Agency: Doyle Dane Bernbach
Client: American Tourister

Dear clumsy bellboys, brutal cab driver.

Careless doormen. Ruthless porters.

Jack: Mama Mia that'sa some speecy...

Jack: Meecy, micy, balsy, balsy...

My name is Peter, I'm a hemophiliac.

My name is Charles. I can't afford it.

➤ **Alka Seltzer/Meatballs**
Art Director: Roy Grace
Director: Howard Zieff
Writer: Evan Stark
Photographer: Ted Pahle
Producer: Lou Florence
Production Company: Zieff Films
Agency: Doyle Dane Bernbach
Client: Miles Laboratories

➤ **National Hemophilia Foundation**
Art Director/Designer: Bob Giraldi
Director: Steve Horn
Writer: Sara Bragin
Production Company: Horn/Griner
Agency: Della Femina,
Travisano and Partners
Client: National Hemophilia Foundation

Woman: It's only Wednesday.

Take along a Polaroid Colorpack II.

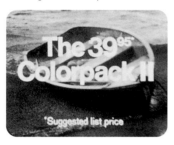

She: Our first homecooked meal.

He: I've never seen a dumpling that big.

➤ **Polaroid/Colorpack II**
Art Director/Designer: Robert Gage
Director: Robert Gage
Writer: Jack Dillon
Photographer: George Silano
Producer: Phil Bodwell
Production Company: Directors Studio
Agency: Doyle Dane Bernbach
Client: Polaroid

➤ **Alka Seltzer/Newlyweds**
Art Director/Designer: Robert Gage
Director: Robert Gage
Writer: Marvin Honig
Photographer: George Silano
Producer: Phil Bodwell
Production Company: Directors Studio
Agency: Doyle Dane Bernbach
Client: Miles Laboratories/ Alka Seltzer

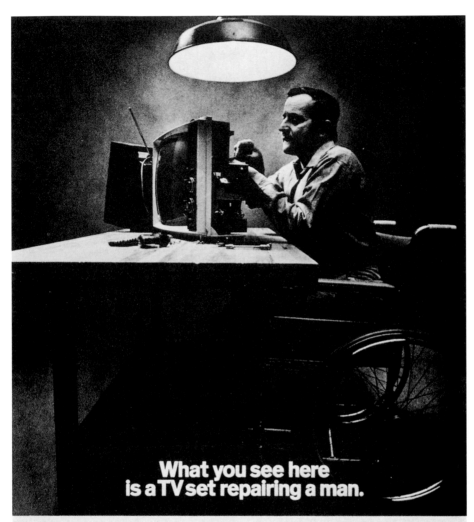

What you see here is a TV set repairing a man.

A broken TV set that seems to you like it's beyond repair isn't beyond doing a little repairing at Goodwill.

For, if it can help a handicapped man learn how to repair TV sets, it's helping him repair something far more important. Himself.

Last year, 25,000 of the handicapped people who came to Goodwill with nothing, left with a trade. (Anything from shoe repair to TV repair, from running a sewing machine to running a computer.) That's 25,000 more handicapped people who'll be able to stand on their own two feet. Not on anybody else's.

While part of the credit goes to the counseling, the training, the mental and physical therapy we supply, a large part of the credit goes to the broken TV sets, the outgrown clothing, the shoes, the dolls and the furniture you supply.

Now, here comes the pitch.

No, we're not going to hold you up for money. (But, don't think we wouldn't take it if you offered it to us.)

What we can use almost as much as your money are the still-usable things from your home or factory that you can no longer use.

After all, money can't do for a handicapped man what a broken TV set can.

Goodwill Industries

Goodwill Industries of America, Inc. 9200 Wisconsin Avenue Washington, D.C. 20014 (301) 530-6500

➤ **Goodwill Industries**
Art Director/Designer: Joe Genova
Copywriter: Neil Drossman
Photographer: Cailor/Resnick
Agency: Kurtz Kambanis Symon
Client: Goodwill Industries

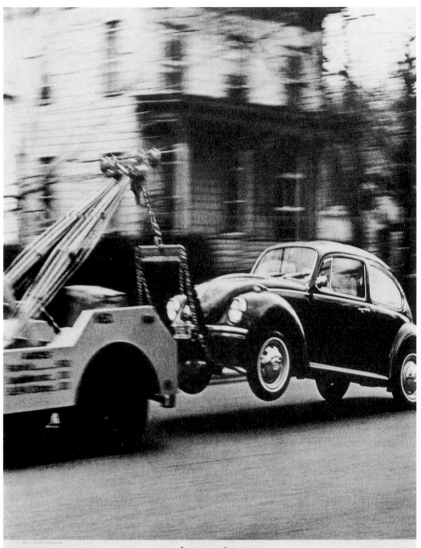

A rare photo.

You don't see too many pictures like this because we really never pictured ourselves this way.

For the past 23 years, while just about every other car company has been feeling the pulse of the nation and changing the looks of their cars accordingly, we've been fixing the inside of our little car just so you wouldn't have to have it fixed so often.

The result is that today, there's not one single part on a '71 Volkswagen that hasn't been improved at least once.

Recently, a top level executive from a big automotive firm summed up our position on the subject for us.

(And we quote.)

"Consumers today are more interested in quality, low cost of operation and durability, and less interested in styling, power and performance."

That's new top level thinking? Our top level thinkers have been thinking that way since 1949.

➤ **Volkswagen**
Art Director: Bob Kuperman
Copywriter: John Noble
Photographer: Dave Langley
Agency: Doyle Dane Bernbach
Client: Volkswagen of America

Coca-Cola
Art Director: Harvey Gabor
Director: Roberto Malenotti
Songwriters: William Backer, Billy Davis
Roger Cook, Roger Greenaway
Cameraman: Giuseppe Rotummo
Producer: Phil Messina
Production Company: Roma Films Service
Agency: McCann-Erickson
Client: Coca-Cola Co.

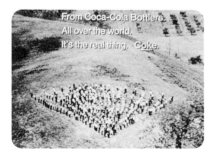

➤ **Fiat**
Art Director/Designer: Ralph Ammirati
Copywriter: Marty Puris
Photographer: George Gomes
Agency: Carl Ally
Client: Fiat

➤ **Crest**
Art Director: Sam Cooperstein
Copywriter: Ellen Massoth
Designer: Sam Cooperstein
Photographer: Phil Marco
Agency: Benton & Bowles
Client: Proctor & Gamble

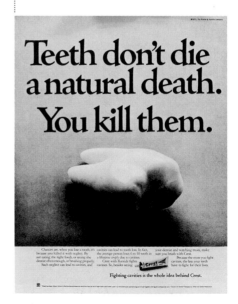

➤ **Xerox/Football**
Art Director: Jeff Cohen
Copywriter: Lester Colodny
TV Producers: Syd Rangell, Allen Kay, Lois Korey
Production Company: Richards & Myers Films
Agency: Needham, Harper & Steers
Client: Xerox

Football
90 seconds

THE DAY OF THE "BIG GAME"
LESS THAN TWO MINUTES TO GO: COACH IS TEARING HIS HAIR OUT
COACH (EXCITEDLY): All right now. Pressure's on. Two minutes to go. No. No. No. Kramer, you idiot. Whatever happened to the game play we talked about? Come on. Come on. Never mind the tarp. Make that block stick. No. No. No.

COACH LOOKS DOWN THE BENCH FOR A SUB. SPOTS THE LEAST LIKELY

Colodny . . .Colodny . . .Colodny. Quick, Colodny, this is critical. All right. This is R 78, power reverse. I've got to get this into the ballgame as soon as I can.

This is, Colodny, pay attention. This is as important as anything you're going to do for this club. Way to go, Colodny.

COLODNY DASHES UP TO XEROX IN LOCKER ROOM

ANNCR. (VO): Xerox is applying its technology to all phases of communication, whether it be in business, government, education, medicine, or even landing on the moon. At Xerox, we're working to find new ways of getting information to people who need it.

COACH: Here it is. Everyone gets one. Okay, here we go.

ANNCR.(VO): And most important. When they need it.

QUARTERBACK FLIPS TOWEL ON CENTER'S BACKSIDE, TUCKS IN XEROX PLAYERS PEER AT PLAYS ON GROUND, IN HAND, OFF TO THE SIDE, ETC.

QUARTERBACK:.....385.....384

BALL SNAPS BACK TO QUARTERBACK WHO HANDS IT TO BACK CARRYING HIS COPY, HANDS BALL TO END PAST GOAL LINE, END READS PLAY. MEANWHILE, OPPONENTS TACKLE WRONG PLAYERS. LONG PASS THROWN TO END, LOOKS UP FROM PLAY JUST IN TIME TO CATCH GAME WINNING PASS

SUPER: XEROX

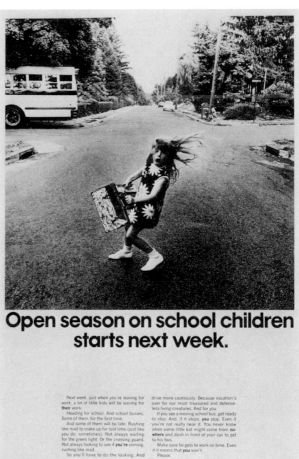

Open season on school children starts next week.

Next week, just when you're leaving for work, a lot of little kids will be leaving for their work.

Heading for school. And school busses. Some of them, for the first time.

And some of them will be late. Rushing like mad to make up for lost time (just like you do, sometimes). Not always waiting for the green light. Or the crossing guard. Not always looking to see if you're coming, rushing like mad.

So you'll have to do the looking. And drive more cautiously. Because vacation's over for our most treasured and defenseless living creatures. And for you.

If you see a moving school bus, get ready to stop. And, if it stops, you stop. Even if you're not really near it. You never know when some little kid might come from nowhere and dash in front of your car to get to his bus.

Make sure he gets to work on time. Even if it means that you won't.

Please.

Drive carefully. We want them to live.

Mobil.

➤ **Mobil**
Art Director/Designer: Lee Epstein
Copywriter: Hal Silverman
Photographer: Dave Langley
Agency: Doyle Dane Bernbach
Client: Mobil

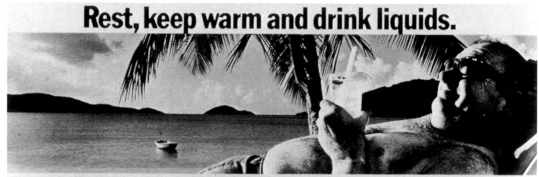

Rest, keep warm and drink liquids.

AMERICAN AIRLINES TO THE CARIBBEAN

➤ **American Airlines**
Art Director: Stan Jones
Writer: Dave Butler
Photographer: Carl Furuta
Agency: Doyle Dane Bernbach Los Angeles
Client: American Airlines

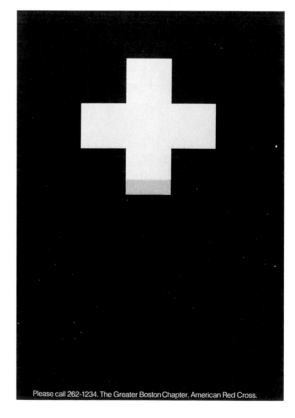

Please call 262-1234. The Greater Boston Chapter, American Red Cross.

➤ **Red Cross**
Art Director: Robert F. Baker
Copywriter: Robert F. Baker
Designers: Russ Veduccio, Robert F. Baker
Artist: Russ Veduccio
Agency: Harold Cabot
Client: Boston Red Cross Blood Donor Program

Engineering
60 seconds

SCENE TAKES PLACE IN A VOLVO FACTORY IN SWEDEN

OPEN ON CU OF PRECISION WORK BEING DONE BEFORE BLUEPRINT AND DIALS

MAN (VO): In Sweden precision is a national preoccupation.

CAMERA MOVES TO CORRIDOR WHERE ENGINEERS ARE ALL AT WORK

Ours is a nation of engineers. Engineering is the largest industry, employing nearly 40 percent of the total labor force.

CAMERA ROAMS FACTORY WITH VIEWS OF ENGINEERS AT WORK

MOVE TO CAR ON LIFT

(SFX: UNDER)

Thirty-five engineers to every styling, which shows where we put the emphasis. We have to, since Volvo is the largest selling car in Sweden a lot of our customers are engineers too.

CU MAN WORKING ON CAR

LONG VIEW OF CAR ON RACK

MAN AT CONTROL PANEL

VIEW OF VOLVO

VIEW INSIDE OF MECHANICAL MAN GIVING CAR A WORKOUT

(SFX)

Volvo. We build them the way we build them because we have to.

SUPER: VOLVO over tracks.

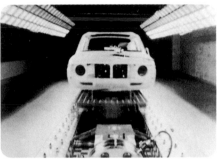

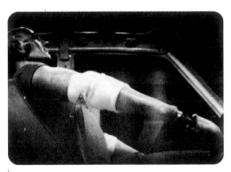

➤ **Volvo**
Art Director: John Danza
Copywriter: Edward A. McCabe
Director: Bo Widerberg
Producers: John Danza, Edward A. McCabe
Production Company: James Garrett & Partners
Agency: Scali, McCabe, Sloves
Client: Volvo Inc.

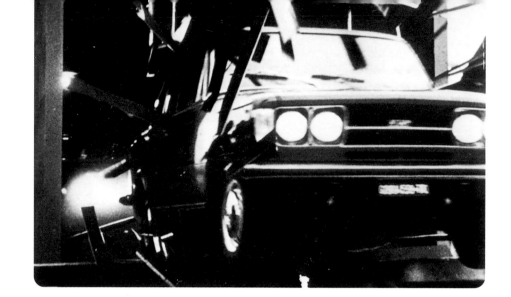

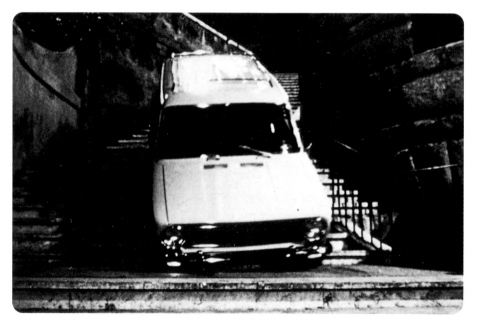

Fiat
Art Director/ Designer: Ralph Ammirati
Director: Giacomo Battiato
Writer: Marty Puris
Producer: Bob Schenkel
Production Company: Politecne Cinematografica
Agency: Carl Ally
Client: Fiat-Roosevelt Motors

Stunt Driver
30 seconds

Visuals show breathtaking ride through streets, down stairs and through
unmatchable hurdles.

(SFX)

VO: This is a man whose life depends on his car.
He's Remy Julienne, Europe's greatest living stunt driver.

(SFX)

In Europe, there are 50 different kinds of cars to choose from, yet in the more
than 100 films Remy Julienne has made, he's done more stunts in Fiats than
in any other car.

(SFX)

VO: And the Fiat he prefers above all is this one. The Fiat 124, a family car.

(SFX)

(Silent)

You're Big Enough to Dress Yourself
60 seconds

ANNCR: From the very beginning people have been dressing you. Your mother, your schoolmates, your country.

SERGEANT: You're out of uniform, soldier!

ANNCR: Even the clothing stores you shopped in.

YOUNG MAN: Don't you have something with just a little different look?

SALESMAN: Sir, that is the look.

ANNCR: Well, at Barney's, we think you're big enough to dress yourself, so when you come to Barney's you'll be able to choose from the widest range of American and international fashions in the world.

MAN: What do you think?

SALESMAN: What do you think?

MAN: Terrific!

ANNCR: Barney's. We let you be you.

➤ **Barney's**
Art Director: Louis Colleth
Director: Steve Horn
Writer: Michael Drazen
Production Company: Steve Horn
Agency: Scali, McCabe, Sloves
Client: Barney's Clothes

JEAN MARCELLINO

FORMERLY ART DIRECTOR OF LORD GELLER

FEDERICO EINSTEIN, J WALTER THOMPSON, WELLS

RICH GREENE, AND YOUNG & RUBICAM

THE GENDER THING

It is true that women have a better shot in advertising than they do in most professions. A casual glance around most agencies would reveal a fifty-fifty split between male and female juniors in most creative departments; maybe sixty-forty favoring males, not a lot more. But as you examine the corporate ladder, guess what? Let's see. There was Mary Wells a few decades ago. Helayne Spivack had a pretty good run for a few years. And, uhhhh. . . .

In view of the obvious inequalities that exist throughout the business, it may be difficult for a new writer or art director to grasp how enormously things have improved. Upon graduation from Cooper Union in 1960, I had two job offers. One was an opportunity to work in the matte room of a new agency called Doyle Dane Bernbach for a paltry sixty dollars a week. Then, there was the chance to be an assistant art director at an almost all-female shop called Ovesey & Strauss, which paid the phenomenal weekly salary of ninety dollars. With stunning foresight, I went for the big bucks. As you might have guessed, the agency specialized in fashion, mainly children's fashion. The owner was a petite, charming woman who wore hats and gloves and smoked a jeweled pipe. Actually, all of the "important" women wore hats all day long. If a secretary had dared to wear one, she would surely have been cast a suspicious glance because somehow one knew without actually being told that this particular prop carried a decidedly hierarchical message. Of course, in those days copy was delivered to the art director "under the door," except in that hot new agency (where matte-room serfs were paid a paltry sixty dollars per week) and a revolution was in the making.

By the time I switched jobs in 1965 and went to CBS/Columbia Records' advertising department, Doyle Dane Bernbach's radical new idea of the "creative team," an equal partnership between writer and art director, had taken hold in most agencies. Columbia Records grasped the basic concept, but, since our duties included designing album covers, labels, and other music-biz paraphernalia, words were often irrelevant to our projects and the art directors considered them to be an added extra. Consequently, we worked with writers when ads were being developed but not as dedicated partners on a full-time basis.

This was a very exciting time for me. Nothing could beat the "eureka" effect which sometimes took hold when a magnificent idea magically presented itself and writer and art director could share the fleeting suspicion that they were, in fact, geniuses. Unfortunately, these moments didn't happen as regularly as I might have preferred, but they were frequent enough to convince me that I was a participant in the most thrilling occupation on earth.

As to the gender thing, yes, I was one of two female art director/designers in a department of twelve people. But, truth be told, I was having such a good time that I barely noticed. The other woman had been my best friend since we were freshmen at Cooper, another contributing factor to my happy days at Columbia Records. Like so many young people in this profession, we labored hard and long, but with a sense of joy. After a while, my friend left to take a job at one of the biggest ad agencies in New York, where she was assigned to the Tampax account. I was surprised

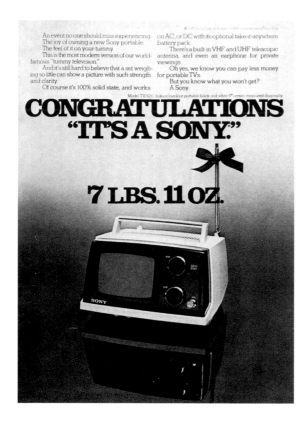

An event no one should miss experiencing.
The joy of owning a new Sony portable.
The feel of it on your tummy.
This is the most modern version of our world-famous "tummy television."
And it's still hard to believe that a set weighing so little can show a picture with such strength and clarity.
Of course it's 100% solid state, and works

on AC, or DC with its optional take-it-anywhere battery pack.
There's a built-in VHF and UHF telescopic antenna, and even an earphone for private viewings.
Oh yes, we know you can pay less money for portable TVs.
But you know what you won't get?
A Sony.

Model TV-520. Indoor/outdoor portable black and white 5" screen measured diagonally

CONGRATULATIONS "IT'S A SONY."

7 LBS. 11 OZ.

➤ **Sony**
Art Director: John Caggiano
Writer: Marvin Honig
Designer: John Caggiano
Photographer: George Hausman
Agency: Doyle Dane Bernbach
Client: Sony

➤ **Perdue**
Art Director: Sam Scali
Writer: Edward A. McCabe
Photographer: Phil Mazzurco
Agency: Scali, McCabe, Sloves
Client: Perdue Farms

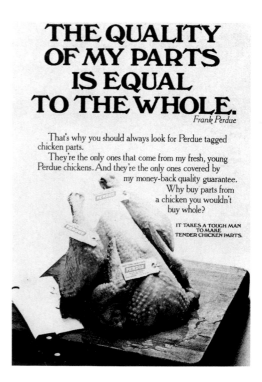

THE QUALITY OF MY PARTS IS EQUAL TO THE WHOLE.
Frank Perdue

That's why you should always look for Perdue tagged chicken parts.
They're the only ones that come from my fresh, young Perdue chickens. And they're the only ones covered by my money-back quality guarantee.
Why buy parts from a chicken you wouldn't buy whole?

IT TAKES A TOUGH MAN TO MAKE TENDER CHICKEN PARTS.

when she told me that the other female creatives there, all writers, worked exclusively on detergents, cosmetics, baby foods, and other such products—and that she herself was now known as the "lady art director." But then, this was the 1960s. Sexism was an unknown concept.

Like most creative departments, ours at Columbia Records was presided over by a creative director. Next in line was the associate creative director, a position which had always been filled from within the department on the basis of seniority. Both were from the art side, since so many of our projects were skewed towards the visual rather than the verbal. I was flattered when my boss introduced me to people as the "workhorse of the department," adding that I did the work of any two. In addition, since I was the only art director who was starting to win creative awards, I felt confident that my efforts were appreciated—quantity and quality.

After a couple of years, an odd thing happened. The associate creative director decided to move on, leaving an opening for the first time since I'd been on staff. I now had departmental seniority (not to mention quantity and quality), but in the wink of an eye the position was filled by a nice young guy who'd started several months after I did. I was a bit befuddled. Maybe it was a clerical error; they'd confused our starting dates. Or maybe I wasn't as good as I'd sometimes dared to think. After awhile an even odder thing happened.

There were still twelve art director/designers—eleven men and me. Occasionally we would go out to a restaurant without the bosses after work on Friday night. Once during the winter holiday season we were all feeling particularly chipper, which led to a greater than usual consumption of alcohol. Our loosened tongues propelled us toward a subject of conversation, which was, and remains, universally taboo. Dare I say it? Our salaries. We all confessed them. And guess what? Not only was I the lowest-paid person in the department, but the next lowest salary was fifty percent more than mine. I was sober enough to be devastated and finally determined to confront the creative director.

"I can't tell you how I found this out," I blurted, "but it's come to my attention that I'm the lowest paid person in the department," quickly adding a condensed list of my victories and accomplishments. He cleared his throat. "Jean," he said with a tone of gravity, "did you know that Steve's wife is pregnant again? That Morty is over his head with two mortgages? This department has a fixed budget for salaries. When I give to one person, I have to take from someone else. Jean, you're a single woman. If I gave you more money, what would you do with it? Buy more clothes?" Talk about speechless. I was stunned—by the degree of my own selfishness. Steve's cute little kids! I sheepishly left his office and retreated to my own, trying to make sense of it all. There was one co-worker with whom I'd become friendly enough to confide, so I plopped down in his visitor's chair and told him the whole story. He looked at me with great sympathy and said, "I think you may have penis envy."

As you might guess, my career at Columbia Records deteriorated from that point on. Doing as little as possible became my primary goal. Each

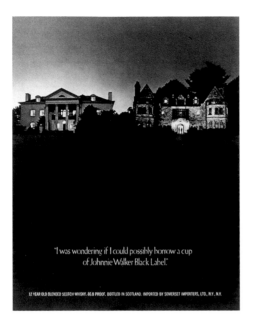

"I was wondering if I could possibly borrow a cup
of Johnnie Walker Black Label."

12 YEAR OLD BLENDED SCOTCH WHISKY. 86.8 PROOF. BOTTLED IN SCOTLAND. IMPORTED BY SOMERSET IMPORTERS, LTD., N.Y., N.Y.

➤ **Johnnie Walker Black**
Art Director: Stuart Pittman, Faith Popcorn
Writer: Murray L. Klein
Photographer: Michael O'Neill
Agency: Smith/Greenland Co.
Client: Somerset Importers

A VOLVO DISCOVERY: RAIN FALLS ON REAR WINDOWS, TOO.

Volvo is the only wagon maker with the foresight to provide its rear window with a wiper and washer as standard equipment.

Volvo has also discovered that everyone doesn't buy a wagon to be fashionable. Many people buy wagons to carry things.

So we didn't design Volvo's cargo area low and sleek to accommodate a styling trend. We designed it high and practical, to accommodate things like a six-foot sofa and two chairs (with the rear seat down). Or three six-foot people and 12 two-suiters (with the rear seat up).

Volvo's rear area not only holds a lot, it comes with a lot. It has its own heating and ventilation vents, its own three-point seat belts, electric rear window defogger, carpeting, tinted glass and childproof door locks.

And Volvo's back door swings up out of your way, instead of out into your stomach. Or down into your knee caps.

It doesn't take a college degree to appreciate the thinking behind our wagon. So we leave you to consider this. If the rear end of your car isn't as well thought out as Volvo's, what other part might not be?

VOLVO
The wagon for people who think.

RP-7902 245 DL VOLVO

➤ **Volvo**
Art Director: Robert Reitzfeld
Writer: Thomas J. Nathan
Photographer: Henry Sandbank
Agency: Scali, McCabe, Sloves
Client: Volvo of America

day I'd shut my door, listen to music, and hope no one would bother me with all that work nonsense. True, my zest for advertising had greatly diminished, but it never occurred to me that quitting was an option. Who could leave a job that everybody in America would envy me for? On any given day I might see, or even talk to, Simon and Garfunkel, Bob Dylan, or Janis Joplin. Everybody in the world of graphic design would kill to work at CBS. But eventually I did quit. In 1969 it was not unusual for a woman to leave a job "to get married." When I told my boss, he became the old philosopher, assuring me that women were really most fulfilled as wives and mothers. Honestly, the man must have been more than a bit relieved to see the last of me, since my work habits had become abysmal.

Although I barely noticed, sometime in the 1970s Women's Lib happened. I wasn't there but I know it took place because when I returned to the work force in 1977 the world was a different place. There were women everywhere who were well paid, taken seriously, and promoted.

In 1980 I had the good fortune to land a job in the ad agency of my dreams, Lord Geller Federico Einstein. All that joie de vivre returned, and once again advertising was the most thrilling occupation on earth. I was hired to work on Avon Paperback Books, but it was understood that after a year I'd have the chance to switch to another account. True, I was offered Vassarette lingerie, but I finally understood that the "girl ghetto" was no place for me. I turned it down. To my astonishment, the creative director suggested IBM.

More often than I like to admit, I'm silently engaged in a diatribe against my old boss at Columbia Records. What I should have said has been perfected to near-poetry: "Who in this country is paid on the basis of need? Does the janitor with six kids earn more than the CEO without any? Who besides Karl Marx might think this would be a workable idea?"

For the past twenty years I've worked in a number of agencies on lots of accounts, from Dippity-Doo to Caterpillar Tractors. Fortunately my enthusiasm for the creative process has never again taken a dive. Everywhere I go, I see successful women in positions of increasing power, many of them as partners in their own shops. And yet, there's no denying it, the creative upper echelons of mainstream companies are largely female-free.

"Where are the women?" A good guess is that my generation of female advertising talent remained in the office with the door shut or never reentered after all that wifely/motherly fulfillment. Or, if they did return, they missed out on the crucial years when TV commercials became an art form and the computer revolutionized the mechanics of how we work.

But women can hardly be confined to their offices or relegated to working on "female" accounts for detergents and baby food. My favorite categories to work with are finance and technology, hardly bastions of traditional female expertise. When women are hired, compensated, and promoted on the basis of our abilities, without bias, there can be no doubt that we will occupy the tops of at least half of all those corporate ladders.

➤ **Xerox**
Art Director: Allen Kay
Director: Neil Tardio
Writer: Steve Penchina
Producer: Syd Rangell
Production Company: Lovinger, Tardio, Melsky
Agency: Needham, Harper & Steers
Client: Xerox

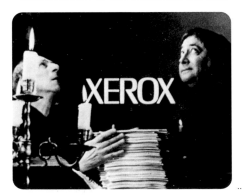

Monks
90 seconds

MUSIC UNDER: (Baroque)

ANNCR: Ever since people started recording information, there's been a need to duplicate it.

FATHER: Very nice work, Brother Dominick.

BROTHER: Thank you

FATHER: Now, I'd like 500 more sets!

BROTHER: (muttering painfully) 500 more sets?

STEPHENS: Brother Dominick, what can I do for you?

MONK: Could you do a big job for me?

ANNCR: Xerox has developed an amazing machine that's unlike anything we've ever made. The Xerox 9200 Duplicating System. It automatically feeds and cycles originals, has a computerized programmer that coordinates the entire system, can duplicate, reduce, and assemble a virtually limitless number of complete sets, and does it all at the incredible rate of 2 pages per second.

BROTHER: Here are your sets, Father.

FATHER: What?

BROTHER: The 500 sets you asked for.

FATHER: It's a miracle!

SUPER: Xerox

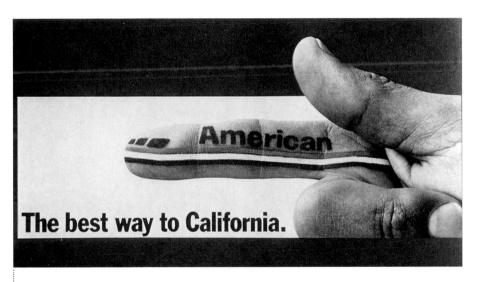

The best way to California.

➤ **American Airlines**
Art Director/Designer: Bill Bartley
Writer: David Butler
Artist: Jay Flammer
Photographer: Peter Sagara
Agency: Doyle Dane Bernbach
Client: American Airlines

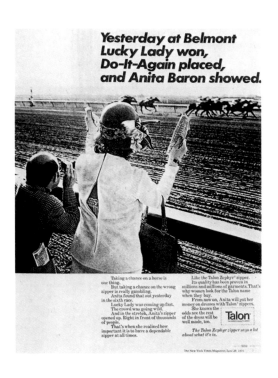

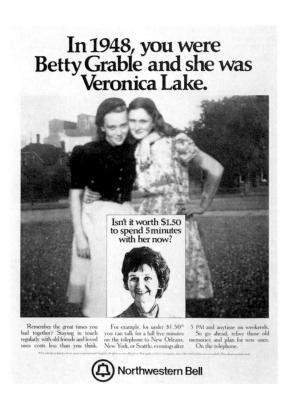

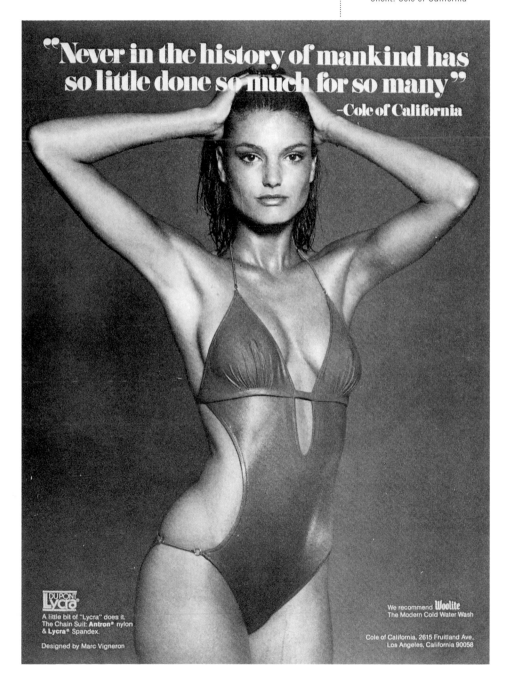

➤ **Dannon Yogurt**
Art Director: Joe Goldberg
Writer: Peter Lubalin
Photographer: Bob Gaffney
Agency: Marsteller
Client: Dannon Yogurt

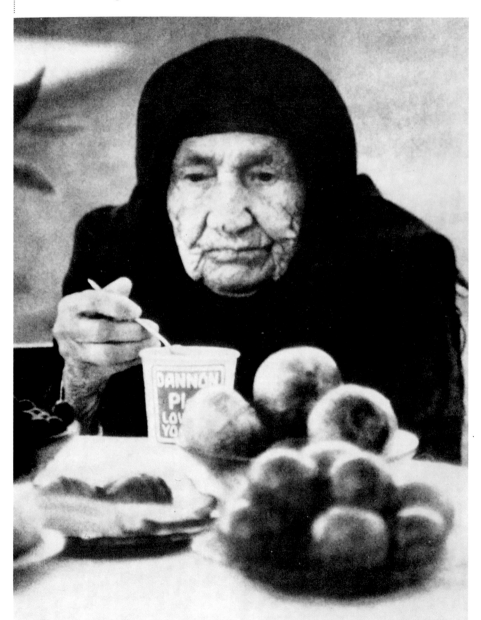

One of Soviet Georgia's senior citizens thought Dannon was an excellent yogurt. She ought to know. She's been eating yogurt for 137 years.

➤ **Steinway & Sons**
Art Directors: Cathie Campbell, Sirje Helder
Writer: Charles Griffith
Photographer: Dave Langley
Agency: Lord, Geller, Federico
Client: Steinway & Sons

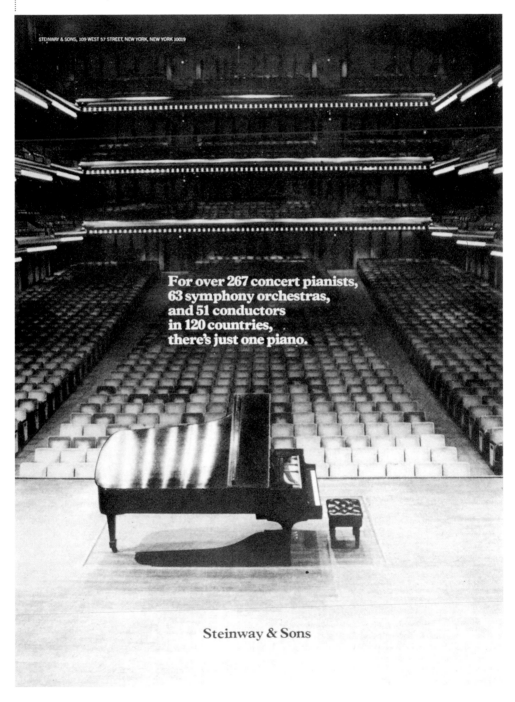

Spritzer
30 seconds

SFX: FOOTSTEPS DOWN THE HALL

MAN: Spritzer that package you sent to Albuquerque last night didn't get there. Spritzer, you're in big trouble Spritzer!

ANNCR: Next time, send it Federal Express

➤ **Federal Express**
Art Director: Michael Tesch
Director: Joe Sedelmaier
Writer: Patrick Kelly
Production Company: Sedelmaier Productions
Agency: Ally & Gargano
Client: Federal Express

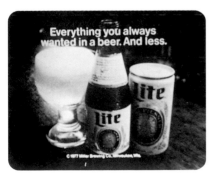

> **Miller Lite Beer/ Bubba Smith**
> Art Director: Bob Engel
> Director: Bob Giraldi
> Writer: Charlie Ryant
> Agency Producer: Bob Engel
> Production Company: Bob Giraldi Productions
> Agency: McCann-Erickson
> Client: Miller Brewing Co.

➤ **Volkswagen**
Art Director/Artist: Charles Piccirillo
Writer: Robert Levenson
Agency: Doyle Dane Bernbach
Client: Volkswagen of America

Listen to the people who work for you, who work alongside of you. (Listen to me!) Listen to the guy you never met, who's sitting next to you at the singles bar. Listen to those two old ladies talking on the Madison Avenue bus. Go to concerts. Listen to music and to those loud noises your teenage kids call music. Listen to your spouse. Of all the keys to creativity, the ability to listen may be the most valuable. Too often we fail to know someone's true needs, because we're not really listening. A good creative person removes the filter and even hears what is said between the lines. I call that "perceptive" listening—listening to the telegraphed message, to the sound of another man's frustrations and fears, to the sound of his hopes and unfulfilled dreams. A good listener is not only popular everywhere, but after awhile he knows something. So listen.

● ● ● ● ● STEVE FRANKFURT

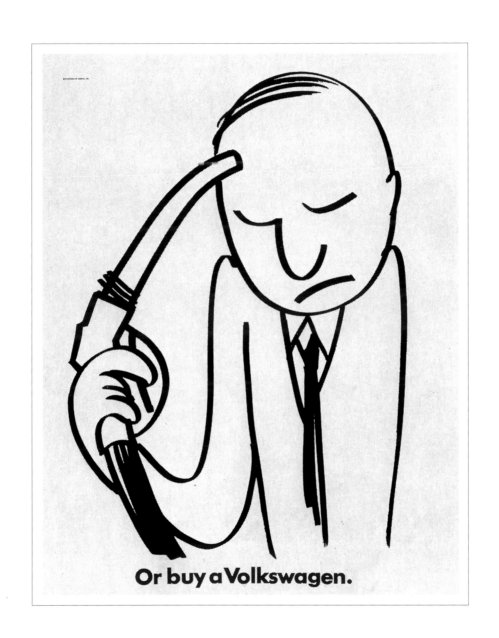

Or buy a Volkswagen.

"As the pace of life in the 1980s seemed to increase to warp speed, speed itself became a dominant motif."

The 1980s: Advertising in the Age of Rampant Consumerism

Advertising usually reflects in some way or another the history and events of its era. The 1980s were no exception. It was a tumultuous decade, and the work produced during that time was, in many ways, reflective of the decade's events—cultural, political, environmental, and financial. The 1980s have frequently been labeled "the decade of greed," and while there is a measure of truth in this label, it falls short of an accurate portrait. Many issues beyond money shaped this decade. To refresh your memory, here, in capsule and quick-cut form, are the events that formed the 1980s and influenced advertising thinking.

In 1980, the U.S. Olympic hockey team beats the USSR, and in 1981, Ronald Reagan is inaugurated, marking Russia's fading fortunes in the closing days of the Cold War. The savings-and-loan industry expands and then ruptures. AIDS begins to stake its claim on thousands of lives. MTV is launched. New technologies infiltrate our daily lives: fiber optics, satellite communications, cable TV, ATMs, microwave ovens, CDs, not to mention designer underwear for men. IBM and Macintosh compete to bring personal computers into thousands of homes, planting the seeds for an infomation revolution.

Acid rain, global warming, hazardous waste, ozone depletion, and asbestos poisoning become environmental buzzwords. The Supreme Court moves in favor of abortion rights and reaffirms *Roe v. Wade*. Materialism makes a comeback and money seems to be everywhere, from power suits to five-hundred-dollar briefcases to "Beemers." Tom Wolfe's *Bonfire of the Vanities* captures the New York money scene as does Oliver Stone's *Wall Street*. Donald Trump perfects the art of the deal, and Ivan Boesky tells us "greed is healthy," only to eat his words. Real estate and stocks soar—until October 1987.

Japan asserts its influence over global trade, real estate, money markets, and Van Goghs. Los Angeles is the place to be, but TriBeCa, Aspen, and Sagaponack aren't far behind. Torn clothes are suddenly in and breakdancing breaks out during the seminal days of hip-hop.

It was also a time of contrasts. The gulf between the very rich and the

just-getting-by seems to grow: People are mesmerized by Robin Leach's *Lifestyles of the Rich and Famous* while airlines like People Express pioneer no-frills flying. The Challenger crashes and burns, yet still inspires; John Belushi crashes and burns and fails to inspire. Hollywood trades heavily in sentiment (*E.T.*), cynicism (*Hannah and her Sisters*), nostalgia (*The Big Chill*), and candor (*Sex, Lies, and Videotape*). Rambo and Conan the Barbarian become knights for one audience, nightmares for another. Television evangelist Jim Bakker is jailed for fraud and never makes up with wife Tammy Faye, who is just made up. Cabbage Patch dolls become surrogate children while real surrogate mothers begin to conceive other people's babies. The first woman walks in space, and a woman designs the Vietnam Memorial.

These are a few of the events that, in some way or another, scripted the adverstising of the 1980s, and just as cultural and social trends shifted and emerged, so did some broad themes in advertising.

As the pace of life in the 1980s seemed to increase to warp speed, speed itself became a dominant motif. Federal Express reflected life's more frenetic schedule with television spots like the "fast-talker." A salesman-type business guy is speaking into multiple phone receivers at an impossible, supersonic rate. It was not only viscerally funny and entertaining, it was conceptually inspired.

In response to the series of scandals surrounding televised evangelism, the Episcopal Church got into the ad business and launched a campaign of bold and disarming ads that encouraged a renewed commitment to Christ. On the one hand we had evangelistic fervor, on the other a religious re-awakening.

In an equally memorable series of ads launched at about the same time, Planned Parenthood revitalized the pro-choice movement with an extremely effective print campaign. One ad showed a photo of a stately looking man in a suit lying in bed between a couple. The headline read: "The decision to have a baby could soon be between you, your husband, and your Senator."

Innovations went beyond print and television. In this time of rampant consumerism and materialism, New York's Bloomingdale's department store issued unique and visually arresting shopping bags, sending customers out of the store as walking advertisements and starting a trend in, yes, designer shopping bags.

Raging consumerism reached new heights when Nike picked up on street vibes and began marketing their big-ticket athletic shoes as status badges. Who would ever have imagined a pair of sneakers selling for a hundred dollars or more? The ads were fresh, bright, and represented a breakthrough in marketing innovation. They almost single-handedly started a sneaker revolution, and they capitalized on the street-savvy attitude permeating popular culture—with a little help, of course, from the likes of Bo Jackson and, later, Michael Jordan.

On a broader front, the gas crunch of the late 1970s was still sending repercussions, in the form of high pump prices, into the early 1980s. Accordingly, Volkswagen ran a newspaper ad with a whimsical drawing of a man holding a gas nozzle up to his temple. It simply said: "Or buy a Volkswagen." It was smart, simple, and direct.

While high flying Wall Street played a prominent part in the decade. John Hancock Financial Services brought us back to reality with facts-of-life ads encouraging the sound managment of real life personal finances.

There was also comic relief. The NYNEX Yellow Pages campaign, for example, blended its listings with ingenious visual puns. Under a listing for furniture stripping, we see an upholstered chair do a burlesque act with appropriate bump-and-grind music. It was funny, wacky, and memorable.

Another of the great publishing campaigns occured when *Rolling Stone* magazine revamped its stuck-in-the-sixties image with a series of brilliant "perception/reality" ads that redefined the product and ushered the publication into the current day.

But if there was one piece of advertising—and one product, for that matter—that reflected its own era and prefigured the one yet to come, it was a television spot for Apple Macintosh called "1984." It ran once during that year's Super Bowl, and anyone who saw it would be hard-pressed to forget it. It was one of the first mega-productions that actually was worth the money, and it legitimized big production budgets from that day on. Unlike many mega-ads that followed, however, this one had a fantastic concept. From that day forward the Super Bowl became televised advertising's premier forum to show its wares—and since then, many people have not-so-secretly admitted that they now tune in mainly for the commercials.

What follow are my suggested picks for the best advertising of the

••••• 1980s, but I inevitably feel compelled to single out a few campaigns that didn't make the list but still merit a mention here for their influence on the industry and culture—namely, Wendy's "Where's the beef?" ads, the Absolut Vodka print campaign, The Partnership for a Drug-Free America's "This is your brain on drugs" series, the California Raisins claymation characters, and Miller Lite's "More taste! Less filling!" campaign.

My criteria for the selections that follow were based not only on an ad's intrinsic conceptual and technical excellence but also on its influence on cultural trends and on the future of the industry. Our country and our culture during the 1980s underwent profound change on many levels—changes that were perhaps less drastic and less hyped than those of the 1960s but that had an equally significant effect on our collective outlook on life, politics, and entertainment. Advertising, as never before, played an integral part in these transformations, responding to and sometimes dictating the paths our commercial culture would take.

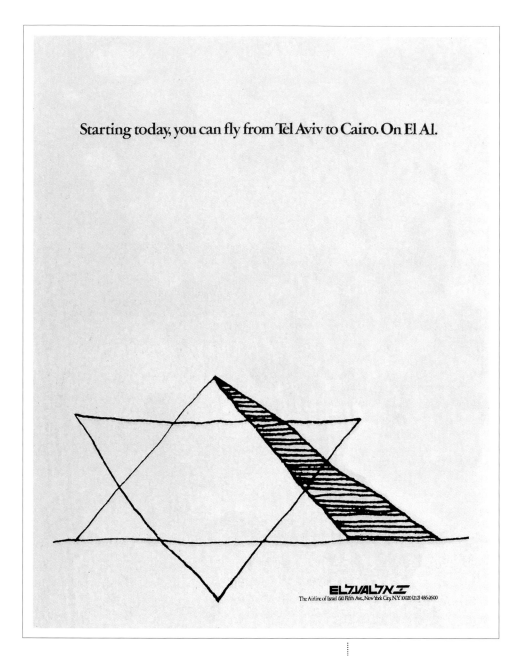

Starting today, you can fly from Tel Aviv to Cairo. On El Al.

EL AL
The Airline of Israel 610 Fifth Ave, New York City, N.Y. 10020 (212) 486-2600

➤ **El Al Airlines**
Art Director/Artist: Joan Niborg
Writer: Leah Gans
Agency: DDB Group Two
Client: El Al Airlines Ltd.

> **Maxell**
> Art Director/Designer: Lars Anderson
> Director: Henry Sandbank, Inc.
> Writer: Peter Levathes
> Editor: Dennis Hayes
> Producer: Dane Johnson (Scali, McCabe, Sloves)
> Production Company: Sandbank Films
> Agency: Scali, McCabe, Sloves
> Client: Maxell Corporation of America

500 plays
30 seconds

SFX: FOOTSTEPS

BUTLER: The usual sir?

COOL GUY: Please.

ANNCR (VO): Even after 500 plays our high fidelity tape. . .

SFX:CLICK

. . . still delivers high fidelity.

SFX: WAGNERIAN MUSIC BUILDS AND EXPLODES

VO: Maxell. It's worth it.

When it absolutely, positively has to be there overnight.

Areas served, delivery times, and liability subject to limitations in our Service Guide.

➤ **Federal Express**
Art Director: Michael Tesch
Writer: Patrick Kelly
Editor: Peggy DeLay
Director: Joe Sedelmaier
Producers: Maureen Kearns,
 Ann Ryan
Agency: Ally & Gargano
Client: Federal Express

Fast Paced World
60-second

MR. SPLEEN (OC): Okay, Eunice, travelplans. IneedtobeinNewYorkonWednesday, LAonThursday,NewYorkonFriday.Gotit?

EUNICE (VO): GOT IT.

MR SPLEEN (OC): Soyouwanttoworkhere,wellwhatmakesyouthinkyoudeserveajobhere?

GUY: Well,sirIthinkonmyfeet,I'mgoodwithfiguresandhaveasharpmind.

SPLEEN: Congratulations,welcomeaboard.

(SFX)

OC: Wonderful,wonderful,wonderful.AndinconclusionJim,Bill,Bob,Paul,Don, Frank,andTed. Businessisbusinessandweallknowinordertogetsomethingdone you'vegottodosomething.Inordertodosomethingyou'vegottogettoworksolet'sallgettowork.
Thankyouforattendingthismeeting.(SFX)

OC: Peteryoudidabang-upjobI'mputtingyouinchargeofPittsburgh.

PETER (OC): Pittsburgh,perfect.

SPLEEN: Iknowit'sperfectPeterthat' whyIpickedPittsburgh.Pittsburgh'sperfectPeter.MayIcallyouPete?

PETER: CallmePete.

SECRETARY (OC): There'saMr.Snitlerheretoseeyou.

SPLEEN: Tellhimtowait15seconds.

MAN: I'llwait15seconds.

SPLEEN (OC): CongratulationsonyourdealinDenverDavid.I'mputtingyoudowntodealinDallas.Donisitadeal?Dowehaveadeal?It'sadeal.Ihaveacallcomingin...

ANNCR (VO): Inthisfastmovinghighpressure,get-it-doneyesterdayworld.
VO: Aren'tyougladthatthere'sonecompanythatcankeepupwithitall?

SPLEEN (OC): Dickwhat'sthedealwiththedeal.Arewedealing?We'redealing. Daveit'sadeal withDon,DorkandDick.Dorkit'sadealwithDon,DaveandDick. Dickit'saDorkwithDonDealandDave.Dave,gotago ,disconnecting.Dorkgottago, disconnecting. Dickgottago,disconnecting...

ANNCR (VO): Federal Express. (SFX) When it absolutely, positively has to be overnight.

> **IBM**
> Art Director: Bob Tore
> Creative Director: Tom Mabley
> Director: Dick Loew, Gomes Loew
> Writers: Tom Mabley, Arlene Jaffe
> Editor: Allen Rozek
> Production Company: Gomes Loew
> Agency: Lord, Geller, Federico, Einstein
> Client: IBM

Bakery
30 seconds

(MUSIC)

Gary Merrill (VO): If you run a small business, profits can get squeezed when inventory doesn't match up with production. What you need is a tool for modern times. The IBM Personal Computer—not only can it help you plan ahead, it'll balance your books and give you more time to make dough.

And the cost?

That's the icing on the cake.

Your own IBM Personal Computer. Try it at a store near you.

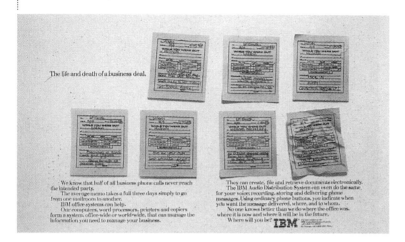

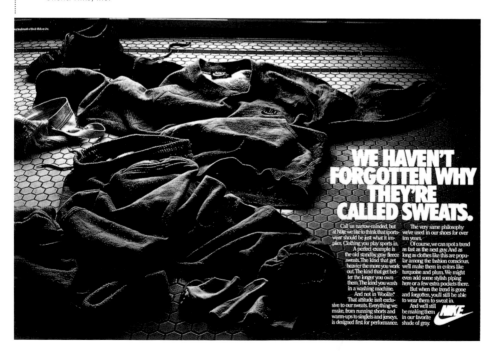

➤ **Planned Parenthood**
Art Director: Tana Klugherz
Writer: Deborah Kasher, Lee Garfinkel
Photographers: Manuel Gonzalez, Larry Robins
Client: Planned Parenthood
Agency: Levine, Huntley, Schmidt & Beaver

THE DECISION TO HAVE A BABY COULD SOON BE BETWEEN YOU, YOUR HUSBAND AND YOUR SENATOR.

ABORTION IS SOMETHING PERSONAL NOT POLITICAL.

**Drinking and Driving Can Kill a Friendship/
The Ad Council**
30 seconds

When friends don't stop friends from drinking and driving (SFX) friends die from drinking and driving.

(SFX) Drinking and driving can kill a friendship.

DRINKING AND DRIVING CAN KILL A FRIENDSHIP

➤ **DRINKING AND DRIVING**
Art Director: Len Fink
Writer: Lou Linder
Agency Producer: Herbert A. Miller/Leber Katz Agency Partners, New York
Director: Phil Marco
Director of Photography: Phil Marco
Editor: Larry Plastrick
Production Company: Phil Marco Productions, Inc.
Client: The Advertising Council National Highway Traffic Safety Administration

If you think being a Christian is inconvenient today, just look back 1500 years.

If you're ready to make the time and commitment that being a Christian sometimes requires, the Episcopal Church invites you to come and join us in the worship and fellowship of Jesus Christ.

The Episcopal Church

➤ **The Episcopal Church**
Art Director/Designer: Nancy Rice
Writers: Tom McElligott
Artist: Art Simmons
Agency: Fallon McElligott Rice
Client: The Episcopal Ad Project

Whose birthday is it, anyway?

The Episcopal Church believes the important news at Christmas is not who comes down the chimney, but who came down from heaven. We invite you to come and join us as we celebrate the birth of Jesus Christ.
The Episcopal Church

➤ **The Episcopal Church**
Art Director/Designer: Nancy Rice
Writers: Tom McElligott
Artist: Art Simmons
Agency: Fallon McElligott Rice
Client: The Episcopal Ad Project

Nike/ Carl Lewis/Moses/Joanie
30 seconds

CARL: My first jump was a joke, nine feet even, but I said to myself "don't give up." In high school, I kept coming in second. I could have called it quits but I believe you should never give up. When that's your philosophy, there's no telling how far you can go.

➤ **Nike**
Art Director: Gary Johns
Director: Bob Giraldi
Writer: Jeff Gorman
Editor: Charlie Chubak
Producer: Ralph Cohen
Agency: Chiat Day/ Morty Baran
Client: Nike, Inc.

The Ten Best Things in Advertising (Count 'em!)

You have ten fingers and ten toes. Good things come in tens. Therefore, since I've been asked to write about the best things in advertising, I'll give you my personal "handful;" ten things about the business that still get me up in the morning.

1. THE INDUSTRY WHERE ART MEETS COMMERCE.
People, usually under the age of twenty-five, often adopt the pose of a starving artist. This, alas, only works for the first year after college; I have rarely seen anyone, artist or otherwise, embrace creative poverty. Everyone, sooner or later, wants a paycheck. Advertising often allows one to feel like an artist yet live like an investment banker.

2. GET PUBLISHED—TODAY!
Faulkner couldn't hack it as a copywriter. He was too busy struggling over those damn words. Why sit in a freezing garret sipping absinthe and going mad when you can see your genius in print, *aujourd'hui*! Client and agency deadlines will force the Peter Principle out of any procrastinator or perfectionist. And that means every brilliant pearl or design idea can end up in the newspaper before you can say "deadline."

3. SEE THE WORLD ON SOMEONE ELSE'S NUT.
People in advertising complain about red-eye flights or bemoan that week shooting in Budapest or Prague, far away from friends, family, and the corner bar. Secretly, they are dancing inside, because they're able to do a post–Iron Curtain teen tour and expense it! Show me a forlorn creative or account type staying in a youth hostel, and I'll buy them a fanny pack as a going-away present.

4. MEET YOUR FAVORITE SUPERMODEL.
Do you like Cindy, Christy, or Marcus? Whatever your proclivity, all you have to do to live out your fantasy life is cast your favorite crush. The client may not understand why Linda needs to be in that mutual fund ad, but you'll find a way to explain it, won't you?

5. JOIN THE CLEAN-PLATE CLUB.
Let's face it, if you want to diet go into retail. For those of us who love food, advertising is the place to be. Whether it's drowning your sorrows with your liquor client or scamming free Chinese takeout and M&Ms at a focus group, *mangia!* Calista Flockhart would never last a day on Madison Avenue.

6. WARDROBE IT!
Try, just try, wearing that Gucci or Prada number at an insurance company. Need I say more?

1984
60 seconds

For today we celebrate the first glorious anniversary of the Information Purification Directives. We have created, for the first time in all history, a garden of pure ideology, where each worker may bloom secure from the pests of contradictory and confusing truths. Our Unification of Thought is more powerful a weapon than any fleet or army on earth. We are one people. With one will. One resolve. One cause. Our enemies shall talk themselves to death and we will bury them with their own confusion. We shall prevail.

➤ **Why Vote?**
Art Director: Jerry Roach
Creative Art Director: John Ferrell
Writer: Joe Lovering
Agency: Young & Rubicam
Client: Young & Rubicam

➤ **Apple Computer**
Art Directors: Brent Thomas, Lee Clow
Director: Ridley Scott
Writer: Steve Hayden
Editor: Pam Powers
Producer: Richard Goldberg
Production: O'Neill Production Co.
Agency: Chiat Day
Client: Apple Computer

7. PUNCH A TIME CLOCK, HA!

We all know that tumbleweeds roll through most ad agencies at nine in the morning. Of course everyone is breaking their backs working nights and weekends, but they're also working it around their pilates, yoga, and therapy sessions. *Om shantih.*

8. THROW A TANTRUM.

In what other industry is it permissible not only to throw a "hissy fit" but to have people actually relate to it? Act this way in a post office, and they'll haul you away. Client or agency got you down? How about slamming your door, stamping your foot, throwing an ashtray, or threatening not to show up. Chances are someone will see it exactly as you do and offer to calm you with cigarettes, a walk in the park, or a shoulder to cry on.

9. GET TO THE TOP OF YOUR PROFESSION BEFORE YOU'RE PHYSICALLY MATURE.

I don't know about you all, but Clearasil is still on my shopping list. Yesterday, I met a creative director who was just graduating from Dalton. She has no experience but comes with a twenty-million-dollar account. She's hired!

10. FUND YOUR SCREENPLAY WITH AD DOLLARS.

Fund your Web site. Fund your band. Fund your trip to Bali. Fund your documentary. Fund your directing career. Fund your new reel. Fund titles for your new reel. Fund your Hampton's share. Screw the Hampton's, fund your theater company. Fund your new free-lance network of Web site developers/writers/directors—the new agency paradigm for the twenty-first century. (I have news for you, you'll be back.)

So there you have it, my top-ten list. Frame it. Laminate it. Commit it to memory. Just don't ask me to cut the body copy.

Do You Know Me?
30 seconds

(MUSIC UNDER)

LANDRY: Do you know me? I'm one of the best known cowboys in Texas but a lot of people don't recognize me in a cowboy hat so I just carry the American Express Card. It can help you out in plenty of tough situations because you never know when you're gonna be surrounded by Redskins. . . Howdy.

ANNCR: To apply for the card, look for this display and take one.

➤ **American Express**
Art Director: F. Paul Pracilio
Writers: Jeff Atlas, Robert Neuman
Agency: Ogilvy & Mather/Sandra Breakstone,
Ann Marcato
Client: American Express Company

➤ **Subaru**
Art Director: Tony DeGregorio
Director: Steve Horn
Writer: Lee Garfinkle
Production: Steve Horn Productions
Agency: Bob Nelson/ Levine, Huntley, Schmidt & Beaver
Client: Subaru of America

You Always Hurt
60 seconds

MUSIC: "YOU ALWAYS HURT THE ONE YOU LOVE."

ANNCR: People have a love-hate relationship with their cars. They love them, but they don't always treat them right. Yet amazingly, over 90% of all Subarus registered since 1974 are still on the road. Now imagine how much longer they would last if people didn't "love" them so much.

ANNCR: Subaru. Inexpensive and built to stay that way.

SUPER: SUBARU. INEXPENSIVE. AND BUILT TO STAY THAT WAY.

➤ **John Hancock**
Art Director: Don Easdon
Director: Joe Pytka
Writer: Bill Heater
Editor: Hank Corwin
Production Company: Joe Pytka, Pytka Productions
Agency: Hill, Holliday, Connors, Cosmopulos
Client: John Hancock Mutual Life Insurance

Single
30 seconds

DAVE: So, how much you making now? Huh? (Chuckle)

MIKE: I'm doing fine.

DAVE: You gotta be making at least twenty-five.

MIKE: I'm fine. Maybe a little better than that.

DAVE: Thirty? Tell me, yes or no. Are you making thirty?

MIKE: Yes.

DAVE: Thirty?

MIKE: Around thirty.

DAVE: You got any investments, any stuff?

MIKE: Got a car.

DAVE: That's not an investment. You got an IRA, life insurance?

MIKE: (sigh) Not really.

DAVE: You're making thirty and you don't have anything like that? What d'ya think you're eighteen years old or something?

➤ **Prince Foods**
Art Director: Bob Barrie
Writer: John Stingley
Illustrators: Dick and Mark Hess
Agency: Fallon McElligott
Client: Prince Foods Canning Division

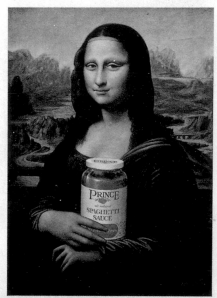

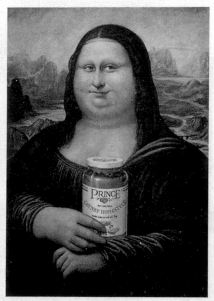

Original. Chunky.

Whether you choose our original sauce with imported olive oil
and romano cheese, or our chunky homestyle with bits of tomato,
herbs and spices, you'll get classic Italian taste.

➤ **Nike**
Designer: Peter Moore
Photographer: Chuck Kuhn
Producer: Francine Gourguechon
Agency: Nike Design
Client: Nike

In my experience, there are two kinds of great clients. The first is a client who knows little about marketing or advertising (these people usually come from the sales side of the business). This client says, "I know how to make widgets, you know how to make ads." The best example was when I was working on the "Three Biggest Lies" campaign for the *New York Post.* The CEO at the time started rewriting some of the headlines of the print work; he suddenly stopped and said, "Ya know, I'm not going to change a word of this, so if it doesn't work I can fire you *f--kers* with a clear conscience." Now that's a great client. Ironically, he did terminate the relationship, because the campaign's success made the *Post* first in sales, and he decided he didn't need to advertise anymore. Go figure.

The second kind of great client is a real cheerleader for the creative person and the creative process. This client knows that this talent is rare and should be cherished and nurtured. This client knows that a creative person is the only one who can get their target audience to believe, with their hearts, in their brand.

The best example of this client is my Minneapolis-based Target client, whom the agency helped launch its first New York-area store. This particular client was so friendly and generous in our first strategic briefing that, as a New Yorker, I was very uncomfortable. "Nice" is something New Yorkers aren't too familiar with, yet it's something that deep down inside they truly crave. That was when the creative premise to the campaign struck me—"A store too nice for New York!" When I told the client this idea, he loved it so much he brought in a cake and gave us gifts to take back to New York. The Target store opened with great fanfare and remains, to date, the second most profitable store in the company.

● ● ● ● ● **BILL OBERLANDER/** MANAGING PARTNER, KIRSHENBAUM, BOND & PARTNERS

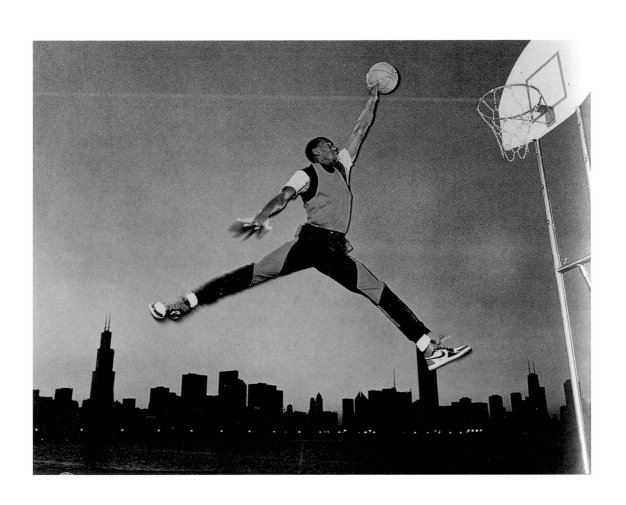

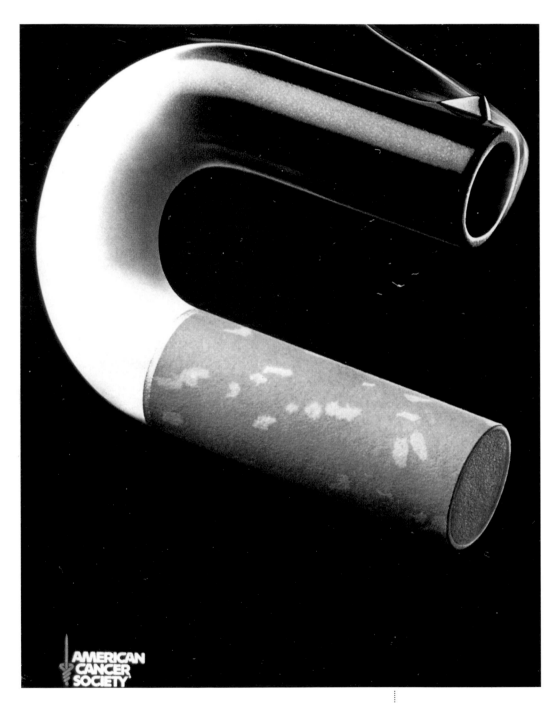

➤ **American Cancer Society**
Art Director: Rob Boezewinkel
Photographer: Nick Koudis
Retoucher: E.S. Paccione
Client: I. Rimer

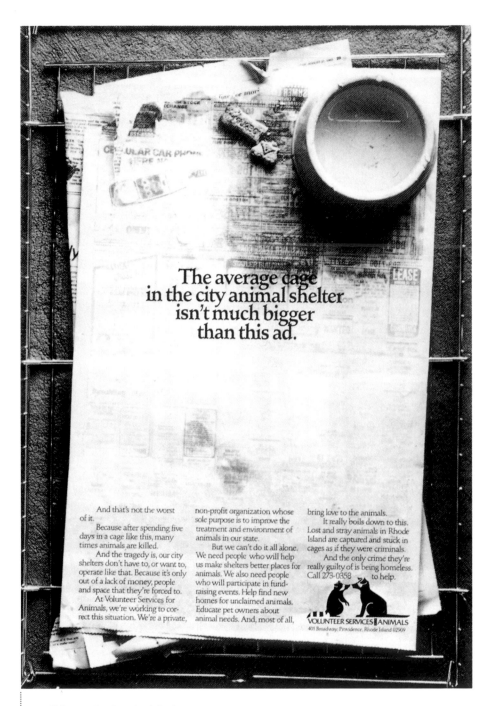

The average cage
in the city animal shelter
isn't much bigger
than this ad.

And that's not the worst of it.

Because after spending five days in a cage like this, many times animals are killed.

And the tragedy is, our city shelters don't have to, or want to, operate like that. Because it's only out of a lack of money, people and space that they're forced to.

At Volunteer Services for Animals, we're working to correct this situation. We're a private,

non-profit organization whose sole purpose is to improve the treatment and environment of animals in our state.

But we can't do it all alone. We need people who will help us make shelters better places for animals. We also need people who will participate in fundraising events. Help find new homes for unclaimed animals. Educate pet owners about animal needs. And, most of all,

bring love to the animals.

It really boils down to this. Lost and stray animals in Rhode Island are captured and stuck in cages as if they were criminals.

And the only crime they're really guilty of is being homeless. Call 273-0358 to help.

VOLUNTEER SERVICES ⬤ ANIMALS
401 Broadway, Providence, Rhode Island 02909

➤ **Volunteer Services for Animals**
Art Director: Debbie Lucke
Writer: David Lubars
Illustrator: Cathy Toelke
Photographer: John Holt
Agency: Leonard Monahan Saabye
Client: Volunteer Services for Animals

➤ **Rolling Stone**
Art Director: Nancy Rice
Writer: Bill Miller
Photographer: Jim Marvy
Agency: Fallon McElligott
Client: Rolling Stone

Perception.

Reality.

If you still think a Rolling Stone reader's idea of standard equipment is flowers on the door panels and incense in the ashtrays, consider this: Rolling Stone households own 5,199,000 automobiles. If you've got cars to sell, welcome to the fast lane. Source: Simmons 1984

Capture the eye, then the heart, and the brain will follow. In other words, advertising works on a visual level, first and foremost. If the art direction and design of the "communication" is not getting attention in a strong, unique, appropriate way for the brand character, the net impression on the viewer/consumer is zero. I always liken it to being introduced to someone at a dinner party— if I'm not attracted to them in a visual, physical sense, then there is little chance I'll ever learn more about their personality, or brand character, if you will.

● ● ● ● ● **BILL OBERLANDER/** MANAGING PARTNER, KIRSHENBAUM, BOND & PARTNERS

Perception.

Reality.

For a new generation of Rolling Stone readers, a mouse is not a furry little animal that processes cheese. The mouse we're talking about processes information. And last year, the mouse population, especially among Rolling Stone readers, was on the rise. Rolling Stone readers purchased more than $697 million worth of personal computer equipment and software during 1988. That ain't cheese. If you want to catch your share of that action, bait your trap in the pages of Rolling Stone.

RollingStone

Perception.

Reality.

For a new generation of Rolling Stone readers, it isn't necessary to process information to appreciate contemporary American literature. Rolling Stone readers turn the pages of America's best sellers at the rate of 3.9 million books a year. If you're looking for a highly educated, discerning audience for your advertising message, you'll get great mileage in the pages of Rolling Stone.

RollingStone

Perception.

Reality.

Bullwinkle. For a new generation of Rolling Stone readers, mousse is a hair care product, not the star of a Saturday morning cartoon. Last week, Rolling Stone readers used mousse and other hair care products more than 3.9 million times. If you've got health and beauty products to sell, rack up the sales with your ad in the pages of Rolling Stone.

RollingStone

Archaeology
60 seconds

PROFESSOR: This, class, is perhaps the greatest archaeological discovery of our time.

PROFESSOR: A dwelling called the split-level ranch. Marvelous!

F-STUDENT #1: What's this professor?

PROFESSOR: Ah, a spherical object they used to hurl at each other with great velocity, while others looked on.

M-STUDENT: What's this?

PROFESSOR: Oh, this device produced excruciatingly loud noises to which they would gyrate in pain.

F-STUDENT#2: Professor, what is it?

PROFESSOR: Odd.

F-STUDENT #2: What is it?

PROFESSOR: I have no idea.

SUPER & VO: PEPSI. The choice of a new generation

Advertising is one of the few jobs that allows you to work in many, many industries. As executive creative director for Kirshenbaum Bond & Partners, I work on dozens of brands in a given day. I can work on a champagne brand, an insurance company brand, a sports team brand, an investment bank on-line trading brand, a camera brand, a fashion brand, a pharmaceutical brand, and a Drug Free America assignment—all before lunch.

My most interesting experience with this "cross-category exposure" was in a new-business-pitch scenario. In the morning I was in Maryland at a slaughter facility to pitch campaign ideas to a chicken company. The scene was quite gruesome. I was doing my presentation in the conference room, while outside the birds were going under the knife, and clouds of feathers were blowing in the wind.

Later in the afternoon I was at the Plaza Hotel pitching ideas to the bejeweled and bedazzled Ivana Trump just after she acquired the hotel from Donald. We were in the Emerald Room with gold leaf, chandeliers, and bodyguards. At the end of the day a group of us all went down to the hotel restaurant for dinner. As you can imagine, no one ordered chicken.

● ● ● ● ● BILL OBERLANDER

➤ **Pepsi-Cola**
Art Director: Harvey Hoffenberg
Director: Joe Pytka
Writer: Ted Sann
Editor: Steve Schreiber
Production Company: Pytka Productions
Agency: Gene Lofaro/BBDO, New York, NY
Client: Pepsi-Cola Company

Heavy Traffic
30 seconds

MUSIC THROUGHOUT

SFX: CLICK

VO: How well does your car stand up to heavy traffic?

MUSIC OUT.

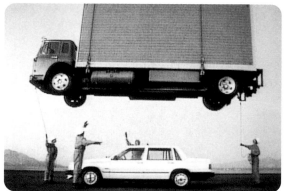

➤ **Volvo**
Art Director: Earl Cavanah
Director: Henry Sandbank
Writer: Larry Cadman
Editor: Barry Stillwell
Producer: Jaki Keuch
Client: Volvo of America

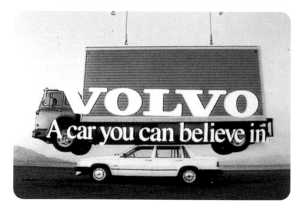

Higher and Higher
60 seconds

CHORUS: Your love has lifted me higher than I've ever been lifted before. so keep it up.

1ST SOLOIST: So keep it up.

CHORUS: Quench my desire.

2ND SOLOIST: Quench my desire.

CHORUS: And I'll be at your side for ever more. You know your love keeps on liftin'. . .

2ND SOLOIST: Keeps on liftin'. . .

3RD SOLOIST: Higher. . .

CHORUS: Higher and higher. I said your love. . .

➤ **NYNEX**
Art Director: Marty Weiss
Director: Kevin Godley, Lol Creme
Editor: Ciro DeNettis
Writer: Robin Raj
Producer: Mark Sitley, Steve Amato
Agency: Chiat Day Mojo Advertising
Client: NYNEX Information Resources

Dog
30 seconds

DOG: I used to like it when she ran. She really didn't go much faster than now when she's walking, but she'd tire out quicker. And then we'd go home and she'd fall asleep in front of the TV. I used to like that. I'd go sit on the chairs I'm not supposed to and she couldn't do nothing about it. Now, we go 3 miles a day, 10 miles on weekends. You know dogs were meant to sit in the sun and sleep. They ought to engrave that on the president of Nike's forehead.

➤ **Nike**
Art Director: Susan Hoffman
Director: Barry Sonnenfeld
Copywriter: Mark Fenske
Producer: Bill Davenport
Agency: Wieden & Kennedy
Client: Nike Inc.

Just do it.

AIR

Indestructible from tip to butt. Rhino graphite makes this rod tougher than Ugly Stik, meaner than Power Pole. We make it more affordable than both. The new Rhino rod. ZEBCO

Zebco
Creative Director: Jack Supple
Art Director: Jud Smith
Copywriter: Kerry Casey
Photographer: Jim Arndt
Producer: Sheila Fitzpatrick
Agency: Carmichael Lynch
Client: Zebco

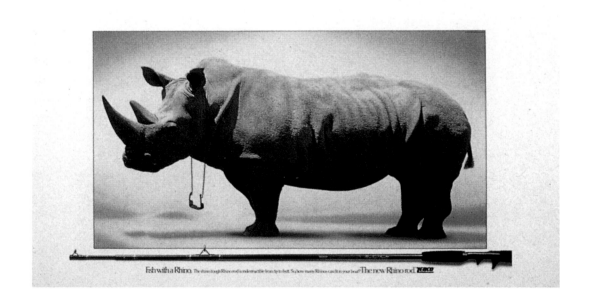

Fish with a Rhino. The ultra-tough Rhino rod is indestructible from tip to butt. So, how many Rhino can fit in your boat? The new Rhino rod. ZEBCO

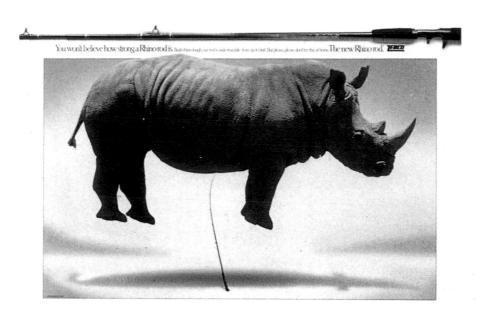

How else could a poor kid from the Bronx get to meet and work with people like Aretha Franklin, Ray Charles, or Joe DiMaggio?

●●●●● ROBERT REITZFELD / PARTNER, BEAVER REITZFELD

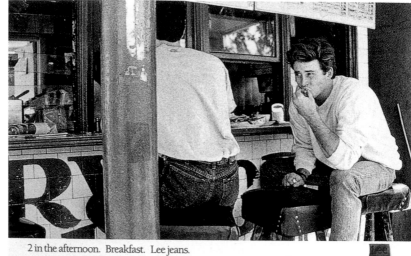

2 in the afternoon. Breakfast. Lee jeans.

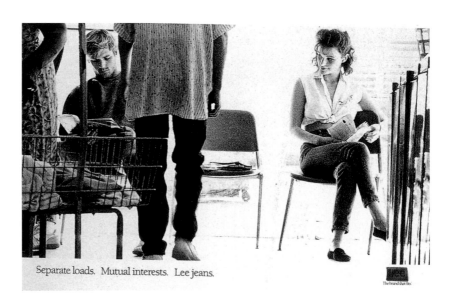

Separate loads. Mutual interests. Lee jeans.

Lee Jeans
Art Director/Designer: Mark Johnson
Copywriter: Bill Miller
Photographers: Kurt Marcus, Joe Pytka
Agency: Fallon McElligott
Client: Lee Jeans

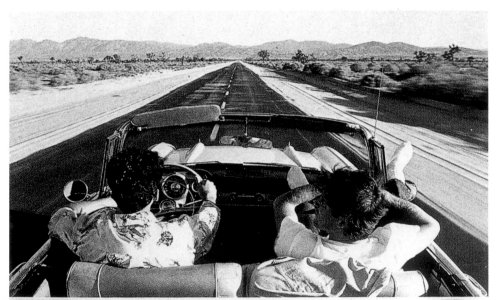

36 hours 'til Monday. 54 dollars and change. Lee jeans.

Would you still drink it?

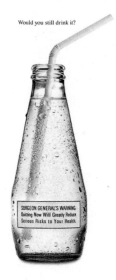

SURGEON GENERAL'S WARNING:
Quitting Now Will Greatly Reduce
Serious Risks to Your Health.

Then why do you still smoke? New York Lung Association.

A Constituent of the American Lung Association.

➤ **New York Lung Association**
Art Director/Designer: Tracy Wong
Copywriter: Tracy Wong
Photographer: Steve Hellerstein
Agency: Goldsmith/Jeffrey
Client: New York Lung Association

Would you still eat it?

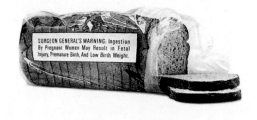

SURGEON GENERAL'S WARNING: Ingestion
By Pregnant Women May Result in Fetal
Injury, Premature Birth, And Low Birth Weight.

Then why do you still smoke? New York Lung Association.

A Constituent of the American Lung Association.

Would you still eat it?

SURGEON GENERAL'S WARNING:
Contains Carbon Monoxide.

Then why do you still smoke? New York Lung Association.

A Constituent of the American Lung Association.

Furniture Stripping
30 seconds

SFX: OPENING CHIME. STRIPPER MUSIC BEGINS, CLAPPING,
WHISTLING, MUSIC, AND CROWD NOISE CONTINUE; SOUND
OF SPRINGS POPPING OFF.

VO: If it's out there, it's in here.

SFX: CATCALL.

VO: The NYNEX Yellow Pages.

SFX: BOOK SLAMS SHUT.

VO: Why would anyone need another?

➤ **NYNEX**
Art Director: Marty Weiss
Director: Kevin Godley, Lol Creme
Writer: Robin Raj
Producer: Mark Sitley, Steve Amato
Agency: Chiat Day Mojo Advertising
Client: NYNEX Information Resources

➤ **Paddington**
Art Director: Chris Graves
Creative Director: Roy Grace, Diane Rothschild
Copywriter: Craig Demeter
Agency: Roy Grace
Client: Paddington

1990

"Quite simply, the Eastern 'establishment' is no longer the center of the advertising universe. The center, in fact, is everywhere."

➤➤ **Advertising at the end of the twentieth century**

As far as personal experience goes, I can't speak about the first fifty or sixty years of the twentieth century, but I'm convinced that the years I have spent in the advertising business are as exhilarating as the decades that came before. The excitement I've enjoyed while working in this industry owes in large part to the legacy of a single man who, during the 1960s, managed to change the business forever. The impact of Bill Bernbach—the man behind the Volkswagen "Think small" campaign, the memorable Alka Seltzer ads, and the American Airlines campaigns of the 1960s—cannot be understated. His work transformed the New York advertising scene and soon sent ripples throughout the country.

Back in 1971, when I was getting my start in California, the West Coast seemed light years away from Madison Avenue, and places like Minneapolis or Portland or Richmond or Seattle weren't even blips on the radar screens of the New York cognoscenti. Bill Bernbach's "creative revolution" was well underway; but while Bill's disciples were busy building wildly successful offshoots of Doyle Dane Bernbach in New York, there were creative people in other parts of the country paying brilliant homage to Bernbach's idea that advertising can be a respectable, honest, intelligent, and artful form of persuasion. These people were asking the question, "Why should you have to be on Madison Avenue to do great ads?"

In Seattle, John Brown and Partners were laying an early foundation for a running-shoe company called Nike, working on the principle that "there is no finish line." Tom McElligott hadn't left Bozell & Jacobs yet, but he was already "selling" the Episcopal Church with thoughts like, "The way some churches act these days you'd think Jesus Christ was an accountant." Hal Riney, who had just established Ogilvy & Mather in San Francisco, was using his unique storytelling abilities not just to sell beer but to actually invent a legend. DDB had an outpost in Los Angeles that took the art of the billboard to another level with the Volkswagen "Floating Beetle" and American Airlines' "Shake and Bake," and Mike Koelker at Foote Cone & Belding in San Francisco was making jeans fly—animating a history for an American fashion icon.

On Olympic Boulevard in Los Angeles, Jay Chiat and Guy Day

were determined to take any product—whether it be the local race-track, a motel that charged six dollars a night, a Japanese car made by a motorcycle manufacturer, or a Japanese motorcycle made by a piano manufacturer—and prove that great advertising ideas didn't have to come from back East. The migration of the "Bernbach school" was starting to happen. Fallon, McElligott, Rice was born in Minneapolis. Jay Chiat looked past New York to London and decided to import account planning; soon, we were introduced to English directors who were shooting commercials more like movies than ads.

Some real brands started to emerge from the West. Levi's was changing the rules in apparel advertising as director Leslie Dector was capturing the romance and gestalt of jeans on the streets of the inner city. Hal Riney took bubbly water from France and created poetry with words and pictures to celebrate the birth of Perrier: "The day everything happened just right." Between Joe Pytka's images and Riney's words, you began to feel that advertising could be art. In 1984, Nike co-opted the Olympic Games in Los Angeles (not by paying to be the official anything but by just doing it).

And then there was the 1984 Super Bowl. Sometime during the first half, a sixty-second commercial introduced viewers to something called a Macintosh; the Apple ad was filmed by Ridley Scott and never once did it actually show the product. And yet our desktops haven't been the same since—and neither has the Super Bowl.

On the East Coast, the advertising "establishment" called some of these stunts irresponsible and indulgent, but there was little doubt that the rules were changing. In Portland, Oregon, Dan Wieden and David Kennedy began to further refine the vision of Nike. They re-introduced us to Bo Jackson, Andre Agassi, John McEnroe, Mars Blackmon, Lil' Penny, Tiger Woods, and of course, Michael Jordan—and to the immortal words, "Just do it." Nike wasn't just redefining advertising, it was reinventing marketing and brand-building. It was selling millions of product units, not just by celebrating the individual product itself but by reframing the larger, collective image of the company.

Then, on a slightly more frivolous level, there were the wine-cooler wars. "Papaoumaumau California Coolers the Real Stuff" vs. yet another Hal Riney brainchild—Bartles & James. And then, on the big-ticket product list, there was Porsche. First Chiat/Day did it: "Of

course you'd be a Porsche." And when the account moved to Fallon McElligott, it was: "Eats Corvettes for lunch." Finally, there was Goodby's succinct "There is no substitute." For his part, Fallon went on to give us *Rolling Stone*, Hush Puppies, Lee, Timex, *The Wall Street Journal* and *Time*; then Goodby, along with guys named Berlin and Silverstein, returned to give us a Mexican restaurant named Chevy's that served up "fresh mex." Of course, for dessert, if you're having that fudge brownie you'd better be sure you've "got milk."

The creative epicenter was moving all over the place. Wieden took ESPN, a cable sports network, and made it famous all over the world for its totally human, funny, and fresh advertising. Then Goodby & Silverstein revitalized Polaroid with evidence that your dog pooped on my lawn. They filmed the romance of a trip on Norwegian Cruise Lines the way we dreamt a great getaway could feel. "It's different out here," they told us, and you actually believed you could look that good with water pouring down your naked back. Then Hal Riney redefined brand-imaging for car companies with the Saturn campaigns.

Then there were the beer wars. Wieden gave us Miller Genuine Draft and a message that beer could bring anyone together, no matter what 'hood you're from. Then Fallon ressurected Miller Time with otherworldly retro spots that became instant cult classics. Finally, Goodby took Budweiser into the realm of fantasy with a group of talking frogs, lizards, and ferrets.

Well, I guess you get the idea. Quite simply, the Eastern "establishment" is no longer the center of the advertising universe. The center, in fact, is everywhere. You can find it in Portland and San Francisco, Los Angeles and Minneapolis, London and Singapore, Johannesburg and Amsterdam. Bill Bernbach would be proud, I think, to discover that his revolutionary approach to creativity in the ad business has permanently busted out of the New York bubble— having changed not only how we work, but where we work.

Thanks Bill.
The difference between the forgettable and the enduring is artistry.
—Bill Bernbach

Absolut Chicago
Art Director/Designer: Tom McManus
Creative Director: Arnie Arlow, Peter Lubalin
Copywriter: David Warren
Photographer: Steve Bronstein
Agency: TBWA Advertising
Client: Carillon Importers, Ltd.

YOU CAN'T GET IT OFF YOUR MIND
Totally natural SMARTFOOD® Air-popped popcorn smothered in white cheddar cheese.

➤ **Smart Food**
Art Director: Amy Watt
Creative Director: Edward Boches
Copywriter: Edward Boches
Photographers: John Holt, Cheryl Clegg
Agency: Mullen
Client: Smartfoods, Inc.

▶ **Hair Tinting**

➤ **Hair Tinting/ NYNEX**
Art Director: Cabell Harris
Copywriter: Dion Hughes
Photographer: Rick Dublin
Agency: Chiat Day Mojo Advertising
Client: NYNEX Information Resources

If it's out there, it's in here. NYNEX Yellow Pages

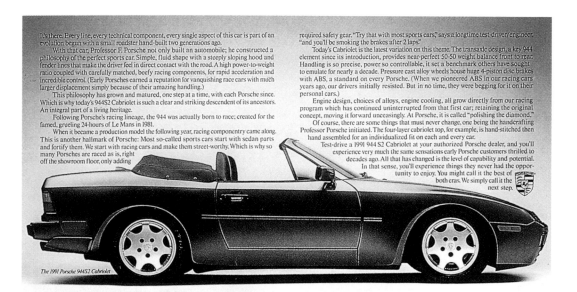

It's there. Every line, every technical component, every single aspect of this car is part of an evolution begun with a small roadster hand-built two generations ago.

With that car, Professor F. Porsche not only built an automobile; he constructed a philosophy of the perfect sports car. Simple, fluid shape with a steeply sloping hood and fender lines that make the driver feel in direct contact with the road. A high power-to-weight ratio coupled with carefully matched, beefy racing components, for rapid acceleration and incredible control. (Early Porsches earned a reputation for vanquishing race cars with much larger displacement simply because of their amazing handling.)

This philosophy has grown and matured, one step at a time, with each Porsche since. Which is why today's 944S2 Cabriolet is such a clear and striking descendent of its ancestors. An integral part of a living heritage.

Following Porsche's racing lineage, the 944 was actually born to race; created for the famed, grueling 24-hours of Le Mans in 1981.

When it became a production model the following year, racing componentry came along. This is another hallmark of Porsche: Most so-called sports cars start with sedan parts and fortify them. We start with racing cars and make them street-worthy. Which is why so many Porsches are raced as is, right off the showroom floor, only adding

required safety gear. "Try that with most sports cars," says a longtime test-driver/engineer, "and you'll be smoking the brakes after 2 laps."

Today's Cabriolet is the latest variation on this theme. The transaxle design, a key 944 element since its introduction, provides near-perfect 50-50 weight balance front to rear. Handling is so precise, power so controllable, it set a benchmark others have sought to emulate for nearly a decade. Pressure cast alloy wheels house huge 4-piston disc brakes with ABS, a standard on every Porsche. (When we pioneered ABS in our racing cars years ago, our drivers initially resisted. But in no time, they were begging for it on their personal cars.)

Engine design, choices of alloys, engine cooling, all grow directly from our racing program which has continued uninterrupted from that first car; retaining the original concept, moving it forward unceasingly. At Porsche, it is called "polishing the diamond."

Of course, there are some things that must never change, one being the handcrafting Professor Porsche initiated. The four-layer cabriolet top, for example, is hand-stitched then hand assembled for an individualized fit on each and every car.

Test-drive a 1991 944 S2 Cabriolet at your authorized Porsche dealer, and you'll experience very much the same sensations early Porsche customers thrilled to decades ago. All that has changed is the level of capability and potential. In that sense, you'll experience things they never had the opportunity to enjoy. You might call it the best of both eras. We simply call it the next step.

The 1991 Porsche 944S2 Cabriolet

Find the 1956 Porsche in this picture.

➤ **Porsche**
Art Director: Mark Johnson
Creative Director: Pat Burnham
Copywriter: John Stingley
Photographer: Jeff Zwart
Agency: Fallon McElligott
Client: Porsche

Amazing Lady
Radio Spot

MIKE: You can find anything in the NYNEX Yellow Pages. Under "Entertainers" I found the amazing Mr. Andy.

ANDY: (Weird voice): That's right Michael.

MIKE: Hey that's really funny. Who's it supposed to be?

ANDY: Whaddya mean? This is my real voice.

MIKE: I, well, uh, what other voices do you do?

ANDY: Listen to this. (Sounding exactly like Mike): They say you can find anything in the NYNEX Yellow Pages.

MIKE: Now that would be. . .

ANDY (As Mike): Well, there it is, more proof that if it's out there, it's in your NYNEX Yellow Pages. Why would anyone need another?

➤ **Amazing Lady**
 Creative Director: Dick Sitting
 Copywriter: Dion Hughes
 Agency: Chiat Day Mojo
 Client: NYNEX Yellow Pages

> **Percentage of Economist Readers. . .**
> Art Directors: Shalom Auslander, Mikal Reich
> Copywriters: Shalom Auslander, Mikal Reich
> Producer: Valerie Hope
> Agency: Mad Dogs & Englishmen
> Client: The Economist

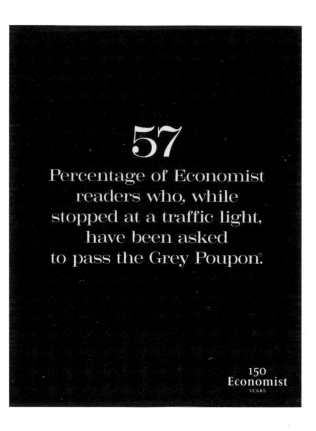

> **Baseball, hotdogs, apple pie, & AIDS**
> Art Director: Gorden Bennett
> Creative Director: Neil Calet
> Copywriter: Steven Landsberg
> Agency: Calet, Hirsch & Ferrell
> Client: Ads Against AIDS

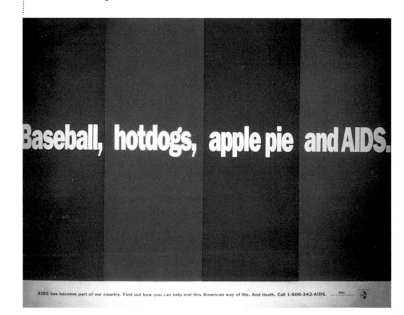

An article in the July 12, 1999 issue of *The New Yorker* featured the Ford Motor Company's recently appointed head of design. His name is J. Mays (the "J" stands for "J"!).

Mr. Mays is a highly regarded automobile designer. He spent most of his automobile design career in Europe. He left Audi/Volkswagen to join Ford. Mays is credited with the design of the new Volkswagen and the latest handsome line of Audi cars.

As head of the Ford design program he oversees all styling of the full line of Ford cars and trucks as well as Lincolns, Jaguars, Volvos, Mazdas, and Aston Martins. It's a full plate of design responsibility!

J. Mays brings a view of design to Ford which is of a much broader spectrum than auto designers practice in general, as you can observe by the following quote from his *New Yorker* interview:

"He wants to bring a holistic point of view to Ford's design efforts. He is eager to make it clear that he is not one of those car designers who think only about cars. He looks at everything, and talks about wanting to position Ford as a company that brings sophisticated design to the mass market, as IBM and CBS did a generation ago."

J. Mays' CBS reference is flattering and most observant. I was the chief Design/Advertising head at that time and, indeed, we operated in the manner that Mays would like to see emulated at Ford.

But all that is gone. The CBS holistic view of design happened because of enlightened and tasteful management by Frank Stanton and William S. Paley. They knew and could sense the advantages of controlling everything from inside the corporation.

And it showed, nothing was left to chance. From matchbooks, to the format for typing a letter; the color and quality of wrapping paper and the string with which to tie the package; to advertising strategy, copy, concepts, and design—everything in our print advertising for new programs, and for our institutional ads, as well as all collateral print and on-air promotion were produced inside.

Even our telephone number was carefully thought out. Frank Stanton fought with AT&T to acquire the following phone number: "Plaza 1-2345!" Everything—from major to minor issues—was on our drawing boards.

In the early 1980s, CBS was taken over and new management ended all that intelligent and provocative work. The return to mundane design, advertising, etc. signaled the end of an era. A skeleton design force remained and most work was scattered between agencies and studios on the West coast.

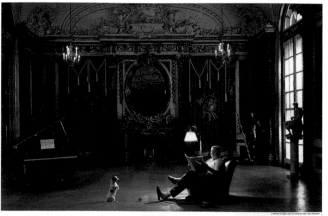

NEW YORK
LOTTO
Hey, you never know.

➤ **New York Lotto**
Executive Creative Directors: Jack Mariucci,
Bob Mackall
Art Director: David Angelo
Copywriter: Paul Spencer
Photographer: Neil Slavin
Agency: DDB Needham Worldwide.
Client: New York State Lottery

When you're bald and toothless, you'd better wear cute clothes.

It's happened to you. You're walking down the middle of the mall when you spot a mother with a newborn baby coming your way. You're excited, remembering how proud you were the first time you went out with your baby and were deluged with compliments.

So you clear your throat, peer into the stroller with that big goofy grin on your face and blurt out, "Oh, isn't he the cutest thing?"

Silence.

The "he" is a "she."

Oops. (To get back on solid footing with mom, compliment her on how great she looks so soon after delivering a baby.)

The simple truth is, a lot of girl babies look like boy babies and vice versa. In fact, quite often, the only distinguishing feature is a baby's clothing. (When they're naked, of course, it's easy.)

At Healthtex, we understand new moms and dads want to avoid this confusion whenever possible. That's why we always make it easy for your infant to look the only way he or she is supposed to look: cute.

For instance, we make sure all of our clothing comes in a wide variety of colors, styles and patterns for both traditional and contemporary tastes. (In other words, for the Bradys as well as the Bundys out there.)

Like pastels, including light pink and powder blue. Primary shades. And more updated colors, including magenta, rose, jade, lilac, lemon and turquoise.

You'll find little cabooses, trucks and trains for boys. And pretty flowers, big hearts and cute cuddly kitties for girls.

With the help of a new advanced computer program, our designers are constantly experimenting with new prints and incorporating them into our clothing designs. (And you thought your baby had cool toys to play with.)

Of course, because we're Healthtex, we also make a big deal out of

tiny details. That's why you'll find buttons, bows and lace trim for girls. And neat little baseball and teddy bear emblems for boys.

All in all, we've put as much thought into making our baby clothes adorable as we have into making them last. And last they will. Our soft, comfortable cotton/poly blend is built to hold up wash after wash, doesn't lose its color and needs little or no ironing.

And not only are all of our clothes designed to stand up to the test of time, so are our styles. Years from now lots of little girls will still be drooling over rompers like the cute one shown here.

We could go on and on about the things we're doing to improve our clothes, like our new soft label that doesn't scratch.

So if you'd like to find out more, call the toll-free number listed below. We'll do our best to answer any questions you might have.

After all, we want you and your baby to be as happy as the little baby girl over there. Or is it a little baby boy?

Healthtex 1-800-554-7637

Questions? Call us at our toll-free number. Look for Healthtex clothing at Boscov's, Kohl's, Kids Mart and Hecht's.

➤ **Bald and Toothless**
Art Director: Carolyn McGeorge
Copywriter: Joe Alexander
Photographer: Dublin Productions
Producer: Jenny Schoenherr
Agency: The Martin Agency.
Client: Healthtex, Inc.

I recall that in the past, Container Corporation and IBM had internal staffs but, from my observations, extensive internal corporate design has lost its standing. Short programming needs are now being met by outside designers; two product design programs that come to mind are Tupperware, with its printed material, and The California Golden Gate National Parks program.

So much for "inside the company" design. Now for television itself.

I see so many commercials that simply do not communicate. The concepts are not clear, production is generally O.K., high quality, but ideas are in short supply in most of what I see. Much obfuscation, ergo meager communication.

I was pleased and amused to see and hear Rosie O'Donnell express exactly the same sentiment about TV commercials on her TV show last week. Why do advertisers buy stuff like that—at those prices? I just don't get it.

Print advertising should not be excluded in this discussion—it certainly has not distinguished itself. The marvelous tool of the computer has not added to the mix—that is not where ideas come from.

I imagine I am to be relegated to the "old Geezer" category by the younger practitioners for not being sufficiently *au courant* to comprehend all these new cutting edge efforts! So be it. I have some hope, however, that matters shall improve.

If I have offended anyone, I offer my apologies.

Angst, intrigue, elation, deception, devotion, disappointment, euphoria, and perseverance. Oh yes, p...e...r...s...e...v...e...r...a...n...c...e.

Sound like a Greek tragedy? It simply describes a working day in the advertising business. The process of creating a decent piece of advertising, getting it through to your partners and finally convincing a client that it might be effective doesn't always (read: almost never) go smoothly.

So what makes this business so appealing?

There is nothing more exciting than working in the world of ideas. The challenge of creating something where nothing existed before. Starting with a tiny fragment of a vague elusive thought and nurturing it until it becomes strong enough for you to even utter it. Having it be understood and even liked enough to be embellished upon by your partner. The trust, vulnerability, and patience it takes to build these thoughts together into a viable piece of communication. The adrenaline released when the moment comes to present your baby to the world. Wow!! Sure, there's always the chance that it isn't received well or needs to be changed or even gets completely trashed. But show me a creative person who still doesn't want to go back to the very beginning of that process and start all over again with the hope of success, and I'll show you someone who doesn't belong in this Greek tragedy we call advertising.

● ● ● ● ● **ARNIE ARLOW/** CREATIVE CONSULTANT / FORMERLY EXECUTIVE VICE PRESIDENT AND CREATIVE DIRECTOR, TBWA / PARTNER AND CREATIVE DIRECTOR, MARGEOTES, FERTITTA AND PARTNERS.

Got Milk?
Creative Director: Jeffrey Goodby, Rich Silverstein
Art Director: Rich Silverstein, Peter di Grazia
Designer: Chuck McBride
Photographer: Terry Heffernan
Producer: Michael Stock
Agency: Goodby, Berlin and Silverstein
Client: California Fluid Milk Processor Advisory Board

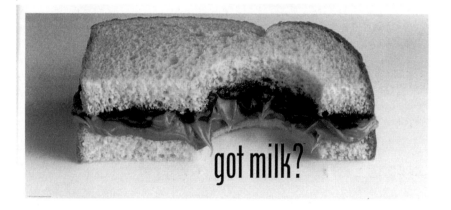

➤ **Transit Campaign**
Creative Director: John C. Jay
Art Director: John C. Jay
Designer: Chris Shipman
Illustrator: Petra Langhammer
Photographer: Stanley Bach
Agency: Wieden & Kennedy
Client: Nike

We've finally arrived at a time when animation can be considered an effective and viable tool for promoting something other than cereal and other children's products. Creatively, I'm encouraged to explore "Farther Reaches" than ever before! Anything goes. Unfortunately, good concepts and ideas are still scarce.

• • • • • J.J. SEDELMAIER / PRESIDENT AND DIRECTOR, SEDELMAIER PRODUCTIONS

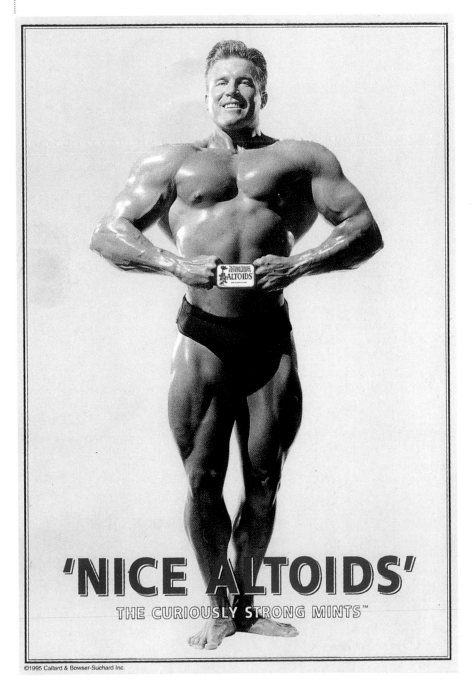

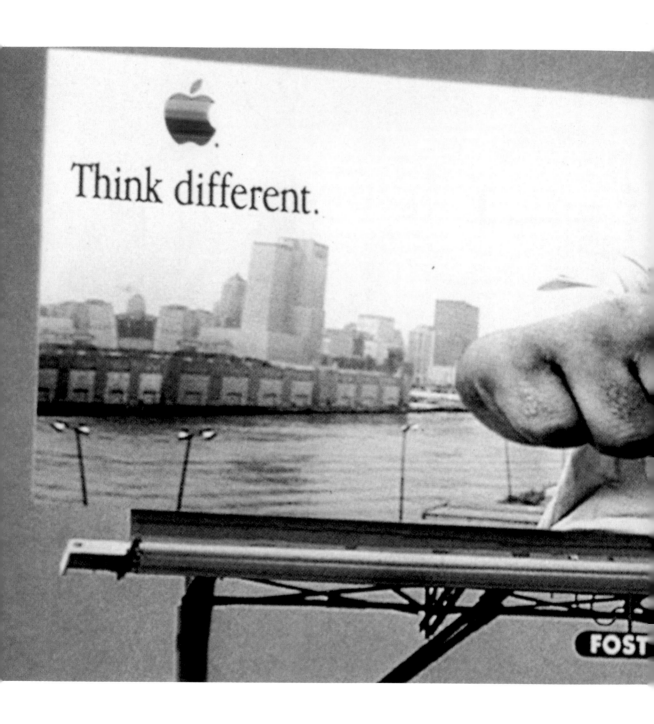

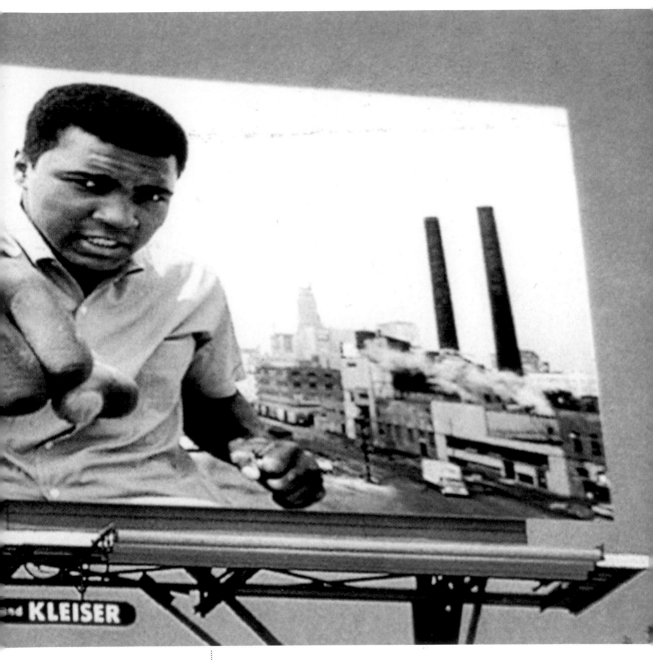

➤ **Muhammad Ali, Think Different**
Creative Director: Lee Clow
Art Directors: Lee Clow, Jessica Shulman, Craig Tanimoto, Eric Grumaum
Copy Writers: Greg Tanimoto, Eric Grumaum
Producers: Chistine Callejas, Laura Heller
Agency: TBWA/Chiat Day Mojo Advertising
Client: Apple Computer

➤ **Levi's**
Creative Director: John Hegarty
Art Director: Tony Davidson
Copywriter: Kim Papworth
Photographer: Nadav Kander
Agency: Bartle Bogle Hegarty
Client: Levi Strauss & Co.

When I came into this business in 1963, I was shocked to learn that this exciting group of people who did the ads I read in the *Saturday Evening Post, Ladies Home Journal,* and *Seventeen,* and who created the *Hallmark Hall of Fame, Lux Television Theatre,* and the *Arthur Godfrey Show,* were almost one-hundred-percent white.

It was in the late 1960s and early 1970s that some agencies began recruiting educated black men and women from colleges and universities. A few agencies even ventured onto historically black college campuses to recruit students. It was at only a few agencies like J. Walter Thompson, Young & Rubicam, Ted Bates, Compton, BBDO, Grey, and Ogilvy & Mather that any of this hiring was going on.

How do we get more minorities into the advertising industry? The answer is simple. Hire them. If I can find excellent young black, Hispanic, and Asian men and women and I don't even advertise for them, then so can others. But there's another problem that must be confronted. If you're hiring minorities to do advertising, as in write, lay out, manage, research, plan, or buy media, then we're all going to have to do business differently. I mean advertise differently, consistently produce advertising that includes minorities. The mission of Caroline Jones Incorporated is unique to the industry: To sell products, through advertising and promotion, by accurately reflecting the colors and cultures of the consumers who buy those products. If not us, who? If not now, when?

● ● ● ● ● **CAROLINE R. JONES** / PRESIDENT AND CREATIVE DIRECTOR, CAROLINE JONES INCORPORATED

▼
1990 / 248

➤ **Public Education**
Art Directors: Aaron Eiseman, Abi Aron Spencer
Creative Director: Sal DeVito
Copywriters: Aaron Eiseman, Abi Aron Spencer
Design: inspired by Barbara Kruger
Photographer: Henry Leutwyler
Agency: DeVito/Verdi
Client: The Pro-Choice Public Education Project

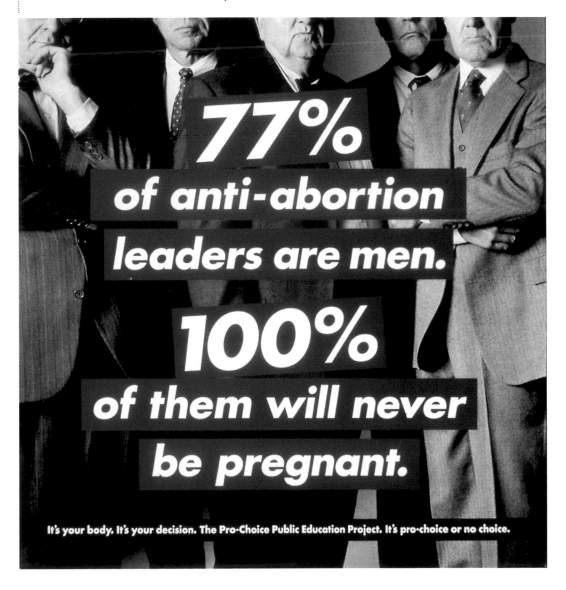

➤ **Feet**
Creative Director: Tony Granger
Art Directors: Erich Funke, Stuart Walsh
Copywriters: Erich Funke, Stuart Walsh
Photographer: Michael Meyersfeld
Agency: TBWA Hunt Lascaris
Client: Playtex, Wonderbra

➤ **STEVEN HELLER (1920s)**
ART DIRECTOR, EDUCATOR, EDITOR, AND AUTHOR

Steven Heller is the art director of the *New York Times Book Review*. He is also editor of the AIGA *Journal of Graphic Design* and Chair of the MFA/Design program at the School of Visual Arts in New York. He is the author, editor, or co-author of over seventy books, including *Design Literacy: Understanding Graphic Design*; *Design*; *Design Dialogues*; *Typology*; and *Paul Rand*. He ws inducted into the Art Directors Hall of Fame with a Special Educator's Award in 1996.

➤ **JAY CHIAT (1930s)**
FOUNDER
CHIAT/ DAY

Jay Chiat started his advertising career as a copywriter for the Leland Oliver Company and became Creative Director there before leaving in 1962 to form Jay Chiat & Associates. Chiat/Day was founded when he teamed up with Guy Day. One of the first major creative agencies to have its headquarters in Los Angeles, it was also the first in the U.S. to introduce Account Planning, a discipline that made Chiat/Day famous for its distinctive, breakthrough campaigns. Chiat believes the working environment has a direct impact on the creative process, a philosophy that is evidenced in the Chiat/Day offices designed by Frank Gehry, Gaetano Pesce, and Rem Koolhaas. Jay reinvented the way people work by transforming Chiat/Day into the first virtual office in the U.S., and in 1989, *Advertising Age* named Chiat/Day Agency of the Decade. Jay Chiat is now CEO of Screaming Media.Net, an internet company that distributes custom news to corporate web sites.

➤ **SHELLY LAZARUS (1940s)**
CHAIRMAN AND CEO
OGILVY & MATHER WORLDWIDE

A 26-year veteran of Ogilvy & Mather, Lazarus has worked in every product category and played a significant role in the management of the company for nearly a decade, culminating in her appointment as Chairman and Chief Executive Officer of Ogilvy & Mather Worldwide in 1996. Lazarus has been recognized by Advertising Women of New York, which named her "Advertising Woman of the Year" in 1994. She is also a recipient of the Women in Communications' Matrix Award and was named "Business Woman of the Year" by the New York City Partnership.

➤ **ROY GRACE (1950s)**
CHAIRMAN AND CREATIVE DIRECTOR
GRACE & ROTHSCHILD

Roy Grace is the chairman and creative director of Grace & Rothschild. He started at Doyle Dane Bernbach as an art director and by the time he left, to start his own firm in 1986, he was Chairman of the U.S. company and Executive Director of DDB-Worldwide. His work for Volkswagen, Alka-Seltzer, Land Rover, Chanel, and IBM, among other clients, has won him twenty-one Effies, twenty-nine Clios, eighteen Art Directors Medals, ten Andys, and eight Cannes Film Festival Lions. His Alka-Seltzer "Spicy Meatball" commercial was named the single best commercial in two decades at the International Broadcasting Awards. He was inducted into the Art Directors Hall of Fame in 1986.

➤ **GEORGE LOIS (1960s)**
CHAIRMAN AND CEO
LOIS/USA

George Lois is the chairman, chief executive officer, and worldwide creative director of Lois/EJL. He is given credit for forcing cable operators of America to put MTV on cable with his "I want my MTV" campaign, and he was praised by Al Neuharth for "saving USA Today." He wrote his autobiography, *George, Be Careful*, as well as the books, *The Art of Advertising, What's the Big Idea*, and *Covering the Sixties*, a book on his legendary covers for *Esquire* magazine. In 1998, Lois was awarded the AIGA Lifetime Achievement award, and was inducted in the Art Directors Hall of Fame in 1978.

➤ **BOB GIRALDI (1970s)**
PARTNER AND DIRECTOR
GIRALDI SUAREZ PRODUCTIONS

After graduating from Pratt Institute, Bob Giraldi spent the next nine years as an Art Director and Creative Director at Young & Rubicam, Inc. In 1970, he moved to Della Femina and Partners as the Creative Director of the agency. In 1973, he founded Giraldi Suarez Productions with Phil Suarez, an association that has produced and directed over 2,000 commercials and music videos, which have earned over 500 major industry awards. One of their most celebrated videos is "Beat It," starring Michael Jackson. In 1998, Mr. Giraldi formed Artustry Partnership, a solution-driven marketing and creative think tank that has developed successful campaigns for Tabacalera Inc., Texaco, Chase Manhattan, and the new Trump World Tower. Also in 1998, he formed Voyeur Films, a cutting-edge commercial and music-video company. In addition, Giraldi and Suarez own ten successful restaurants, including the Mercer Kitchen in Soho's Mercer Hotel, and Jean Georges, which has earned the *New York Times* Four Stars—the first time a restaurant has been awarded Four Stars on the first review. Giraldi was inducted into the Art Directors Hall of Fame in 1991.

> **ALLAN BEAVER (1980s)**
> **PARTNER AND FOUNDER**
> **BEAVER REITZFELD**

Allan Beaver was founding partner, vice-chairman, and chief creative officer of Levine Huntley Schmidt & Beaver. He is a past president of the Art Directors Club of New York, was elected to the Art Directors Club Hall of Fame in 1997, and sits on the Ad Council's Creative Review Board. He teaches and lectures at the School of Visual Arts, Princeton University, and Syracuse University. His most recent venture is Beaver Reitzbeld, Inc. in New York, where he is founder and partner. Beaver was inducted into the Art Directors Hall of Fame in 1997.

> **LEE CLOW (1990's)**
> **CHAIRMAN AND CEO**
> **TBWA CHIAT/DAY**

Lee Clow is the chief creative officer, worldwide, at TBWA Chiat/Day. Under his leadership, TBWA Chiat/Day was voted 1997 Agency of the Year by *USA Today, Adweek, Shoot Magazine*, and *Advertising Age's Creativity*. Mr. Clow and his team have been behind some of the most talked-about advertising in the world, including the "1984" commercial for Apple Computer, which is considered to be one of the best commercials ever made. Clow was inducted into the Art Directors Hall of Fame in 1990.

> **JERRY DELLA FEMINA (FOREWORD)**
> **CHAIRMAN AND CEO**
> **DELLA FEMINA/JEARY AND PARTNERS**

Advertising Age recently named Jerry Della Femina one of the 100 most influential advertising people of the century. Della Femina co-founded Della Femina Travisano & Partners in 1967 which quickly became one of the top 20 agencies in the country. Leaving his agency briefly in 1992, Della Femina re-entered the advertising business with *Newsweek* as the flagship account of his new agency Jerry Inc. which later came to be known as Della Femina/Jeary and Partners. Della Femina has written two books, *From the Wonderful Folks Who Gave You Pearl Harbor* and *An Italian Grows in Brooklyn*.

► ARNIE ARLOW
CREATIVE CONSULTANT
FORMERLY EXECUTIVE VICE PRESIDENT
AND CREATIVE DIRECTOR, TBWA
PARTNER AND CREATIVE DIRECTOR,
MARGEOTES, FERTITTA AND PARTNERS

► LOU DORFSMAN
CREATIVE DIRECTOR
MUSEUM OF TELEVISION AND RADIO
(ART DIRECTORS HALL OF FAME 1978)

► STEVE FRANKFURT
SENIOR VICE PRESIDENT, SPECIAL
PROJECTS, NUFORIA, INC.
VICE CHAIRMAN, THE WOLF GROUP
(ART DIRECTORS HALL OF FAME 1983)

► CAROLINE R. JONES
PRESIDENT AND CREATIVE DIRECTOR
CAROLINE JONES INCORPORATED

► RICHARD KIRSHENBAUM
CO-CHAIRMAN
KIRSHENBAUM, BOND
& PARTNERS

> JEAN MARCELLINO
> FREELANCE ART DIRECTOR, FORMERLY
> OF LORD GELLER FEDERICO EINSTEIN,
> J WALTER THOMPSON, WELLS RICH
> GREENE, AND YOUNG & RUBICAM

> EDWARD A. MCCABE
> CO-FOUNDER
> SCALI, MCCABE, SLOVES

> BILL OBERLANDER
> MANAGING PARTNER
> KIRSHENBAUM, BOND & PARTNERS

> JAY SCHULBERG
> VICE CHAIRMAN/CHIEF
> CREATIVE OFFICER
> BOZELL WORLDWIDE

> KARL H. STEINBRENNER
> PRESIDENT STEINBRENNER & CO.
> ADVERTISING AND MARKETING
> CONSULTANT, FORMER PRESIDENT,
> ART DIRECTORS CLUB, CREATIVE
> INTERNATIONAL, MCCANN-
> ERICKSON WORLDWIDE